BONNIE KEMSKE

KINTSUGI

The
POETIC MEND

HERBERT PRESS
Bloomsbury Publishing Plc
50 Bedford Square, London, WC1B 3DP, UK
29 Earlsfort Terrace, Dublin 2, Ireland

BLOOMSBURY, HERBERT PRESS and the Herbert Press logo are trademarks of
Bloomsbury Publishing Plc

First published in Great Britain in 2021

A catalogue record for this book is available from the British Library

UK ISBN: 978-1-912217-99-1

4 6 8 10 9 7 5 3

Designed and typeset by Plum5 Limited
Printed and bound in China by RRD Asia Printing Solutions Limited

To find out more about our authors and books visit www.bloomsbury.com
and sign up for our newsletters

BONNIE KEMSKE

KINTSUGI

The
POETIC MEND

HERBERT PRESS
LONDON · OXFORD · NEW YORK · NEW DELHI · SYDNEY

DEDICATION

For David Emil Kemske 1952–1963,
whose loss has been a lifetime kintsugi project

PROLOGUE

Broken pots repaired with veins of gold – who wouldn't be drawn in by such a concept?

When I started this book I thought it would run along similar lines as *The Teabowl: East and West*. Like *The Teabowl*, I knew that this book's perspective would again need to be based on my background as a ceramicist, a writer, a Japanese tea ceremony student, and a lover of Japanese arts and culture. What I didn't anticipate was just how personal it would become. It took only a little research to find myself immersed in the intriguing world of beauty, narrative and metaphor that is kintsugi. One story built onto another, and I began to think about ways to present them, as well as the basic knowledge about kintsugi. I decided to entrust these personal stories of researching the book to you, the reader. You'll find them between each chapter and interspersed in the text.

Like most people, when I first came across kintsugi, I didn't realize that the repairs weren't entirely gold. I can't recall when I first learned that kintsugi is actually a lacquer art form. It must have been during my studies of Japanese tea ceremony in Kyoto when I was a young woman. Later, as Editor of *Ceramic Review*, I was offered a short article on it for the 'Knowledge' pages of the magazine. I jumped at it. Suddenly, kintsugi went from being something that was just there, to something I wanted to know more about. I became intrigued by a technique that seemed so closely tied to ceramics that wasn't a ceramic technique at all.

Then in 2013 I was asked to be a contributor to an episode of *Something Understood*, the BBC Radio 4 programme that 'examines some of the larger questions of life'. They were exploring kintsugi as a metaphor for overcoming tragedy. I invited Jo Fidgen, the producer, to the Japanese tearoom at Kaetsu Centre in Cambridge, where we study Japanese tea ceremony and hold gatherings. With the kettle quietly simmering and the incense lightly scenting the air, for the first time I articulated what kintsugi meant to me. I spoke of the loss of a brother when I was a child, and how that had shaped me, positively and negatively.

In writing *The Teabowl* I again explored kintsugi. In fact, I chose a photo of a seventeenth-century kintsugi-repaired bowl for the cover. In the book I looked at the metaphor of kintsugi as it is used in contemporary art, and how, at a time of environmental catastrophe and a turning away from unfettered capitalism, it serves as a model of sustainability and renewal. I found it hard to keep from writing a complete chapter on kintsugi alone, and that was when I started contemplating this book.

Poetry and pottery, music and art, psychology and spiritual healing. I looked for the many different ways that kintsugi has been interpreted in our world.

I spoke to anyone I could think of who was willing and interested, and was surprised by how many people were. I met with historians and practitioners, collectors and teachers, and those who described themselves as 'just curious'. This took me into realms of metaphor I hadn't expected, such as kintsugi's use as a model for disability and reconstructive surgery.

During the writing of this book, the topic of kintsugi often came up in my weekly Japanese tea ceremony lessons in Cambridge. My teacher, Peter Sōrin Cavaciuti, repeatedly challenged my thinking and assumptions, always offering new perspectives. It was his suggestion that led Hiroko Roberts-Taira, a fellow Tea student, to join me on this project. Let me introduce her, as you will come across her throughout the book. Hiroko is one of the most able and organized people I know. She served as Historical Researcher for this project, but she did much more than that. In our partnership Hiroko pushed me to go more deeply into understanding kintsugi's history and context. I pushed her to think of kintsugi in ways she had never considered. With support from Daiwa Anglo-Japanese Foundation and The Great Britain Sasakawa Foundation, we undertook a research trip together to Japan, organized brilliantly by Hiroko. There we met with archaeologists, curators, potters, *urushi* (lacquer) artists and craftsmen, and those in the new profession of *kintsugi-shi* (kintsugi practitioners), as well as experts in related fields.

Hiroko took a special interest in uncovering kintsugi's history, for which there was very little written material, and she is largely responsible for Chapter Three. Hiroko helped with all aspects of Japanese language, including the decision to use the Japanese convention of name order: family name followed by given name, except in some historical cases where individuals have come to be known by their given names alone.

The aim of this book is to give a context for both traditional and contemporary kintsugi through exposition, discussion and narrative, and to broaden our understanding of its importance as more than just a repair. As a reader you may be surprised that there are stories that demonstrate kintsugi as metaphor for overcoming grief or tragedy; or maybe you don't anticipate seeing so much written on the physicality of its materials and techniques. It was the months of juggling these divergent aspects of kintsugi that made me realize that it is kintsugi's capacity to encompass both a down-to-earth practicality and a full-blown metaphoric torrent that gives this amazing technique its powerful appeal.

'The world breaks everyone and afterward many are strong at the broken places.'[1]
–Ernest Hemingway

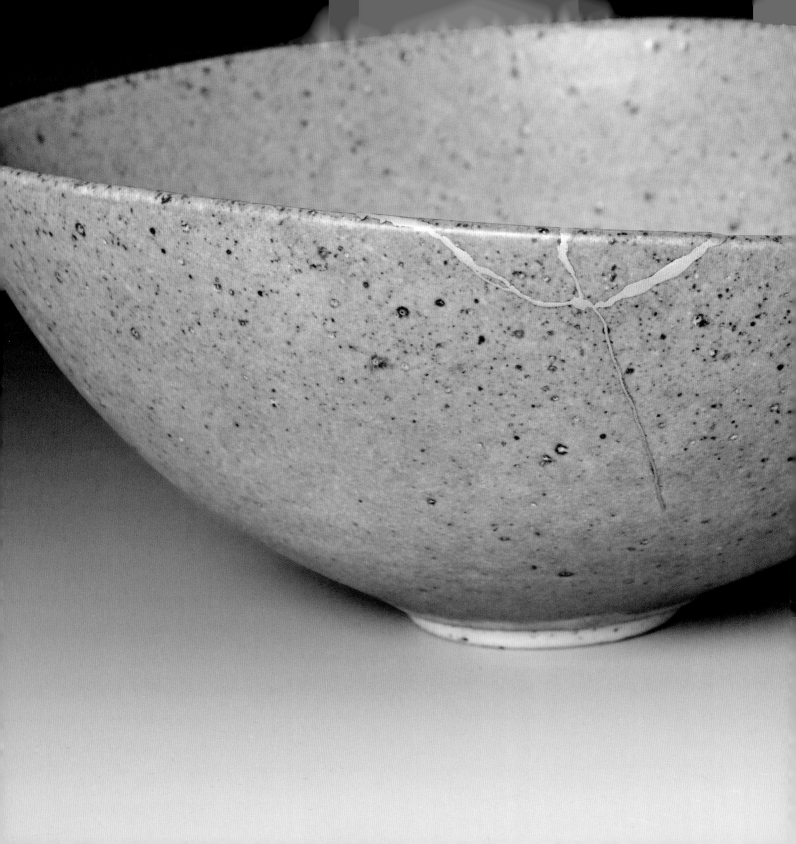

CRACKS MADE WHOLE IN A GOLDEN REPAIR

You are staring into the box, and silly as it seems to cry over a broken dish, you feel yourself welling up. Inside, carefully nesting in the packaging, lie three pieces of a small dish. It was the dish your grandmother used when you visited, always filled with treats. You had been thrilled when your mother told you that your grandmother had asked for you to have it. She had little to leave, but she knew that this dish would always remind you of her.

And now it is broken.

What should you do? You can't use it as it is. And it is too precious to discard; that would be throwing away layers of memory. Should you gather together the fragments, feeling the shapes and weights of each piece as you carefully put them in the back of the cupboard to be unseen, unused, unloved? Or do you try to glue the pieces back together, in what would likely be an unsightly outcome? It doesn't seem right to do this to such a precious object. Maybe you could find a professional restorer. But even with the finest restoration, even if it looks as good as new, you will always know that it has been broken. The little dish has, in effect, been destroyed. It will never again be what it was.

There is another way.

Figure 1: Stephanie Hammill, Fruit Bowl, *thrown, glazed and repaired by Stephanie Hammill, 2014. Stoneware with ash glaze; repaired with urushi and 24-carat gold powder. 12 x 20 cm. Photo by Bo Wong 2018.*

KINTSUGI: SEAMS OF GOLD

Kintsugi (gold joining), or kintsukuroi (gold repair), is a Japanese repair technique that takes ceramic destruction and makes a broken object into a new entity. It leaves clear, bold, visible lines with the appearance of solid gold. Using fine lacquer and gold to mark the scars, it never hides the story of the object's damage. Kintsugi traces the memories, bringing together the moment of destruction and the gold seams of repair through finely-honed skills and painstaking, time-consuming labour in the creation of a new pot from the old, one that may be stronger and even more beautiful than the original. Kintsugi can make a ceramic pot that has lost its function usable again, and the repair will be durable, waterproof and stable. But the same can be said of some invisible mending. So why choose kintsugi? Why invest in a process that can take many months to complete and possibly set you back a small fortune?

It is because kintsugi is much more than just a repair. Ultimately, it is not only practical, it is also decorative, in the best sense. That golden mend will make the pot unique. Even if an identical pot breaks and is repaired, no two kintsugi pieces will ever be the same.

As our eyes follow the lines of destruction now filled with gold, we recognize at some level that there is a story to be told with every crack, every chip. This story inevitably leads to kintsugi's greatest strength: an intimate metaphoric narrative of loss and recovery, breakage and restoration, tragedy and the ability to overcome it. A kintsugi repair speaks of individuality and uniqueness, fortitude and resilience, and the beauty to be found in survival. Kintsugi leads us to a respectful and appreciative acceptance of hardship and ageing. What was a broken dish from your grandmother can become a precious new item that will mark the transition of life, from her to you.

AESTHETIC ORIGINS

Although the material components of kintsugi – ceramics, lacquer and gold – exist in other places in East Asia, kintsugi is distinctly Japanese. It is thought that this highly-refined repair technique appeared or at least became established in the late sixteenth or early seventeenth century.[2] Its development comes out of the context of three components of the time: the

Figure 2: Keiko Shimoda, 金継ぎ (kintsugi), 2020. Sumi ink on Japanese paper with brush. Photo by the artist.

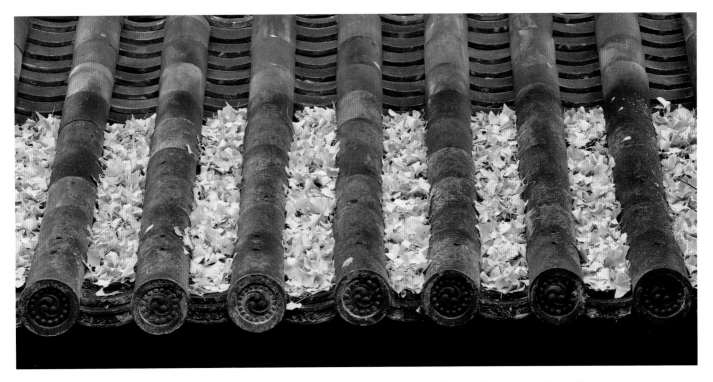

Figure 3: Ichō (gingko) leaves create bright gold lines on the roof of a temple in Kyoto. Photo: Alex Ramsay/Alamy Stock Photo.

opulence of the Momoyama era (*c.* 1573–1600); the rising cultural, political and economic importance of *chanoyu*, Japanese tea ceremony; and the expansion of *maki-e*, lacquer art, which uses gold. The Momoyama era brought an end to over one hundred years of continual conflict throughout Japan, through military unification under the *daimyō*[3] Oda Nobunaga, and his successor, Toyotomi Hideyoshi. With peace and the concentration of the samurai into towns and cities, the arts flourished. *Chanoyu* was one of those arts. During this time large amounts of money went into extensive and highly cultivated collections of *chadōgu*, or tea utensils, which were sometimes used as rewards, or guerdons, to reinforce loyalty within society's strict hierarchies. Teabowls, tea caddies and other utensils gained not only aesthetic, but political and economic value. In the Edo period that followed, the lacquer art of *maki-e* ('sprinkled picture'), in which highly complex images are created using gold on an *urushi* (lacquer) background, flourished. It is within *maki-e* that we find the techniques of kintsugi.

TOPOGRAPHY AND ENVIRONMENT

Lines of gold. If you start looking, you will see them. In Japan they are easily found, especially in the autumn when the gold leaves of *ichō*, or gingko, turn. Here is an entry from my 1980 Kyoto journal:

> I am on my way to Manjuin Temple for a tea ceremony event. I don't know exactly what today is all about, but I'm ready to experience whatever it is. It's a long bus ride, so I have plenty of time to think about it. We're coming through a residential area. The houses all have traditional Japanese tiled roofs, the tiles half-cylinders interlocked one up/one down. It's November and the *ichō* are at their most golden and lavish. The bus has stopped to pick up passengers, and on the house beside us the leaves have fallen with the early dew into the valleys formed by the rows of tiles – channels of dark gold leaves contrast the sombre tiles.

The sun then streaks out from under the thick cloud cover, changing the dark gold lines to gleaming golden ones.

Breaks and cracks. In Japan the mountains produce a beauty that is, like kintsugi, at once fragile but also ruggedly monumental, just as we see in the Bashō poem:

Along the mountain road
Somehow it tugs at my heart –
A wild violet[3]

Cracks are found around the world, but in Japan's topography they seem to be celebrated, rather than avoided. In Kyushu I came across walls of fitted stones that create endless paths of cracks, all covered with a patina of delicate climbing plants. A stream running through Arita appears as cracks in the earth. In Kyoto, near Ginkakuji, the Silver Pavilion, even the trees had beautiful cracks and voids in their trunks. And I regularly spotted walls with cracks that had an almost calligraphic or painterly quality. These sights are all part of Japan's visual vocabulary.

Cracks and breaks were a noted feature within the ceramic tradition at the time of the development of kintsugi. *Yaburebukuro* ('broken or torn pouch'), an Important Cultural Property, is a *mizusashi*, or water jar used in tea ceremony, dating to the turn of the seventeenth century. It features several distinctive cracks, formed in its making, which add to its character. Ceramics such as these fit well into the aesthetic of *wabi*, the Zen Buddhist concept that recognizes and accepts the irregular, the imperfect and the incomplete, giving us a feeling of humbleness and rustic simplicity.

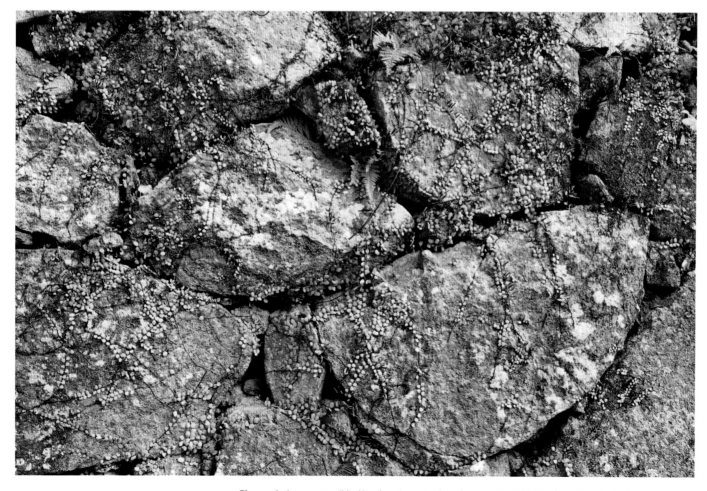

Figure 4: *A stone wall in Kyushu, Japan, showing intricate lines of cracks. Photo by the author.*

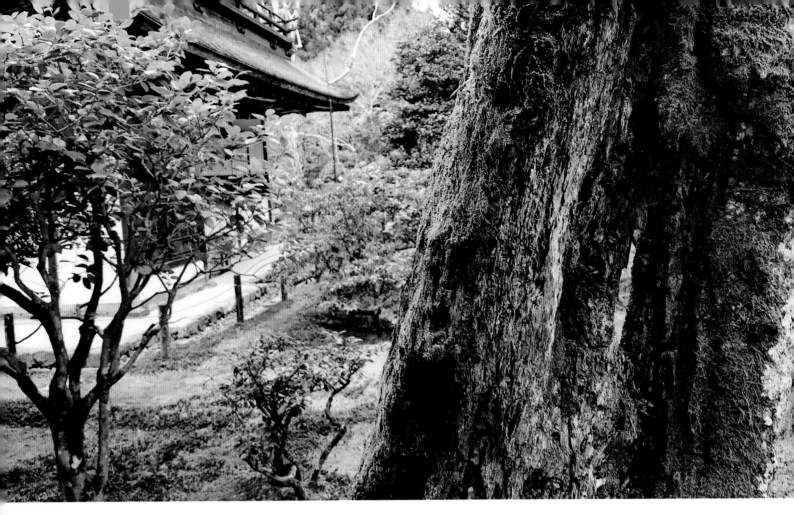

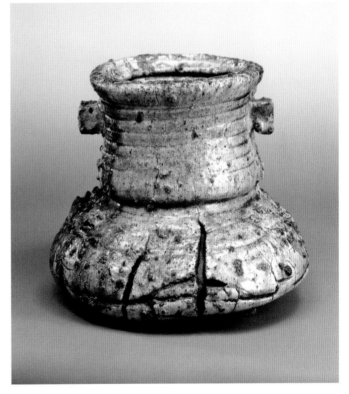

Figure 5: A tree near Ginkakuji (Silver Pavilion), Kyoto, Japan, with a void in the centre of its trunk. Photo by the author.

Figure 6: A wall with a painterly quality and a crack running through it, Arita, Kyushu, Japan. Photo by the author.

Figure 7: Yaburebukuro (Burst Pouch) mizusashi (fresh water jar), Japan, showing how cracks were already part of the Japanese aesthetic. Momoyama period (early 17th century). Important Cultural Property. Iga ware, stoneware with natural ash glaze, 21.4 x 23.7 cm; 15.2 cm rim. The Gotoh Museum, Japan.

5

6 7

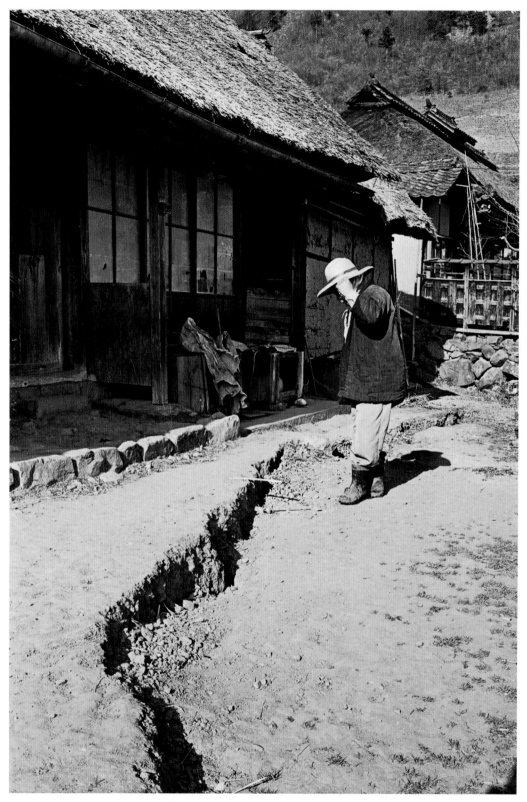

Figure 8: *A farmer studies the cracked earth in front of his house in Matsushiro, Japan, following an earthquake in 1966. Photo by Bettmann/Getty Images.*

形あるもの全て壊れる
Katachi aru mono subete kowareru

Everything that has a shape, breaks.

There is a Japanese saying that everything that has a shape, breaks. In Japan, even the earth shatters. Japan is on the Circum-Pacific Belt, or Ring of Fire, the horseshoe-shaped edge around the Pacific Ocean responsible for ninety percent of the world's earthquakes. The Japanese experience more than 1,500 earthquakes every year, with additional smaller tremors occurring daily. The long history and unrelenting frequency of earthquakes and tremors in Japan, and the cracks they create, reinforce an acceptance of life as imperfect and precarious.

Kintsugi is, in fact, even more directly linked to earthquakes, as it is after such disasters that lacquer artists and artisans, who traditionally undertake kintsugi, are busiest. Nakamura Kunio, who writes about and teaches kintsugi skills, said, 'Popularity seems to follow large earthquakes. People want to fix things that they associate with people they've lost.'[4] Or perhaps they cherish the repaired objects, which tell of a past that's gone. Nakamura also says that even outside the earthquake zone requests for kintsugi repairs seem to spike, as these disasters become part of a shared psyche.[5] In another article Pallavi Aiyar quotes Nakamura as saying, 'For us [Japanese], particular pieces of pottery are like family members. We cannot just throw them away.' He also says, 'Kintsugi not only joins the broken pieces of a bowl but also welds the past to the present.'[6]

Hiroko Roberts-Taira and I have come to see Mitamura Arisumi, a noted contemporary artist in maki-e, *or gold 'sprinkled' lacquer art. Mitamura is also Professor Emeritus from Tokyo University of the Arts. He is the third generation of the Mitamura line and the tenth of the Akatsuka line of* makie-shi *(lacquer artists). He and his wife Izumi greet us with typical Japanese graciousness and soon we are sitting and chatting about kintsugi. Mitamura brings out his tools, explaining how the craft of* maki-e, *the basis of kintsugi, is done.* [Figure 9] *Just for interest, he brings out a bowl of seeds from the* urushi *tree. They are waxy in feel and warm in colour.* [Figure 10]

He shows us some of his artwork. It is dramatic, modern and sleek. He then brings out two precious bowls, explaining that his father and grandfather did not do kintsugi repairs, but each had undertaken one repair during their lifetimes. The piece his grandfather chose to repair was a teabowl damaged in the devastating 1923 Tokyo earthquake, which took the lives of more than 140,000 people. The piece held special significance for Mitamura. [Figure 11] *The piece his father repaired was a celadon lotus bowl, intricate in design and requiring complicated kintsugi work.* [Figure 12] *Mitamura told us that he has yet to find the one and only broken piece he will mend.*

REPAIRS AND SCARS

The drive to repair, which led philosopher Elizabeth Spelman to refer to humans as *homo reparans*[7], is universal, but how different cultures regard damage, breakage or decay varies. It is said that kintsugi would not have developed in China, for instance, because the overriding aesthetic within Chinese classical tradition is towards perfection. I have been told that in China when a pot is broken, it may be repaired, but it is then banished to the kitchen. Spelman describes different approaches to repair, with some practitioners

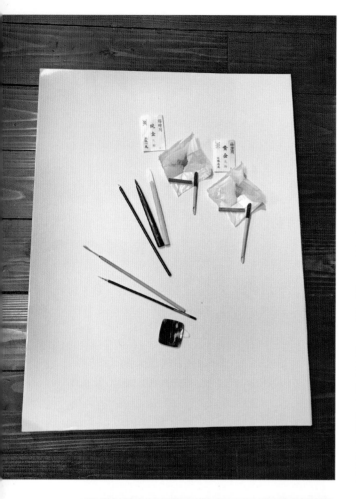

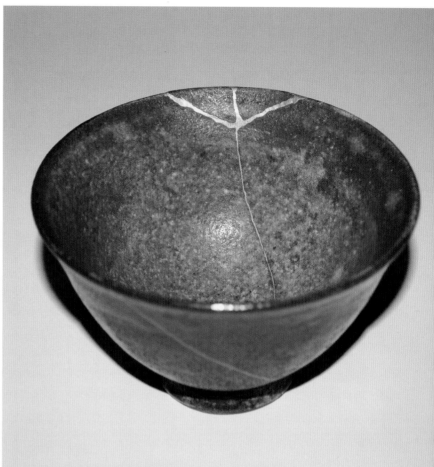

Figure 9: *Tools used by Mitamura Arisumi for maki-e ('sprinkled picture'). Photo by the author.*

Figure 10: *Seeds from the urushi tree, from which lacquer is produced. Photo by the author.*

Figure 11: *A teabowl broken in the 1923 Tokyo earthquake and repaired by Mitamura Arisumi's grandfather, Jihō. Photo by the author.*

Figure 12: *A celadon lotus bowl repaired by Mitamura Arisumi's father, Shūhō. Photo by the author.*

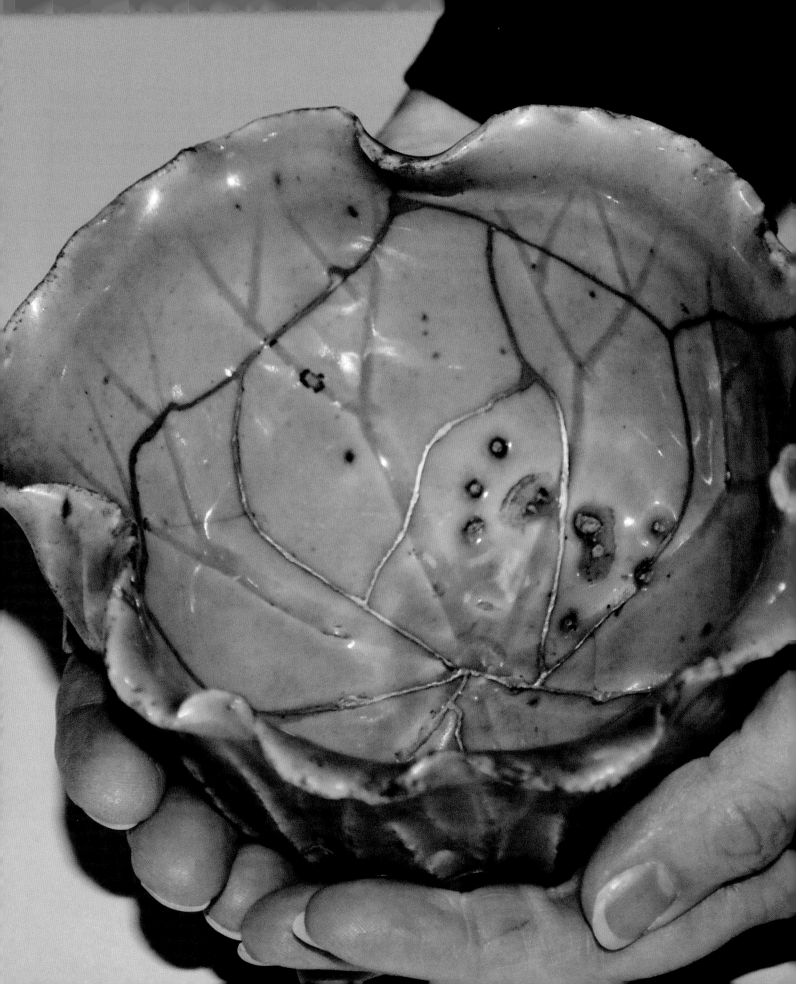

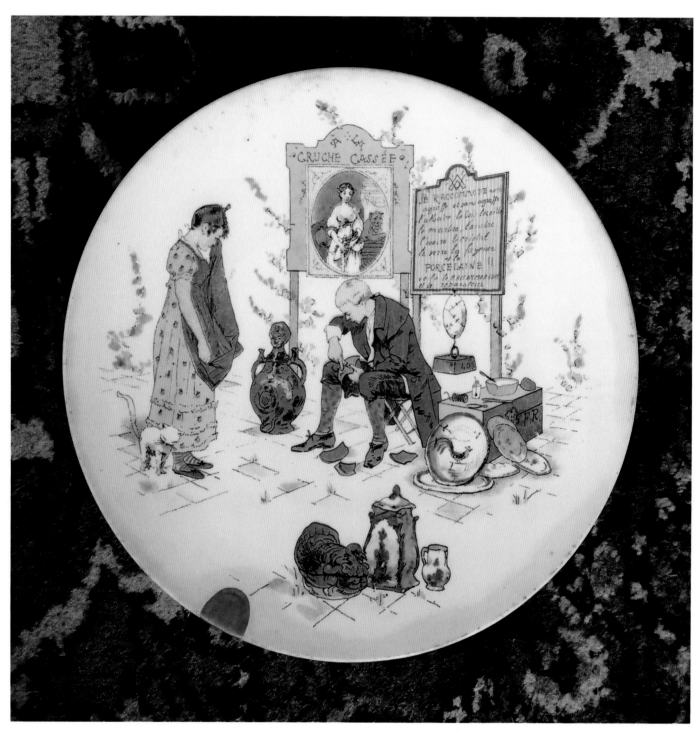

Figure 13: *The Broken Jug, c. 1890. Sarreguemines porcelain plate with transfer-printed decoration and kintsugi repair on lower left rim by Andrew Baseman, 21 cm. The plate shows a young woman in tears as a repairman mends a broken jug. Photo by Andrew Baseman.*

devoted to authenticity, and others inclined towards a looser interpretation of restoration.[8] Richard Sennett in his book *The Craftsman* latterly specified 'static' repairs, which restore the object to its original state, and 'dynamic' repairs, which 'will change the object's current form or function'.[9] Kintsugi repairs create new objects from the remains of the old, certainly a dynamic process.

In China, riveting to join broken pieces of a pot has a long history. In Colonial America as well, rivets and glues were used. Angelika Kuettner, a curator from Williamsburg, Virginia, says that repaired ceramics were often kept only for show to announce and reinforce one's status.[10] Sarah Barack from Cooper Hewitt, Smithsonian Design Museum, says that rivets are usually on the underside of a plate because of this.[11] These demonstrate views of repaired ceramics that clearly contrast that of kintsugi, where repairs are always discernible, and the repaired ceramics functional.

Andrew Baseman, a designer and set decorator, has a blog about his collection of inventively repaired antiques. His own kintsugi mends include a lovely *c.* 1890 French plate made in Sarreguemines. The kintsugi consists of a significant repaired chip on the rim, which contrasts the European story illustrated on the plate. A young woman is in tears as she watches a ceramic repairman mend a broken jug. A cat rubs her legs in sympathy. The man is making staples, or rivets, for the repair. Around him are his tools and examples of his trade, and behind him is a sign: 'I mend with staples and without staples'. There follows a list of things he will mend, and it closes with 'Here is the repairer and the renovator'. But why is the girl crying? Is she afraid he won't be able to repair her jug? Is it because the jug belongs to her mistress? Or perhaps her mother? Or does the jug have some special significance to her?

Because of the cost, it is usually valuable wares that undergo professional restoration, but, as with the young woman's jug, even everyday ceramics break. As Hiroko discovered in her research into the history of kintsugi, even after kintsugi became established, the use of gold and other precious metals and its time-intensive nature meant that kintsugi remained too expensive for the general public. A more affordable method developed called *yakitsugi*, in which glass was melted on a portable brazier and used to join the broken ceramic pieces. According to *Morisada Mankō*, an encyclopaedia of life through the Edo era, a profession called *yakitsugi-shi* arose towards the end of the eighteenth century in Kyoto and in Edo (Tokyo) in the beginning of the nineteenth century. '[A]lthough valuable ceramics and tea bowls are repaired with *urushi* and then gold is applied, daily use ceramics are repaired with *yaki-tsugi*.'[12] There was even a *senryū* (comical poem) about *yakitsugi-shi*:

焼き継ぎ屋　夫婦喧嘩の門に立ち
Yakitsugi man
Standing and waiting as
Matrimonial quarrels start[13]

The trade is said to have been so popular that ceramic shops complained that it was affecting their sales. *Yakitsugi-shi* gradually disappeared in the Meiji period (1868–1912), when modern technology and mass production arrived.

If there is no one to take a broken pot to, there are various natural glues, and now some new adhesive substances available for repairs. One traditional Japanese glue is made from cashew shells. A time-tested European repair technique used domestically for small cracks is to cover the object with milk, leave it on a low heat for an hour, then allow it to cool before

rinsing it. The proteins in the milk will bond the ceramic edges together.

AS GOOD AS NEW?

For much of European history the aim in mending broken things was to make them 'as good as new', and this continues to this day, often in commercial repairs. In fact, the definition of restoration is to return something to its original state. Historically, restoration work undertaken in museum collections was often of the 'good as new' variety, but in the latter part of the twentieth century a sea change occurred, with the move towards 'stewardship'. This led to the adoption of three principles: minimal intervention, appropriate materials and reversible methods, and the full documentation of all repair work undertaken.[14] 'Minimal intervention' and 'reversible methods' mean that the broken fragments of a piece will rarely be further damaged in the repair. If further damage is absolutely necessary, there will be a complete and exacting record kept. In contrast is a story told to me by restorer Ronald Pile, who trained in kintsugi in Kyoto. He said that when faced with a perfect break, where putting lacquer on the two pieces would cause a poor fit, he asked for advice. His teacher replied that he should bevel the edge, slicing it back to create space for the lacquer. This highlights a fundamental difference: the *kintsugi-shi* does not treat the broken object as something they are 'stewarding', preserving as much as possible of the past. A kintsugi-repaired object becomes a new piece with a new life. As Julie Dawson, Head of Conservation at the Fitzwilliam Museum, University of Cambridge, added in conversation, 'Artworks going into a museum often undergo a significant change in their role as they lose their function.'[15] In effect, they become frozen at the time of the repair. However, one area in which there is accord is about visibility.

New museum repair techniques often apply the 6/6 rule: from six feet away the repair should not be noticeable; from six inches you should be able to see it clearly. Like kintsugi, this acknowledges the break, although it does not highlight it.

An excellent museum restoration of recent years involved the reconstruction of three large seventeenth-century Kangxi Vases at the Fitzwilliam Museum, Cambridge. The vases were broken when a visitor took a singularly dramatic fall down the stairs, hitting one vase, which fell onto the next, which fell onto the next. The three vases ended up as thousands of sherds of varying sizes, many minute. The restoration was long and arduous, and the story of the three vases has become part of the Fitzwilliam's history.

The charger or large platter called *Spinster's Rock* is a powerful example of the narrative of breakage. [Figure 16]. The platter was made in the 1940s by the surrealist painter and ceramicist Sam Haile. As Chris Yeo, the BBC *Antiques Roadshow* expert, relates on the show: 'Very sadly, [Sam] was travelling back with a beloved army jeep full of pottery, and a bus crashed into him, and he was killed instantly. Only one piece could be saved from the jeep. And that's this piece. It was repaired by his wife, a woman named Marianne de Trey, who was a significant potter in her own right. The piece came directly from the family. So it's provenance, every time. In that condition, [I would value it at] £6,000. If it were perfect, without the damage, £4,000 – because of the story.'[16] This raises another issue, that of the value of repair. As this story shows, on occasion a repaired object can increase in value, rather than decrease. We have seen that kintsugi-repaired ceramics can be seen as a symbol of wealth. It seems that repair outside Japan, even without the addition of gold, can have the same result.

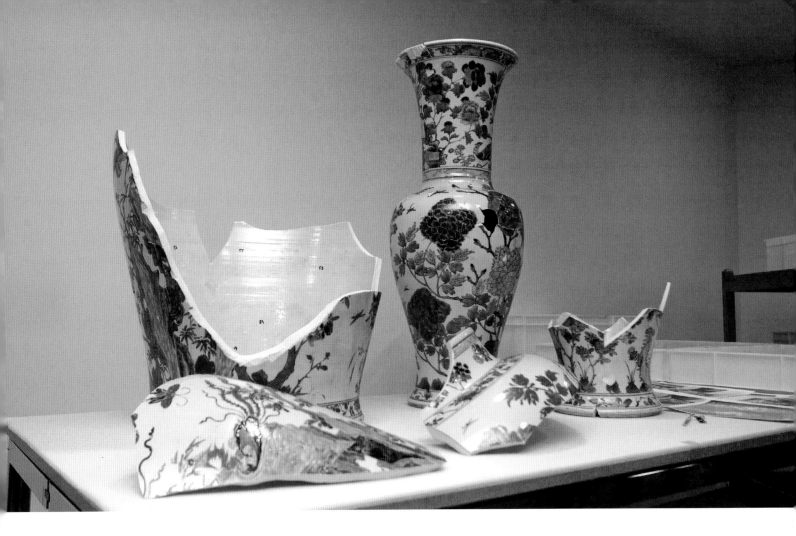

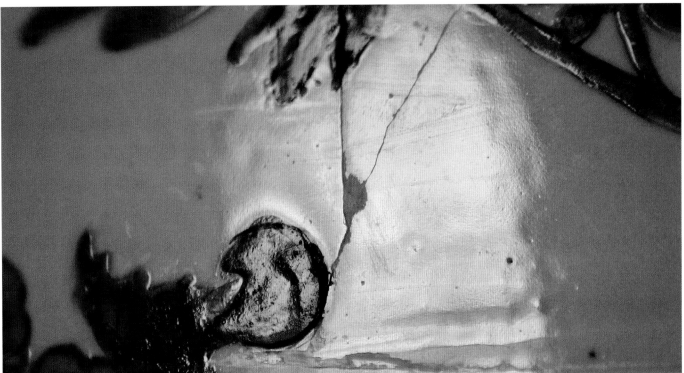

Figure 14: *Three Kangxi vases at the Fitzwilliam Museum, Cambridge, were broken in 2006. This photo shows two, one of which has been restored. Photo by Ian McCarney/Shutterstock.com.*

Figure 15: *Detail of a repair on one of the Kangxi vases at the Fitzwilliam Museum, Cambridge, showing contemporary restoration techniques, which allow us to see the repair if we are close. Photo by Daniel Berehulak/Getty Images.*

Figure 16: Thomas 'Sam' Haile, Spinster's Rock, c. 1948. Earthenware, slip-decorated, painted and glazed. 6 x 40 cm. Sam Haile was killed in an accident in his jeep, in which he had many of his pots. This is the only one to survive. It was repaired by his wife, noted potter Marianne de Trey. Photo by Stephen Morris. Courtesy of The Ken Stradling Collection, Bristol.

CULTURAL BEARINGS

It is difficult to know when kintsugi began to become part of the contemporary art and craft scene. Two significant exhibitions were mounted in 2008. *Golden Seams: The Japanese Art of Mending Ceramics* was a small but important exhibition at the Smithsonian Museum in Washington, DC, which drew objects from the Freer Sackler collection. *Flickwerk: The Aesthetics of Mended Japanese Ceramics* was a kintsugi exhibition held at the Johnson Museum of Art at Cornell University and at Museum für Lackkunst in Münster, Germany. The

exhibition catalogue offers excellent essays by Christy Bartlett, James-Henry Holland and Charly Iten. Dave Pike, a *kintsugi-shi* (kintsugi practitioner) working in Japan, has how-to videos on YouTube going back to 2010. When I was Editor of *Ceramic Review* we ran a how-to piece by Caterina Roma in 2013. That same year I was asked to contribute to a programme on kintsugi for BBC Radio 4. Andrew Baseman curated an exhibition that included works based on the concept of kintsugi as well as other unusual mending techniques with Ferrin Contemporary Gallery in 2016 as part of the New York Ceramics & Glass Fair. No doubt there are other kintsugi events from this period. Articles about kintsugi have appeared in most major English language newspapers, and social media has been awash with it for some time. TED Talks have featured kintsugi several times, unfortunately, sometimes spreading incorrect information to their huge audiences. Much of this wide-ranging coverage is about kintsugi-style repairs, but nonetheless, it shows that the concept of kintsugi has fallen onto a field ready for sowing.

At the time of writing, an internet search for kintsugi came up with more than three million sites, although many of these were in reference to the metaphor of kintsugi. A search for 'kintsugi workshop' resulted in offerings from around the world, including Japan, North America, Australia, many countries in Europe, China and the Middle East. There are now numerous how-to videos on popular video platforms in several languages. Outside Japan, both Japanese and non-Japanese *kintsugi-shi* not only undertake repairs but also offer workshops and classes. Often, because of the time involved and the hazards of using *urushi* (See Chapter four), *kan'i-kintsugi*, or easy kintsugi, is taught. This uses other forms of adhesive, usually epoxies and sometimes the new, less-allergenic *urushi*. Many of these workshops and classes are being held in ceramic

lacquer) and *nuri* (wood with lacquer) in Kyoto. They also offer classes and workshops in *urushi* techniques. Sato Takahiko, President, says that kintsugi is in more demand now than ever. Traditionally, they taught kintsugi only as part of more general tuition in *urushi* skills, but because of the increasing number of requests from overseas, students can now learn kintsugi as an independent skill. Whereas kintsugi had been restricted to those with *maki-e* and *nuri* skills, nowadays we can add the profession *kintsugi-shi* to that of *makie-shi* (maker of lacquer 'sprinkled pictures') and *nuri-shi* (lacquerware maker).

COMMERCIAL 'KINTSUGI'

With the popularity of kintsugi it was inevitable that kintsugi-like products would be developed on an industrial scale. Faux kintsugi tableware is the most common. Yoko Ono collaborated with the company *illy* on a set of 'kintsugi' espresso cups. The French artist Sarkis has designed a line of tableware with Bernardaud that mimics kintsugi. The Italian company Seletti has also produced a successful line of tableware called 'Kintsugi'.

This commercial 'kintsugi'-ware, where ceramics are never broken first, deny us one of the fundamentals of kintsugi, that of uniqueness. I came across the Seletti china at the Festival Terrace Shop, Southbank, in London. What amused me most was the fact that the plates are identical, something that can never happen with kintsugi. [Figure 18]

This industrial trend also does not allow for kintsugi's implicit or explicit collaboration. Once a repair has been made by someone other than the maker, it ceases to be an artwork by a single person, regardless of how much 'instruction' goes into the repair. The mark of the repairer will forever remain in the work.

Figure 17: A familiar event now, guests participate in a kintsugi workshop led by Iku Nishikawa at PISQU Peruvian Restaurant, London. Photo courtesy of Oxford Kintsugi.

centres, and kintsugi is becoming a ceramic technique or tool, rather than only a lacquer skill. Another development is the sale of 'kintsugi kits'. These usually contain an instruction sheet, glue and gold powder. True kintsugi is based on fine craftsmanship and is a skill requiring many years of training and experience, but the availability of these quick alternatives is an indication of how drawn people are to it. Kintsugi is now popular both in its original, traditional form and as a 'home remedy' for our broken bits and pieces.

Sato Kiyomatsu-Shoten Company is a supplier of materials for *maki-e* (gold pictures on *urushi*, or

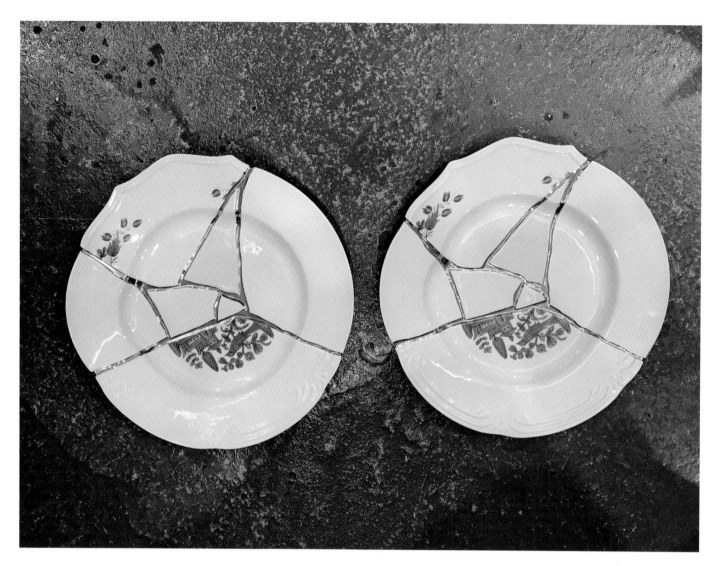

Figure 18 (above): *Identical dinner plates from the Seletti 'Kintsugi' range, found at the Festival Terrace Shop, Southbank, London. Not kintsugi repaired but industrially produced. No two authentic kintsugi pieces will ever be the same. Photo by the author.*

Figure 19 (right): *Laetitia Pineda,* Plate, *2018. Gathered clays in South West of France, modelled by pinching, with terra sigillata surface, wood-fired to low temperature. Kintsugi by Catherine Nicolas. 2.3 x 14/14.7 cm.*

A PLACE IN OUR LIVES

Kintsugi offers us a way to hold on to our most precious possessions. It takes an accident and transforms it into a glorious rebirth. As Elizabeth Spelman says, 'Repair is the creative destruction of brokenness.'[17]

On another level, kintsugi serves as a powerful and dramatic metaphor of acceptance, resilience and renewal in a time of environmental, political and civil upheaval. Having kintsugi in our lives encourages us to remember that we can get through more than we may feel we are able to, in what sometimes feels like a world of overwhelming sorrow and desperation. In the very ordinary act of repair we are offered the opportunity to experience an extraordinary sense of hope and beauty.

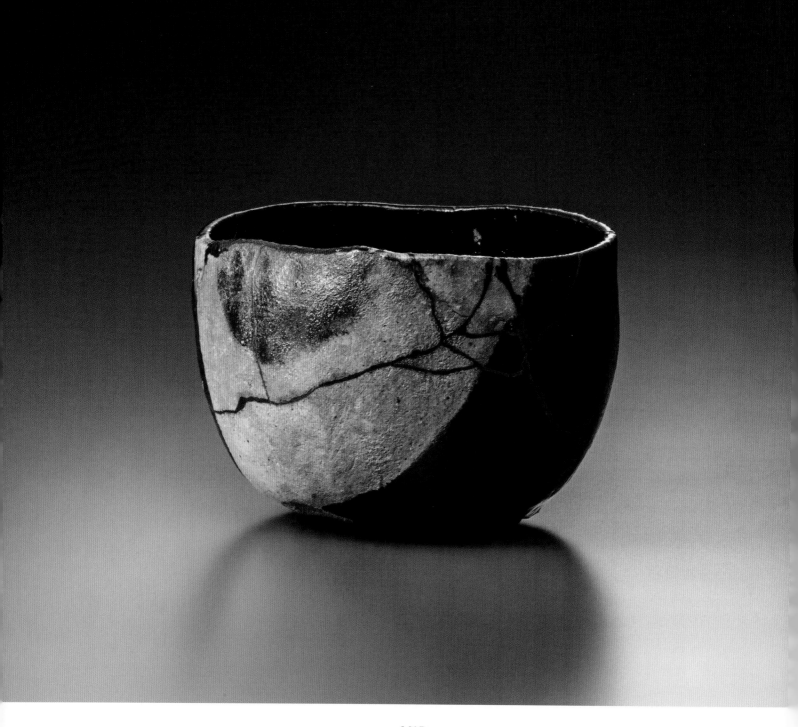

...AND
NEKOWARIDE

A powerful force in Japanese ceramics and a strong influence on contemporary ceramics in general, Raku Kichizaemon XV was grand master of the revered line of Raku potters until stepping down in 2019. His son has acceded to the title.

It is the 7th of February, cool and a bit grey. My research partner, Hiroko, has arranged for us to visit the Raku Museum in Kyoto, with a request to see the gintsugi (silver-repaired) teabowl *Nekowaride*, made by Raku Kichizaemon, the fifteenth in a line of potters that goes back to Chōjirō in the sixteenth century. But I don't hold out much hope. I've been told that this precious *chawan* (teabowl) is in the private collection of the Raku family and unlikely to be on exhibit or even within the museum.

We arrive and introduce ourselves and after some discussion, we are taken to a large upstairs meeting room. We are told that Raku XV is working and cannot meet with us, but we are asked to wait. Inagaki Yumiko, a curator at the museum, brings us *sencha* (steeped green tea) and *wagashi* (soft sweets). *Oishikattadesu!* Delicious! A few minutes later a small and beautifully poised woman enters and introduces herself as Raku Fujiko, Raku's wife. In her hands she holds a teabowl: *Nekowaride*. I know it instantly. She sets it on the low table in front of us, and I sink to my knees to look at it more closely. Mrs Raku is speaking, but her Japanese is far beyond my comprehension, and her voice is soft and delicate.

My eyes are drawn back to the bowl. *Nekowaride* is slightly round in shape, its bottom just barely lifted from the table on a low foot-ring. It has an undulating rim that hints at an inward curve, and just below the rim vague shadows indicate where Raku's fingers must have worked the clay. The dark lines of the repaired cracks run through the bowl's form and through its two primary tones of deep black and mottled white, and two secondary colours of yellowish gold and warm dark red. This is a perfect example of *yakinuki*, a technique for which Raku XV is famous.

'The repaired cracks are dark,' I observe.

'Yes. They are gintsugi, done in silver rather than gold.' Hiroko translates for Mrs Raku. 'I chose silver because I wanted to see it change with time. I could have had it repaired as *tomotsukuroi*, so the breaks were not so noticeable, but I wanted the joins to be visible so the repair would be evident, to show that this *chawan* was once broken then brought back to life.'

The gintsugi work on *Nekowaride* is extensive. It must have been quite a mishap to have broken the bowl into so many pieces. There is a break across what looks like the *shomen*, or front, making the repaired cracks a bold statement. The darkened silver repairs dance and splinter all the way around it, each one echoing and contrasting the distinct delineations of the glaze, as well as making a resolute statement about this bowl's story.

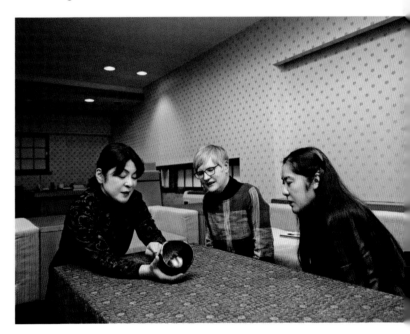

Figure 20, left: Raku Kichizaemon XV (Raku Jikinyū), Nekowaride (Broken by a Cat), *1985. Black Raku teabowl, yakinuki-type, 8.1 x 10.5-13 cm mouth diameter. Private Collection. Photo: Hatakeyama Takashi.*

Figure 21, above: Raku Fujiko points out the features of the teabowl Nekowaride *to Bonnie Kemske and Hiroko Roberts-Taira. February 2019. Photo by Ōyama Seiko & Tsunei Iori/ DAIMEDIA.*

I had been hard-pressed to do no more than look at *Nekowaride*, but now I ask, 'May I hold the bowl?'

'Yes. But please wait a moment.' Mrs Raku gives the bowl to Ms Inagaki, who takes it away. Then she explains, 'To make the bowl closer to how it would be if you were having *matcha* (powdered green tea), I will have some lukewarm water put in it and that will change the *keshiki*.' *Keshiki* is usually translated as 'landscape'. It refers to the quality and characteristics of the surface of the pot, which are created by the interplay of the clay, the glaze and the firing. When the bowl is brought back, it is warm and slightly damp. Still seated on the floor, I lift it and hold it in the palms of my hands. It feels 'soft', and fits my palms perfectly. And even though I know it's not possible, it feels like it is filling all the voids created by the folds of skin in my palms. As I hold it, I explore with my fingers the repaired cracks that my eyes have seen.

I ask, 'Why is it called *Nekowaride*?'

'It is because it was broken by a cat years ago. You know 'neko' is cat; 'wari' is part of the word that means broken; and 'de' is 'te' or hand. Perhaps there's also a little hidden meaning. The sound 'wari' is close to 'warui', which means 'bad' or 'naughty', like the cat was.

'This bowl has special significance for my husband. He always kept it near him in his studio because it was the first piece he felt was successful when he began to use the *yakinuki* technique. We had a small Yorkshire terrier then and that terrier loved my husband. They were together all the time, the dog sitting with my husband while he worked. He was a very clever dog and never broke anything. One day, Raku worked in the morning, then went to have lunch, leaving the dog in the studio. The door to the studio swung open both inward and out

very easily: *padann... padann...* [gesturing and imitating the sound of the door]. The dog couldn't open it, only humans. When Raku left the room, the door immediately swung open in the other direction, and without his seeing, a cat from the street went in.

'When my husband returned, the dog was on the floor, but the cat was running everywhere, even around the walls. We could see the scratches there. The cat came down and its leg hit the *chawan*. The *chawan* fell and broke. My husband went pale. He was devastated. I think he didn't even want to look because it was in so many pieces. He left the studio and couldn't work for three days.

'Normally if a *chawan* breaks, the pieces are broken up until it is no longer a pot. That's because the *chawan* has no life anymore. But I knew that this *chawan* had Raku's heart in it, so I carefully collected the pieces to keep them until he had recovered from the loss. I kept the pieces in a box for about a year. Then, I took the pieces to a *makie-shi*, whom we had known for a long time. It took about a year for him to repair it. When it was finished and I surprised Raku with it, he really *was* surprised. He thought the *chawan* was long gone. He said that the repaired *chawan* was better than the original.'

We ended our visit with Mrs Raku inviting us to return the following day to have a bowl of tea in *Nekowaride* in their tearoom. High anticipation with a light overlay of nerves settled onto both Hiroko and me.

We arrive at their home, adjacent to the museum, the next day as planned. There is a small open courtyard, off of which is Raku's studio, clearly marked with *noren*, the hanging split curtains used to delineate a specific space.

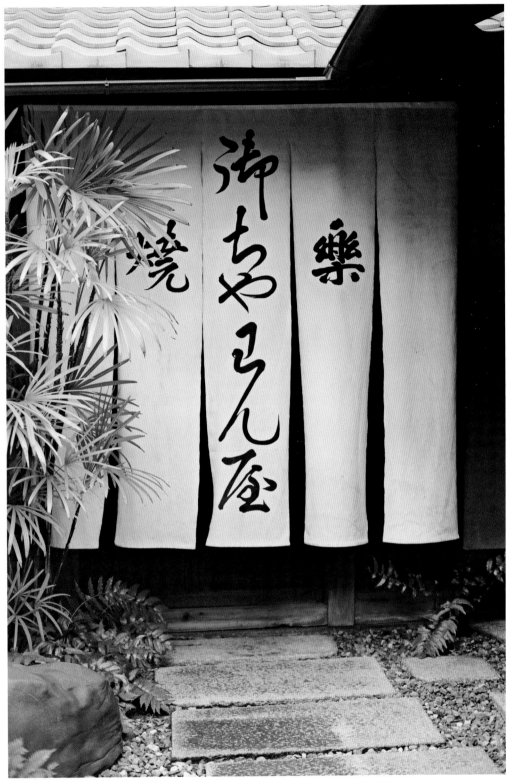

Figure 22: Noren, a traditional curtain hung in doors in Japan, marks the entrance to Raku Kichizaemon XV's studio. Photo by Ōyama Seiko/DAIMEDIA.

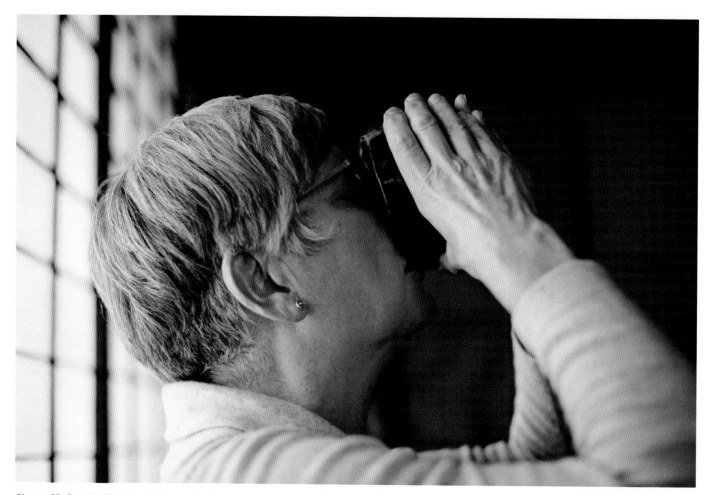

Figure 23: Bonnie Kemske drinks matcha *(made from powdered green tea) from the teabowl* Nekowaride. *Photo by Ōyama Seiko/DAIMEDIA.*

We enter the house to the gracious greeting of Mrs Raku, and make our way into the tearoom. The room is lit by the cool February sunlight, which is further softened by the closed *shoji*.

Mrs Raku brings us *wagashi* once more – green *mochi* (a sticky rice cake) this time, filled with azuki bean paste. Then she brings *matcha* for me in *Nekowaride*, and brings Hiroko *matcha* in another Raku *chawan* of quiet and subtle beauty.

Although this is not, of course, a tea ceremony, I handle the *chawan* with careful intention, to pay my respects – to Raku for making it and to Mrs Raku for preparing the tea. I bow to Hiroko to apologize for having my tea

first. Then I lift *Nekowaride* with my right hand, fingers under its hip and thumb on the rim, and place it on my left palm, readjusting so my right hand surrounds the side. My fingers go forward, my fingertips feeling the delicate silver repairs. My thumb comes back, feeling more repairs as it wraps towards the front of this precious bowl.

This is the moment when a teabowl reaches its inherent potentiality, when it fulfils its role and justifies its existence. The weight of it fills my palms. The scent of the *matcha* rises to meet me. It fits my hands with perfect, almost glowing snugness. In that instant I experience one of tea ceremony's greatest gifts, a sense of rightness, a sense that 'no doubt the universe

is unfolding as it should'. Lifting the bowl slightly, I give a small bow, then turn the bowl two quarter turns clockwise so the *shomen*, or front of the bowl, faces away from me.

You do not rush drinking *matcha*. Neither do you linger overlong. Time will be what it will be, and you must accommodate it, not the other way around. The *matcha* is now the perfect temperature, the teabowl the perfect warmth. The rim fits my lips snugly as I drink the tea in three considered sips.

After using my finger and thumb to wipe the area on the rim where I've drunk, I turn the bowl back so the *shomen* faces me, and place it on the tatami. This is *haiken*. In Tea lessons we remind ourselves that this is the opportunity to really look, to really appreciate a bowl that you may never see again. Today, I know this is actually the case, and I let my mind clear of everything but *Nekowaride* as it sits in front of me. The remaining tea has pooled in the bottom in a slight puddle of light green froth. The silver repairs, already dark and rather mottled in colour, have darkened more from the tea and they now blend into the shadows and warmth of the inside. The different sections of glaze, broken by the ageing silver repair, are in harmony with the roundness of the form. What I had first described to myself as an 'undulating' rim, I now see as too subtle to be described as such. You feel the edge move up and down with the gentle buoyancy of a slight ocean swell.

Light and shadow. In the dim light of the tearoom *Nekowaride* is beautiful – warm and natural, cradleable. Almost sleepy and warm. Its gintsugi is quiet, unobtrusive. Although it is, of course, silent, you feel a soft-voiced hum from it. It feels different with tea in it – stronger, more purposed – or is that just a shift in my perception?

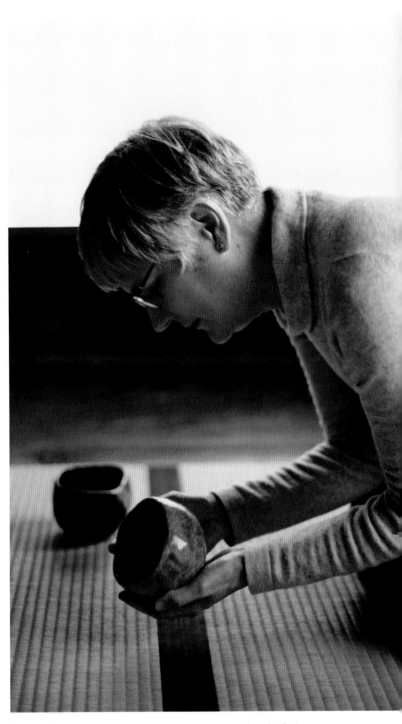

Figure 24: Bonnie Kemske appreciates a teabowl in the Raku tearoom. This is called haiken *in chanoyu (tea ceremony) and is a specified time to carefully look at the utensils. Photo by Ōyama Seiko/DAIMEDIA.*

After we have had time to look at *Nekowaride* in *haiken*, Mrs Raku goes behind us and opens the *shoji*. The room fills with winter light, and *Nekowaride* takes on a new character. Its quietness becomes enlivened. It sings more brightly. But this brightness is not a better quality; it is just another quality, like the difference between a quiet joyful mood and a loud happy mood of someone you know well.

The air coming in from outside is cool. After closing the *shoji* once more, we sit quietly with Mrs Raku. We aren't sure why we are waiting, but soon Raku XV enters and sits with us. After our greetings, we talk about *Nekowaride*: about the role of the *makie-shi* who undertakes the repair, about the use of silver instead of gold. He expresses his bemusement with how kintsugi is now viewed outside Japan, and tells us of a visit from an American rock band, which resulted in their naming their next album 'Kintsugi'. Then he reiterates how surprised he was when his wife revealed *Nekowaride* after it had been repaired. As he talks, it is clear that he was moved by his wife's thoughtfulness, just as we had felt her concern for him as she told us her story.

Soon, Raku leaves us and goes back to the studio. Thanking Mrs Raku for her gracious hospitality, we too leave the tearoom.

Figure 25: The teabowl Nekowaride *sits on the tatami mat in the muted light of the tearoom. Photo by Ōyama Seiko/DAIMEDIA.*

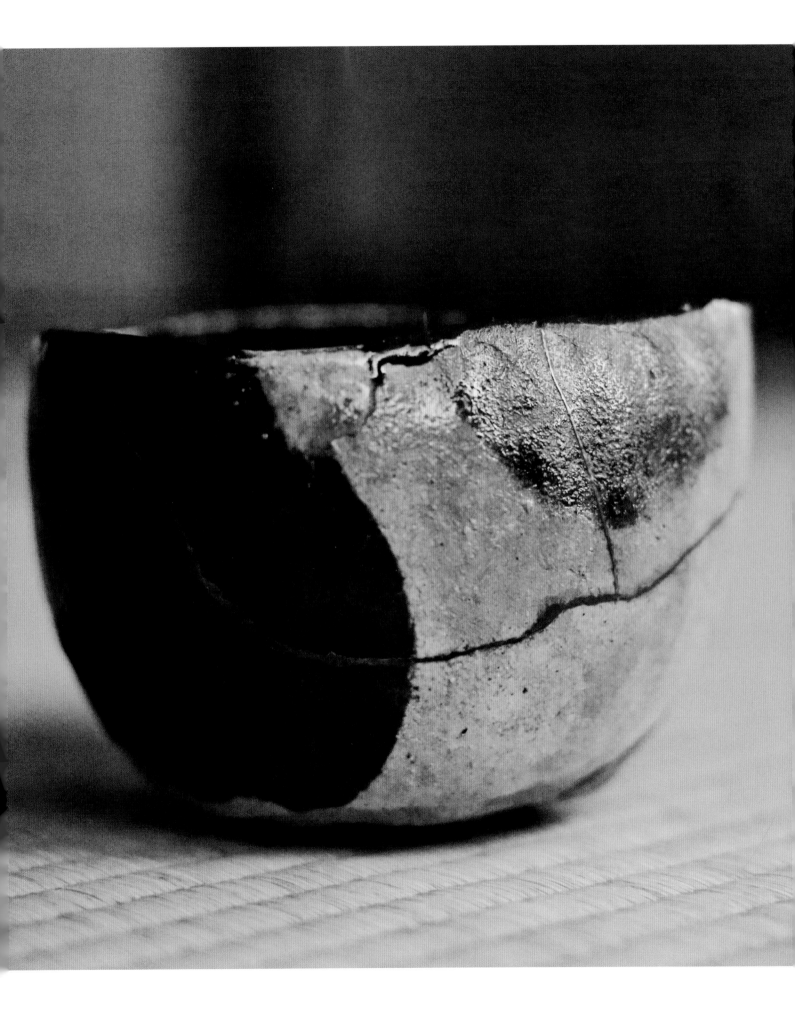

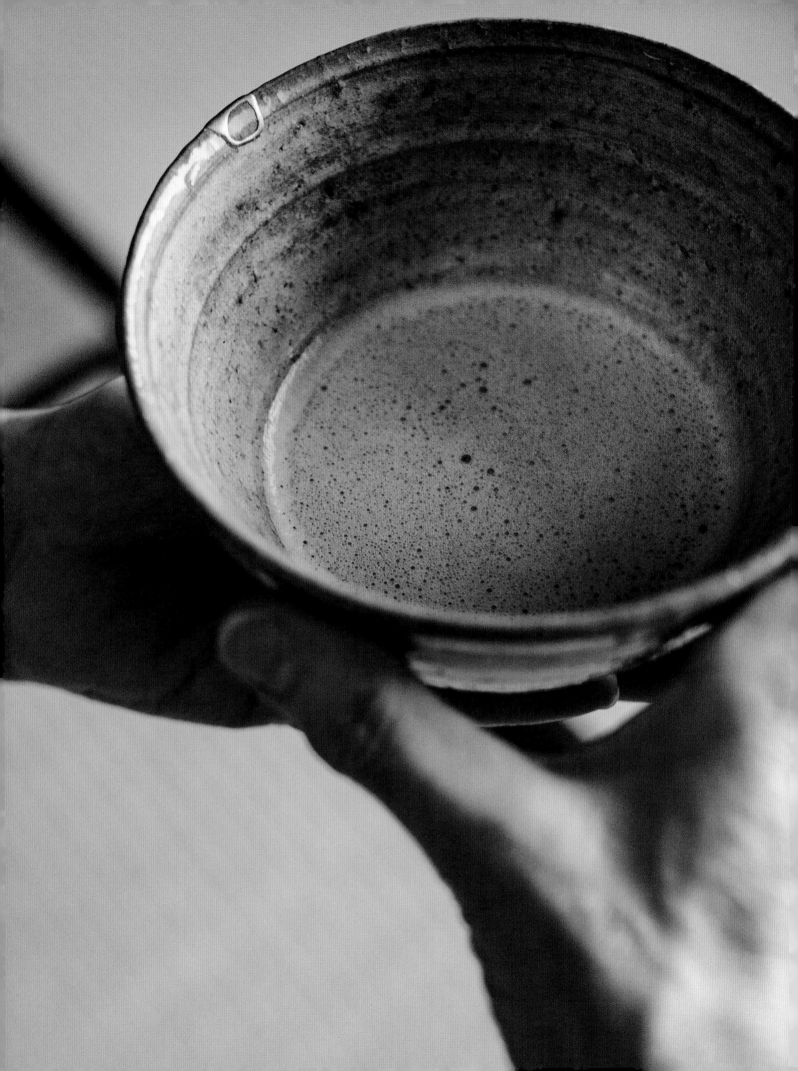

BEAUTIFUL JOINS

It is robiraki, *one of the most important tea ceremonies of the year, as it is the time when we mark the turn of the season by opening the* ro, *or sunken hearth. In summer we use a portable hearth called a* furo, *which sits next to the wall farthest from the guests, but the* ro *is nearer the middle of the room and brings the warmth of the fire closer to the guests.*

On this occasion the tearoom is full. There are about ten of us with varying degrees of experience in Tea. We sit quietly facing the host. After the buzz of our arrival it is restful to hear only the simmering of the water in the kettle. I watch as the host makes the first bowl of tea. He is using a beautiful Hagi teabowl that has an unusual rosiness to its glaze. He finishes whisking, swirls the chasen, *or tea whisk, once in the froth at the top of the tea, then places the bowl beside the* ro. *The* hanto, *or helper, collects it, then sets it on the tatami before me. I look down at the bowl and feel my breath catch. On the rim is a small circle of gold about the size of the tip of my fingerprint – a kintsugi repair. What had seemed a beautiful bowl now has become startlingly precious. The fine gold circle draws my eye to the delicacy of the rim and the graceful curve of its inner surface.*

Figure 26: Ōno Zuiho (a leading Hagi potter, b. 1910), Hagi ware teabowl used at a tea ceremony gathering. Kintsugi repair on rim by Ronald Pile. Bonnie Kemske is surprised by the delicate kintsugi repair on the rim of this teabowl. From Kōshosai Collection. Photo by Lee Allison.

'...IN ALL ITS FLAWED SPLENDOUR'[18]

Gold lines: thick or thin, subtle or bold, delicate or strong, a single straight channel or a spider's web. There can be an abundance of gold or just a whisper to repair a chip. The gold finish can be bright and cheerful or deeply lustrous. Each broken pot is cherished by someone, and kintsugi will only increase that preciousness. It deserves time and thought when determining the mantle of its new life.

Different qualities of kintsugi convey different feelings. Sometimes a single characteristic can elicit conflicting responses. One thin crack can evoke a sense of fragility, while also raising in us a sense of strength. It can speak of both the ephemerality of life and the permanence of existence. A kintsugi-repaired pot may be intimate in scale but monumental in stature. The lines of gold may lift it or ground it, depending on how they run through the pot. This is part of kintsugi's inherent dual nature. We see ceramics as permanent. After all, pottery exists for millennia; it does not rot or decay. Yet it is still relatively fragile and certainly breakable. Kintsugi represents both permanence and impermanence. It expresses the passage of time through the object's wounds, then offers us a sense of continuity in its repair.[19] It can also evoke conflicting emotions. Guy Keulemans, a designer and researcher in Australia, has said, 'A repaired crack can trigger and link to many things, not least perceptions of threat, urgency, catastrophe, risk, but also care, amelioration or hope.'[20] You can feel an emotional resonance in a kintsugi repair because it appeals to both our aesthetic and emotional senses. Every kintsugi repair carries both the story of its previous life and its new one. Christie Bartlett links this to a 'mirage of "before".'[21]

With a bold kintsugi repair there can be a sense of 'crude vitality',[22] or with a finely-done repair, a calligraphic quality. The lines, though not representational, can still be suggestive of images we carry within ourselves – of mountains, streams, foliage, or as we've seen, calligraphy. Underlying it all, a good kintsugi repair has integrity; the gold lines will feel appropriate to the form, not gratuitous.

There is no one way, one style, to kintsugi; and kintsugi is not a singular repair method. A variety of techniques and materials, which come from the lacquer art of maki-e ('sprinkled picture'), can all be employed. Choosing which are appropriate, and the addition of the skill and experience of the repairer, will determine the finished aesthetic of the mended object. The quality and character of the damage will also be a factor. A kiln fault may be a deep rupture, calling for a dramatic intervention. In the case of the famous teabowl Seppō, the repair is sunken, giving a sense of a cascade (see Chapter three). A fine crack or chip will want a delicate touch, like the one I encountered at robiraki.

If you want to continue to use the pot, the repair must be functional. Should it be togidashi, flush to the surface? Or perhaps it can be hiramakie, ever so slightly raised. If it were takamakie, high relief, it might be quickly worn down through use.

With a pot broken into many pieces there will be a profusion of gold lines. If they are too heavy or too high, the original piece will be eclipsed, and it will serve only as a canvas for ostentation. Generally, a kintsugi repair should add to a pot's character, not crush it. A quiet and calm pot should retain its serenity. A pot with a quirky character should still have eccentricities.

There are exceptions to every rule, though. For instance, a break may dramatically radiate from the point of impact, changing the nature of the pot itself.

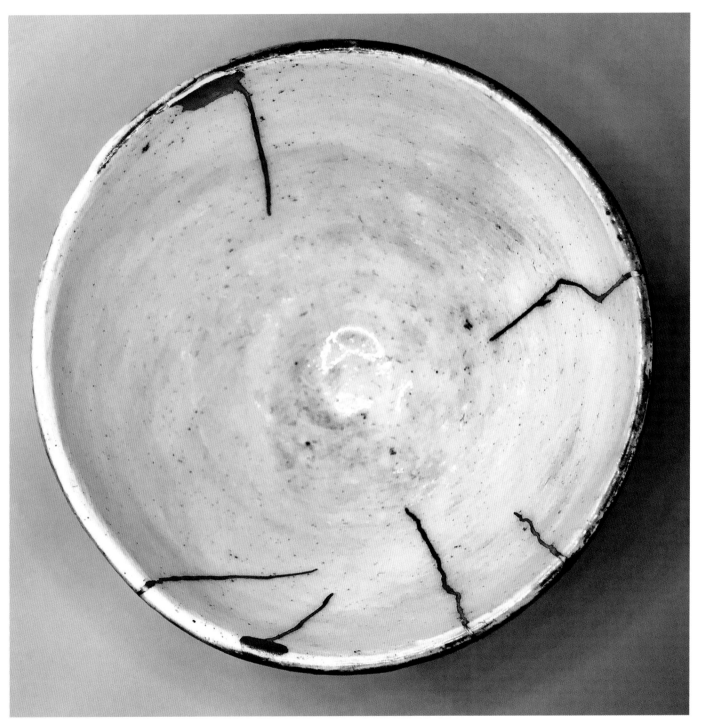

Figure 27: Nakano Kazuma, Bowl, date unknown. Kintsugi repair using urushi, tonoko and pure gold powder by Heki Mio. 13 x 13 cm. Courtesy of Robert Yellin Yakimono Gallery, Kyoto.

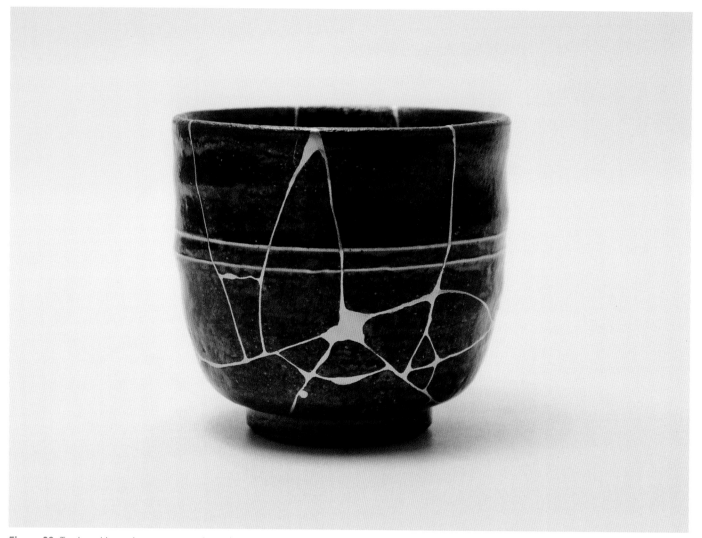

Figure 28: *Teabowl by unknown potter, bought in Kyoto, date unknown. Repaired by Natsuyo Watanabe in 2017. 90 x 90 cm approx. Photo by tsugi.de. Private collection.*

In this case the story of the pot is found in the lines of the break. There is no such thing as a random crack or break in ceramics. As cracks in the earth occur on seismic fault lines and craters are created by meteorites, so ceramic vessels break according to their internal structure, because of outside impact, or both. We may subconsciously sense this structure in the patterning of the kintsugi repair, which can give us a sense of rightness, even while also seeming serendipitous. In *Another Kyoto*, Alex Kerr, a writer with an engaging and sometimes irreverent perspective on Japan, talks about the Japanese artistic quality that he calls 'scattering':

'I think this approach to art goes back to primeval, pre-Chinese, original Japanese higgledy-pigglediness. From the beginning in Japan there never was much rhyme or reason; it was *all* scattering. Plenty of symmetry was imported over the centuries from China, but it never quite "took." The default mode was ad hoc, something here, something there... Artists learned how to make unbalanced, unorganized things feel "just right" – the appeal of Japanese art in a nutshell.'[23] The lines of kintsugi may follow a pattern determined by the way in which the pot has broken, but those lines may not appear orderly to us. Kintsugi fully exploits Kerr's 'scattering' aesthetic.

TOMOTSUGI AND MAKIENAOSHI

Kintsugi is a creative endeavour, so there are many manifestations within it. However, there are three basic repairs usually called for: crack repair, reconstruction, and reconstruction using materials other than the original pot. Fine cracks are said to be the hardest to do, but often give the most exquisite results. The most common kintsugi repair is a reconstruction called *tomotsugi*, where the pieces of the broken pot are re-assembled. But what if one of the pieces is missing? The void can be filled with lacquer, then gold can be added. Or it can be filled with some other material, then built up with layers of lacquer. The filled area can be polished, giving the appearance of solid gold. [Figure 29]

If desired, the area can be decorated using *maki-e* techniques. Gold decoration on dark lacquer is sometimes used. Or gold can be layered in a raised pattern or design on a gold field so it appears to have been impressed or stamped. Often, this decoration continues the existing patterning on the piece. A surface with cobalt blue flower decoration may have a raised flower motif in the gold repair. A flowing decorative brush mark of dark oxide on the surface of the original pot may continue into the newly-repaired area of gold with a dark lacquer. This type of decoration is sometimes called *makienaoshi* (*maki-e* repair). [Figure 30] [Figure 31]

In speaking to *kintsugi-shi* in Japan, few worked in this style. Shimode Muneaki, third-generation *makie-shi*, says he only came across *makienaoshi* when he was lecturing in Oxford. He hypothesized that this type of work may have been done in the late Edo period for an export market, which demanded a very different aesthetic from the domestic Japanese market.

He says, 'That kind of decoration may be too much for Japanese taste. Look at *shodō* (Japanese calligraphy), for example. The letters are, of course, important, but the blank spaces are also important, just as the beauty of the black in traditional lacquerware and the *maki-e* drawing in gold are both important. So, extravagantly filling a space like that would not suit Japanese taste. Saying that, I can certainly understand the craftman's desire to show off his technique!'[24]

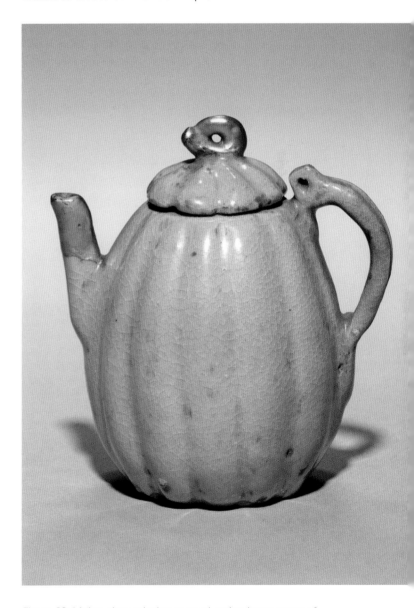

Figure 29: Melon-shaped wine ewer, showing large areas of kintsugi repair on spout and lid, Korea, 1100s–1200s, Goryeo period. Outer diameter 6.7 cm high (with lid 9 cm). The Cleveland Museum of Art, Gift of John L. Severance.

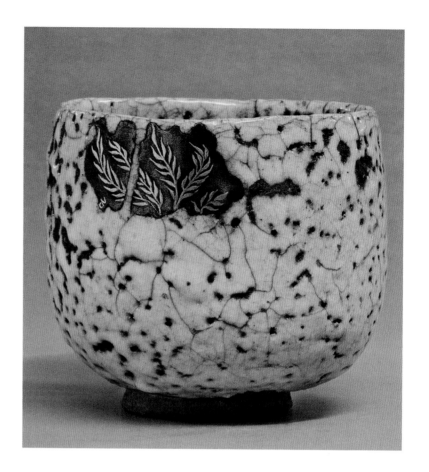

Figure 30: Alain Vernis, teabowl, 2011.
Pinched technique in 'Rod's Bod' raku clay
from California (given to the potter by Mark
Tyson), to which the potter added sand and
grog. The glaze is ground feldspar; raku-fired with
wood in a small kiln outside Vernis's house. It was gifted
to Mark Tyson at the time of the firing. Kintsugi repair
in makienaoshi by Catherine Nicolas using urushi and
24-carat gold powder (2012). 9 x 10.5 cm. Photo by
Catherine Nicholas. Collection of Mark Tyson.

Figure 31: Seto or Mino ware teabowl, Muromachi
period (1510–1530). Buff-coloured stoneware with
iron wash; dark brown iron glaze splashed with ash
glaze. Takamakie repair with cherry blossom design.
6.3 x 16.8 cm. This outstanding bowl shows both delicate
kintsugi lines and makienaoshi (maki-e decoration). Freer
Gallery of Art, Smithsonian Institution, Washington, DC:
Gift of Charles Lang Freer, F1900.53.

Figure 32: Teabowl, Karatsu ware, c. 1590–1630. Glazed
stoneware with yobitsugi repair using a fragment from
another pot that is similar to the original. 7.6 x 11.4 cm.
©Victoria and Albert Museum, London.

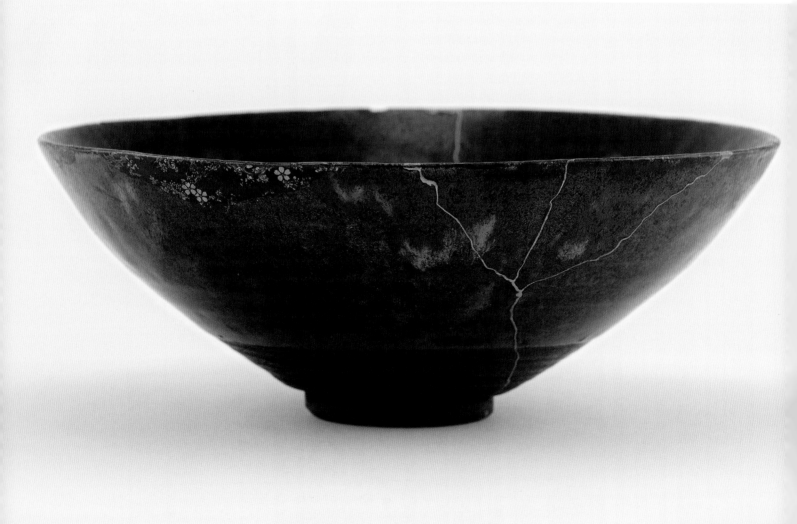

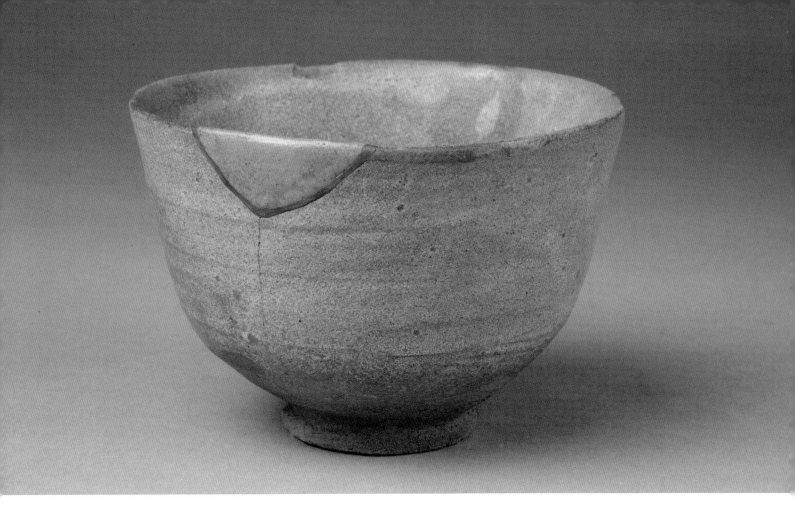

YOBITSUGI

Using ceramic techniques, patching or filling can be difficult because different clays shrink and expand at different rates and extents throughout drying and firing. Since kintsugi is not a ceramic, but a lacquer technique, and does not involve clay drying or firing in a kiln, fragments from different pots, made from different clays and glazes can be used together. This is the third common repair technique. It is called *yobitsugi* (*yobi*=patched/*tsugi*=joining). Sometimes the fragment used for the fill is similar in shape and colour so that it is hard to see that the sherds are from different pots. Often a contrasting sherd is chosen. (See Chapter three for a photo of Urakusai's *Yobitsugi*.) A finely made and colourfully decorated Edo period Imari sherd might be incorporated into a plain, rustic Karatsu bowl. There are also examples where wood has been used as a contrasting fill. [Figure 33]

Yobitsugi can certainly be the most playful of kintsugi techniques. Contrasting colours and patterns and the use of a fragment that does not completely fit the shape of the original often produces a cheerful 'wonky' quality in the finished piece.

Falling between *tomotsugi* (using the original pieces) and *yobitsugi* (patchwork repair) is another approach. Kuroda Yukiko, a *kintsugi-shi* in Tokyo, has been making pots from *ko-garatsu* (Old Karatsu) kiln wasters, or damaged sherds discarded by the original potters long ago. [Figure 34] These fragments are not all from the same pot, but are from the same kiln, and perhaps even the same firing. In this way they are from one family. The pieces fit together in quality, but not necessarily in shape. In his hometown of Arita, Kyushu, an area with many old kiln sites, Tsuruta Yoshihisa also creates new pots from old sherds, further decorating the wares with bold brushwork. [Figure 35]

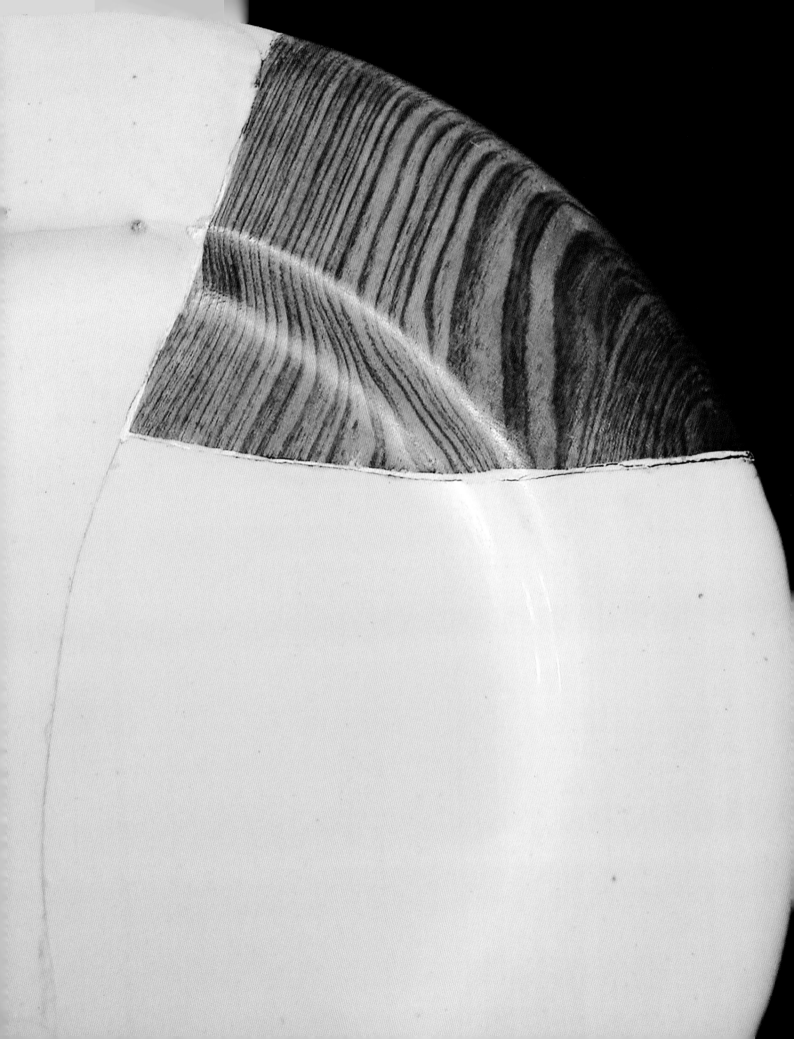

Figure 33: *18th-century Delft plate with an unusual repair using Cryptomeria (Japanese cedar) repair. The repair was done in the 20th century. 21.6 cm diameter. Photo by Galen Lowe. Courtesy of Galen Lowe Art & Antiques.*

Figure 34: *Kuroda Yukiko, a new bowl created by using ko-karatsu (Old Karatsu) wasters (discarded sherds). Photo by the author.*

Figure 35: *Tsuruta Yoshihisa, Ko-karatsu matsumon mukōzuke (pine motif food bowl used in kaiseki, the chanoyu meal), 2019. Yobitsugi (patchwork kintsugi) of ko-karatsu (Old Karatsu) sherds, joined with resin and decorated. 6 x 15.7 cm. Photo by the artist.*

奇跡のかけら

窯から出されると茶碗はすぐに投げ捨てられて割れた。出来損ないと言わた。ただの一度も使われなかった。

雨に打たれ、風にさらされていつか土の中に埋もれた。四百年間、眠った。

ある日、鍬が当たって地表に出た。畑の邪魔もんと呼ばれた。一人の男に拾い上げられた。初めて洗われた。

次に目が覚めたとき、かけらとかけらはきれいに継ぎ合わされていた。やさしく手に包まれる。だれもが大事に扱ってくれる。

茶碗として生きる、と決めた。これから百年、二百年と生きてやる。

Kintsugi Miraculous Sherds

Right after I came out of the fire, I was thrown to the ground and broke.

The old potter who created me thought me inferior and of no use.

So, I lay on the ground pelted by the rain,
blown by the wind
And then was buried for 400 years.

One day, a hoe hit me and I flew out of the ground.
Someone called me a nuisance in the rice paddy
and tossed me aside.

But after a while, a man picked me up and
took me home.
He washed me.
When I next woke up, other broken sherds of
chawan were joined to me with gold slip and
I became a beautiful new vessel.

Now people cherish me.
And I will live for another 200 years
or maybe, forever.

– Miyauchi Tonao

AS GOOD AS GOLD

The quality of the gold itself will also impact the pot's finished appearance. There are many, many grades of gold. The least expensive grades are made from gold leaf, which is an extremely thin, flattened gold. The most expensive are gold balls. Generally, the more expensive the gold, the greater the 'depth' of colour and lustre, and the higher the skill required to use it.

The use of gold in kintsugi is not an arbitrary choice. Gold is pure and inert. It does not tarnish and its

brilliance does not fade. It is malleable and can be worked into a state of consummate elegance. It is long-lasting and signifies permanence. And the metaphors that surround gold reflect these qualities. They speak of purity, agelessness, refinement and sophistication. Traditionally seen as the most coveted metal, gold inherently speaks of wealth and prestige, and marks the repaired object as extraordinarily precious and highly valued. In Japan in centuries past, the high cost of gold and restrictions accessing it meant that its use conferred an exclusivity to the person having the repair done. It said, 'My possessions are worth this investment, and I am worth enough to pay for it.' There is also a dynamic contrast inherent in the use of such a perfect material in something that is flawed.

With most kintsugi repairs a layer of lacquer (*urushi*) is added to the gold after it is applied. However, over time and through use, it is possible for that lacquer to thin. I wondered what gold tastes like and whether or not it affects the flavour of food and drink, in particular, of *matcha*, the powdered green tea used in Japanese tea ceremony, as kintsugi is so closely tied to that art form. In a research project undertaken at University College London's Institute of Making, the taste of different metals when coated in cream were evaluated. The research results produced the following descriptors for gold: 'soft sweetness'; 'highly pleasant'; 'smooth, almost creamy'; 'harmonious'; 'does not react with acidic foods',[25] which shows that gold serves the taste of *matcha* well.

Figure 37: *Shigaraki Jar, Muromachi period (16th century). Stoneware pottery from Shigaraki area, Japan, showing black kintsugi repairs done by unknown artisan. 54.6 x 48.2 cm. Photo by Galen Lowe. Courtesy of Galen Lowe Art & Antiques.*

OTHER METALS AND MATERIALS

Urushi was used on its own before metals were added to it, and it still is today. Sometimes this results in a neutral hue, but often, by choice, red or black *urushi* are used for dramatic and contrasting effect. [Figure 37] Other metals are also used. These non-gold repairs are sometimes also referred to as kintsugi, although, technically, this is a misnomer. There are no hard and fast rules for what type or style of kintsugi should be used. Each piece must be considered sensitively on its own merits.

Silver is often chosen, in which case the repair is called gintsugi: 'gin' meaning silver. Raku Fujiko, the wife of Raku Kichizaemon XV, spoke about her choice of silver when having the *chawan* (teabowl) *Nekowaride* repaired.

I chose silver because I wanted to see it change with time. Gold doesn't change, but the colour of silver alters as time passes, and it becomes more subtle and subdued; it calms down; it becomes closer to the *chawan*'s aesthetic. Gold shouts out, but silver is quieter, and I knew that would suit this bowl. It's been many years since this bowl was repaired, and the *chawan* has 'become itself'. The colour originally was silvery in appearance, but now the colour and the *chawan* have become more settled together. We use this *chawan*, so some sections of the silver have worn through. The silver wasn't applied thickly so it has worn in a way that gives it a very natural appearance. If need be, we will repair it again. Not only because the repair is silver, but because we use it, this *chawan* is always changing. Through use it matures and continues to change day by day, and our appreciation of it continues to grow.[26]

Many different kinds of metals that can be made into a powder or very small particles or balls can be applied to the *urushi* to finish a repair, although commonly gold, silver or platinum are used. Heki Mio, who works as a *kintsugi-shi* in Kyoto, often uses platinum. Pewter is also used, as well as a gold/brass alloy. When meeting with Shimode at his family studio and showroom, he showed me a piece he had repaired using both gold and silver. It was a high-fired green lotus leaf plate. He repaired the break and added gold frogs. Shimode said that he was afraid the gold would not show well on the shiny green glaze, so he first used silver underneath to make the gold brighter.

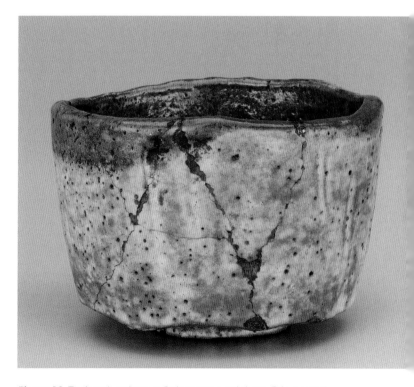

Figure 38: Teabowl, *unknown Raku ware workshop, Edo period or Meiji era (19th century). Style of Hon'ami Kōetsu, Raku-type earthenware with red slip under milky glaze, smoke-blacked rim; red lacquer repairs. Each kintsugi repair is unique and may require different approaches, such as the use of red* urushi. *8.5 x 12.4 cm. Freer Gallery of Art, Smithsonian Institution, Washington, DC: Gift of Charles Lang Freer.*

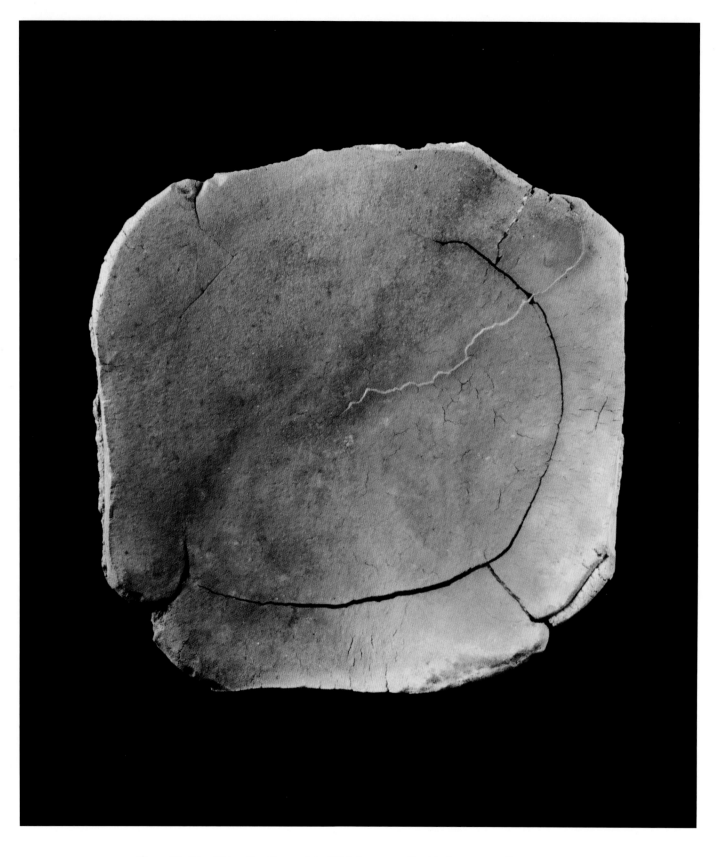

Figure 39: Otani Shiro, Fired large dish, 1984. Anagama fired in Arrowmont, Tennessee. Repairs by unknown artist. This contemporary piece has both gold and black kintsugi. 57.1 x 58.4 cm. Photo by Galen Lowe. Courtesy of Galen Lowe Art & Antiques.

Figure 40: Teabowl with gintsugi (silver joins) repairs, origin and date unknown. 7.7 x 11.5–12 cm. Gintsugi repair by Natsuyo Watanabe. Photo by tsugi.de. Courtesy of David Panzl.

Figure 41: Green plate of unknown origin with high-gloss glaze. Kintsugi repair and maki-e decoration of frogs by Shimode Munaeki. 23 x 21.5 x 57 cm. Photo by the author.

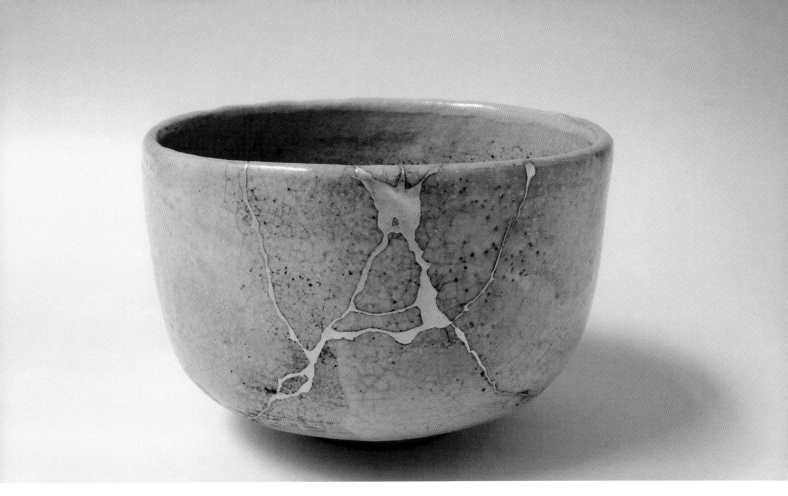

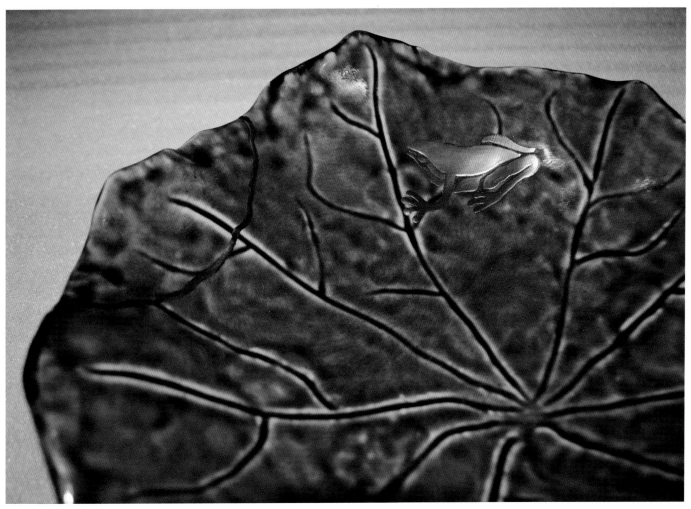

Urushi is a responsive material, perhaps because it is not very far from its organic origin, but today there are more stable chemical pigments available, which allow for a wide palette of colours, taking this repair technique out of the complementary qualities of the traditional aesthetic. In a later chapter we will see how contemporary artists are stretching the term kintsugi in ways that the early practitioners could never have imagined.

WITHIN THE CULTURE OF TEA

I have talked about the different qualities of kintsugi – thick or thin, flat or raised, for instance – and of the variety of techniques and styles that are used, but kintsugi's aesthetics are rooted in more than just its physical attributes. Kintsugi reflects the attitudes and character of Japan, and more specifically, it is a manifestation of the culture of Japanese tea ceremony (*chanoyu*), within which it developed in the sixteenth and seventeenth centuries. It is not surprising that kintsugi is so often used for teabowls.

MOTTAINAI

Tea ceremony is not an art form outside of Japanese norms and principles. It is sometimes seen as the most Japanese of Japanese arts, and therefore a manifestation of Japanese values. *Mottainai*, or 'waste not', is perhaps the most fundamental Japanese belief enacted through kintsugi. *Mottainai*, which has been revitalized within Japanese culture in recent years, can serve as an everyday approach to life. An example is *boro*, which comes from the adjective *boroboro*, or shabby or tattered. *Boro* are cotton or hemp indigo-dyed fabrics of patched old cloth. They were originally used for garments and household items by farmers and workers, especially in the Edo period when sumptuary laws restricted which fabrics could be worn by members of the different social classes. The garments would be repaired multiple times as they were used, sometimes being handed down generations. When they eventually reached their end as clothing, they would become rags, and finally could be used for lighting fires. In this way nothing was ever wasted. Those practising tea ceremony had no need to wear *boro*, as *chanoyu* was an art form of the privileged classes, but the concept of *mottainai*, which *boro* illustrates so well, is part of the texture of Japanese culture, and kintsugi can be seen as one of its expressions.

Mottainai implies not only frugality but also the principle that every object should be allowed to fulfil its role or usefulness. In Shinto, the indigenous religion of Japan, *kami*, or gods, are found everywhere, including in animate and inanimate objects. Therefore, all things should be treated with respect. This also reflects Buddhist teachings. A broken cup, mended and put back on the shelf for tomorrow morning's coffee, reflects *mottainai*. It has many more cups of coffee to hold. Sasaki Mizue, Professor of Japanese, explains, 'The term expresses the sense of regret felt when a valuable person or thing is not handled with due respect, or when something has not been effectively made use of. This meaning covers "sacred" or "important" things and the context for this is the Japanese polytheistic way of thinking.'[27]

WABI AND *KIREISABI*

The concept of *wabi*, closely associated with Japanese tea ceremony (*chanoyu*) and other arts, long ago became part of the Japanese worldview. Outside Japan *wabi* is often seen as anything that is oddly shaped or simply flawed, and the concept often appears in architectural and interior design materials. However,

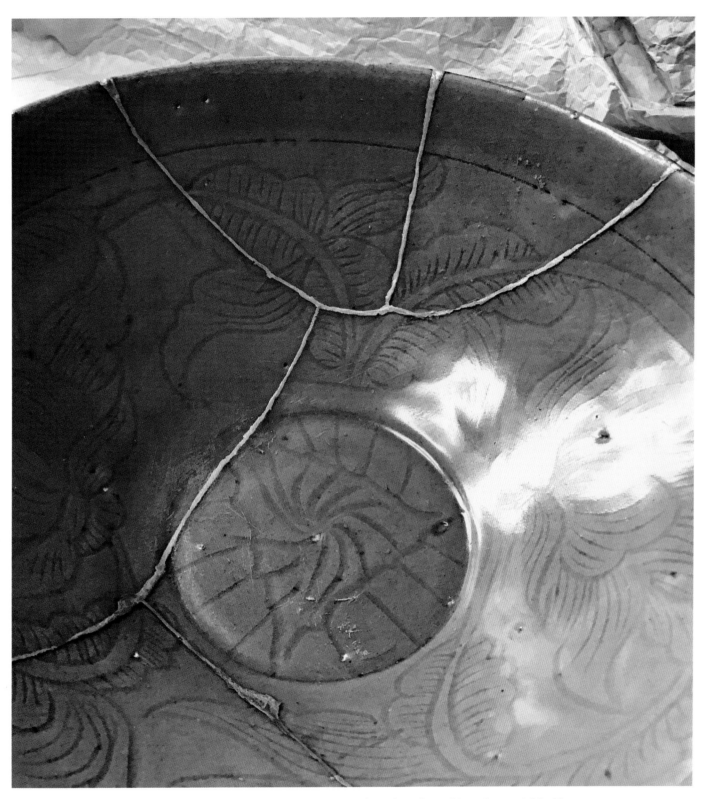

Figure 42: *Thought to be a 13th-century, shallow, finely-made celadon bowl from Korea (Koryo Dynasty). 10 x 25 cm approx.*
Gintsugi finish by Iku Nishikawa. Photo by Kintsugi Oxford. Private collection.

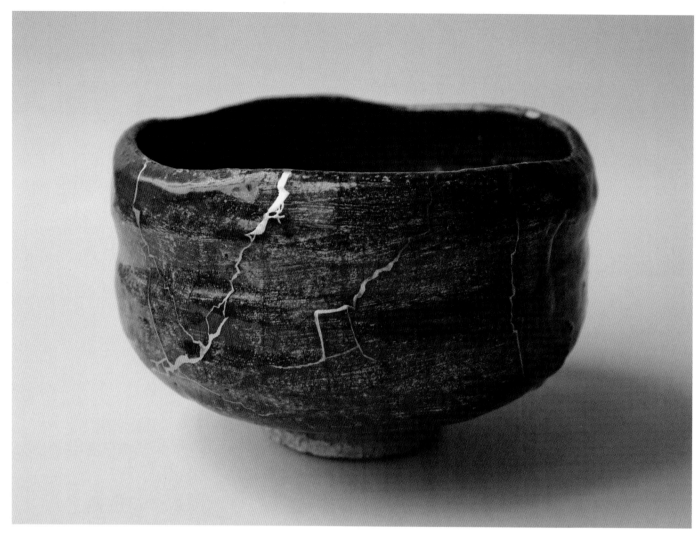

Figure 43: Red raku-style teabowl by unknown potter, date unknown. Repaired by Natsuyo Watanabe in 2016. Photo by tsugi.de. Private collection.

linked to Zen Buddhism, *wabi* is a much deeper and more complicated concept. Zen Buddhism is a belief system grounded in experience, and as such, its teachings often purposely remain unarticulated. When asked, I describe *wabi* as a way of living that is imbued with a profound acknowledgement of the mutability and ephemerality of life, which can be recognized in objects that embody a sense of imperfection, simplicity, an impoverished elegance and a lack of self-consciousness. For me, it also speaks clearly of gratitude for what we have and active acceptance of what we don't.

Because of its close link to the aesthetics of the Japanese teabowl and other tea ceremony utensils, kintsugi is generally accepted as reflecting a *wabi* aesthetic, even though the use of gold is not generally associated with *wabi*. The fifteenth-century tea master Murata Jukō, who is seen as the father of *wabi-cha* (*wabi* tea), is often quoted as saying: 'It is fine to have an excellent horse tethered to a straw-thatched hut.'[28] Professor Kumakura Isao suggests that it is the 'startling contrast' between a hut and a fine horse that expresses the feeling of *wabi*.[29] This translates well when considering fine gold repairs done to a roughly-made bowl. However, for

me, not all kintsugi ware is *wabi*. The elaborate use of gold in some kintsugi wares makes those pieces sit rather uncomfortably within *wabi*. Historically, *wabi* is most closely associated with the great tea master Sen no Rikyū. There is no evidence that Rikyū used kintsugi-repaired items, and as far as we can determine, the development of kintsugi probably occurred after Rikyū's death. However, Rikyū owned and commented upon objects that were repaired with *urushi* alone, and embraced the aesthetics found in cracks, breaks and repairs. In this way, we can safely say that *wabi* is, at the very least, part of the foundation necessary for the creation of kintsugi through its embrace of the irregular and the imperfect.

Often conflated to *wabi-sabi*, the related but discrete term *sabi* is usually translated as an appreciation of that which is old, worn and tinged with sadness. Lorenzo Marinucci refers to it as 'the cold, the old, the passive and broken, the lowly'.[30] Kintsugi's clear statement about the beauty found in surviving damage and wear can be seen in *sabi*.

Following Rikyū, a different style of *chanoyu* developed under the influence of the tea masters Furuta Oribe, Kobori Enshū and others. Enshū is credited with establishing *daimyō-cha*, warrior Tea, which incorporated the aesthetic sensibilities of the earlier Heian courtier culture.[31] Kumakura Isao suggests that Enshū did not turn away from *wabi-cha*, but rather added another layer, creating 'an amalgam of taste'.[32] He defines *kirei* taste as having three components: '...first, a strongly ornamental brilliance and subtlety of expression taken to the point of delicacy; second, clear and sharp lines and coloring; and third, a symbolism that is found in the literature of China and Japan in all periods.'[33] If we look at some of the most finely done kintsugi repairs, we can see 'ornamental brilliance'

and 'delicacy', as well as 'clear and sharp lines', placing at least some manifestations of kintsugi within this important Tea aesthetic. Most importantly for kintsugi, this artistic movement, which also included other art forms, adopted the use of gold, a vital ingredient in kintsugi. Many kintsugi pieces, however, are not *kireisabi* in character, in particular, those with heavy and bold repairs.

MUSHIN AND MONO NO AWARE

Mushin is another term often associated with kintsugi. The term is often translated as 'no mind', or as Suzuki Daisetsu (Daisetz) translated it, 'no-mind-ness'.[34] In Japanese, *shin*, or mind, is not set in binary opposition to feeling, as it often is in the English dichotomy of mind and body. Frequently found in reference to the practice of martial arts, *mushin* calls for a sense of non-attachment, but not a withdrawal from the world. It refers to an uncalculated and unforced state of being where there is no self-judgement, no fear and no ego. It is a total acceptance of life as it is, as it has been and as it will be.

Mono no aware ('the pathos of things') is a concept associated with the Heian period (794–1185), although it has resurfaced in the more recent past, and now has found its way into contemporary discourse. *Mono no aware* is about acceptance, appreciation and compassion. There is a sadness about the impermanence of life and of things, yet there can be within that feeling a fulfilled acceptance and appreciation of it. A flower just past its bloom can stir our emotions; dusk, with its quiet greys can speak to our hearts; and loss is a natural part of human existence. As with *mushin*, kintsugi reminds us that there is injury, loss and destruction in our world, but offers us a way of accepting it without allowing it to destroy us.

TORIAWASE

Toriawase ('taking and assembling') is about bringing together the many art forms that make up *chanoyu* through the choosing of utensils for a specific gathering. Among others, these include: ceramics, lacquerware, bamboo ware, calligraphy and *sumi-e* (ink painting), flower arranging, incense, cuisine and, of course, the preparation and fine appreciation of tea. *Toriawase* expresses the distinctive quality of a *chajin*, or 'person of Tea', and reveals his or her skill, knowledge and sensitivity. The most overt choices will reflect the season. On a hot summer's day the host may use a shallow teabowl filled with water when he enters. The scroll may allude to a clear night in July. The poetic name of the *chashaku* (bamboo tea scoop) may be something like *kawa semi* (kingfisher),[35] which brings to mind images of the beautiful bird hovering above the water. This sense of seasonality is often called upon in the use of kintsugi. Kintsugi items, reflecting the symbolism of breakage and repair, are often used in autumn, when we experience the loss of the brightness and warmth of summer.

Chanoyu is about communication between host and guests, and *toriawase* is one aspect of this. A host may, for instance, include something that will send a personal message to one of the guests, perhaps an acknowledgement of a recent loss or unspoken congratulations for some achievement, through the use of a relevant utensil. An example might be the use of the kintsugi-repaired teabowl *Nekowaride* by Mr and Mrs Raku for a friend who had lost everything (see Chapter six). *Toriawase* is how the *chajin* enfolds the guests into the event.

Toriawase gives a sense of a harmonious whole, rather than offering a collection of strongly individualistic objects. There are conventions that guide decisions about utensil selection. One is that we usually avoid repetition; sets of matching objects are restricted to a few specific tea procedures. If you are using a Shino teabowl, you would probably choose not to use a similar Shino *mizusashi* (water jar). This is an important point for kintsugi. A kintsugi-repaired object is dramatic, and it can be surprising, as I was surprised by the teabowl at the beginning of this chapter. Because of this, a kintsugi-repaired object often draws attention to itself, making it unlikely that more than one kintsugi object would be used in a single tea event.

LOOKING THROUGH KINTSUGI

Alex Fraser, a friend and colleague, whom I know through my study of *chanoyu*, once told me a story about seeing a kintsugi repair in Kyoto. He was studying Tea with Akanuma Taka at Urasenke, one of the three Sen schools of *chanoyu*. The students had gathered to see an exhibition of teaware. One student spotted a teabowl with a beautiful kintsugi repair. Soon all the students were huddled around the showcase, oohing and aahing over the fineness of the gold mend. Akanuma-sensei came up and looked at them all disapprovingly. 'Do not look at the kintsugi. Look through the kintsugi to the pot that it is.'

With its current popularity, and with its undeniable beauty on both the physical and metaphorical level, it would be easy to make kintsugi into a fetish, of seeing it as a thing in itself. Ultimately, no matter how beautiful, how clever, or how symbolic a kintsugi repair may be, in the end kintsugi exists only as part of a greater whole. Its 'joining' is on more than one level.

Figure 44: Tearoom showing the utensils used in chanoyu. Photo by Lee Allison. Courtesy of Kaetsu Educational & Cultural Centre, Cambridge UK.

An example of a tearoom during a *chaji* or *chakai*, gatherings for *chanoyu*, Japanese tea ceremony. This shows the *toriawase* (utensil selection) of the host, Peter Sōrin Cavaciuti. It is February, the cusp of the change of season. The scroll is from a poem by Song dynasty poet Su Tong Po, and is translated as: 'Within nothing, everything exists/Flowers exist, the moon exists, and mansions exist', suggesting that we look forward, including to the arrival of spring. The black raku-style teabowl, named *Zui Un*, 'Auspicious Cloud', is a half-cylinder (*han tsutsu*), not the taller form used in the depth of winter and not the shallow one used at the height of summer, but one used when the days begin to warm. The red lacquer tea caddy is Sotetsu and picks up the colour of an early Sasanka camellia and plum blossom in an Iga vase in the *tokonoma* (alcove). The poetic name of the tea scoop is *Katarai*, 'chatting', which creates a warm feeling between the host and guests. Although themes such as the change of seasons and the communion shared between people are reflected in the different utensils, nothing is repeated directly.

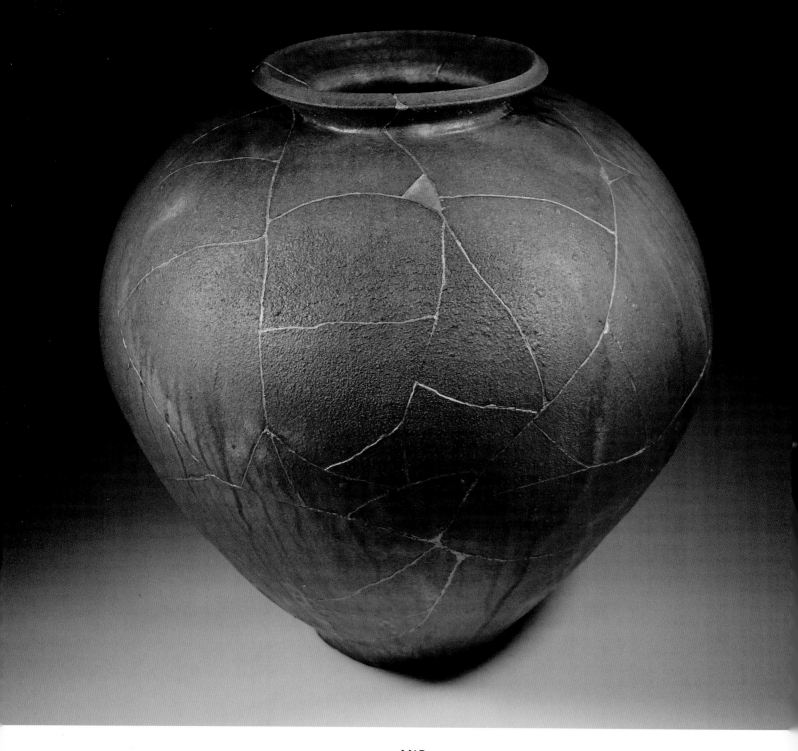

...AND
KINTSUGI IN ARIZONA

Every kintsugi repair has a story to tell. It is not surprising that the stories are often about family bonds, a kintsugi of human relationships. The story that follows was told to me by John Domenico, a young American ceramicist. John is the nephew of John Balistreri, so ceramics may be in his genetic make-up, but the real family business is Balistreri Vineyards, a boutique wine producer in Denver, Colorado. John has worked his summers in the winery since he was a child.

An anagama kiln. A first firing. A lot of broken pots.

It is the summer of 2016. John is home from university where he is studying ceramics and engineering. Like many young American potters he has fallen in love with Japanese ceramics and is keen to build his first kiln. The Japanese anagama kiln is large-chambered, with an uphill rise that moves the heat through the kiln as it fires. Building one is arduous, just the kind of challenge an ambitious twenty-year-old would undertake.

Many years earlier, John's uncle had built a kiln on the land that became Balistreri Vineyards. He went on to become a well-known American ceramicist. The kiln was abandoned and became part of young John's playground, a dark cavern to explore and a great place to look for garter snakes. When it later needed to be cleared as part of the winery development, John's grandfather conscripted the twelve-year-old John to help take the old kiln down.

> My mother explained we were going to tear the kiln down brick by brick and save them so one day she could build a commemorative wall in the new winery. I was less than pleased. I was in favour of burying the kiln rather than spending weeks in the hot sun chipping mortar off bricks and stacking them.

Resentful as he was then, that time with his grandfather became precious to the youngster. Creating this new kiln almost a decade later will be a reverse re-enactment of its dismantling with Grandpa. After a lot of research and many conversations with his uncle, John designs a massive kiln twenty-five feet long and six feet high (7.5 x 2 m). John, with his newfound book knowledge, and his grandfather, with his experience of the earlier kiln construction, build it together, working side by side as they lay each brick in the dry heat of a Denver summer. Brick by brick it grows to completion, and as each brick is cemented into place, so the grandson and grandfather are brought together.

> I built the arch form and began laying brick, and the whole while Grandpa worked alongside me. I thought I was learning about mortar, bricks and kiln construction, but I learned far more about the value of work ethic and the importance of having people in your life who support and believe in you. Nothing made me want to work harder and faster than when my seventy-three-year-old winemaker grandfather was laying brick faster than I could, even after a full day at the winery, and with no more incentive than to help me.

As much pride as you can have in your kiln, it still needs to serve its purpose; it needs to be filled. With the kiln almost finished, John makes new work with furious speed, creating more work than he's ever produced before to fill the enormous void. The largest and most precious of these are large jars, or *tsubo* by their Japanese name, each one about three feet tall. John finishes the work, pleased with the forms, and carefully loads the kiln, then bricks it up to close it.

Each step of this project brings a new thrill, and lighting the first flame ratchets up John's anticipation.

> I had no experience of this kind of firing to draw on; I barely remember the firings my uncle did when I was a kid. However, to my amazement my family greeted the chaos like an old friend and fell into the motions of how they had helped fire the old kiln.

Figure 45: John Domenico, Kintsugi Jar V, 2016. Wood-fired ceramic with kintsugi repair done by artist. 58.4 x 61 x 61 cm. Photo by the artist.

With a handful of family, friends and John's wife-to-be Claire – just barely enough people to make it happen – they fire the kiln for five days straight, working in shifts to stoke and mind the flames around the clock. Those not working still gather at the kiln to drink wine from the winery, with Grandpa bringing a few bottles from the tasting room each evening, although by necessity, water is the first choice most of the time. In the day the heat of the kiln competes with that of the bright August sun, but at night the kiln's heat warms them under the cool, dark skies.

Five days to fire. A full eight days to cool. Each day of the cooling feels like a month to John. Finally, the kiln temperature has dropped enough to begin the unbricking. Peering in as the bricks come away John

Figure 46: John and his wife-to-be Claire side-stoking the Denver anagama kiln, 2016.

spies the first of the *tsubo*. It is perfect: flawless, its surface and texture amazing and vibrant. John is flushed with pleasure. Brick by brick the kiln opens until finally John can reach in to bring out the *tsubo*. He puts his fingers into the first huge pot, grasping the rim and using his other hand below. A small tug to lift it – but... the rim comes away in his hand. Then the rest of the pot falls to pieces onto the kiln shelf, his hand still gripping the rim. John tries another. It happens again. It is clear that the firing has been very uneven. The high heat in the front of the kiln and the resulting fly ash settling on the *tsubo* has caused the natural glaze to melt down over the wadding John has used to keep them from sticking to the kiln shelves. As the pots and the shelves shrink at different rates as they cool, the stress on the pots has made them crack. John says that never has the old joke about hoping for Christmas when you unload the kiln, but getting Halloween instead, been more true.

John had put all of himself into building this kiln, but most importantly, he had built it with the help of his grandfather and his family. And he had created beautiful pots to fill it, and spent five hard days firing. Then he also feels he carries the legacy of his uncle's kiln. John can't let the pots go. For a year he considers everything he has put into them, and how much others have invested in him, and that makes him think about the kind of power these objects hold. For John, kintsugi, which speaks to that power, seems the right thing to do.

> ...but I needed to understand not only why I decided to appropriate this Japanese tradition but also the essence of what kintsugi is. In the works I salvaged, all of the beauty, hardship, family lineage, work and narrative cumulate into a physical form. To dispose of

Figure 47: *'More Halloween than Christmas.' John unloading the first firing of the Denver anagama at 93.3°C. Blankets were used to minimize thermal shock on the works.*

Figure 48 (above): Kintsugi Jar V with Claire and Grandpa enjoying a glass of Balistreri Syrah in the background.

Figure 49 (right): John Domenico, Kintsugi Jar II, 2016. Wood-fired ceramic with kintsugi repair done by artist, shown in front of the Denver anagama kiln. 78.7 x 66 cm. Photo by the artist.

all the work from early mishap firings of the kiln would have been to do a disservice to all that went into it. And for me, that spoke of what I felt kintsugi to be.

Back at university in Phoenix, John decides that using traditional *urushi* for these large *tsubo* isn't an option. For one thing, kintsugi was developed in the humid climate of Japan. Phoenix is the second driest city in the USA. John draws on his engineering background to find other adhesives. Then he painstakingly reassembles

the *tsubo*, using gold on some to finish the seams and an imported Japanese material that has gold in it on the others. The completed pots are beautiful, full of volume with gold seams that accentuate the strong forms and dark surfaces.

John fixes the problems with his anagama kiln and goes on to successfully fire more work – but these first pieces, testaments to learning, experience and, most importantly, family, will always mark a significant time in his career.

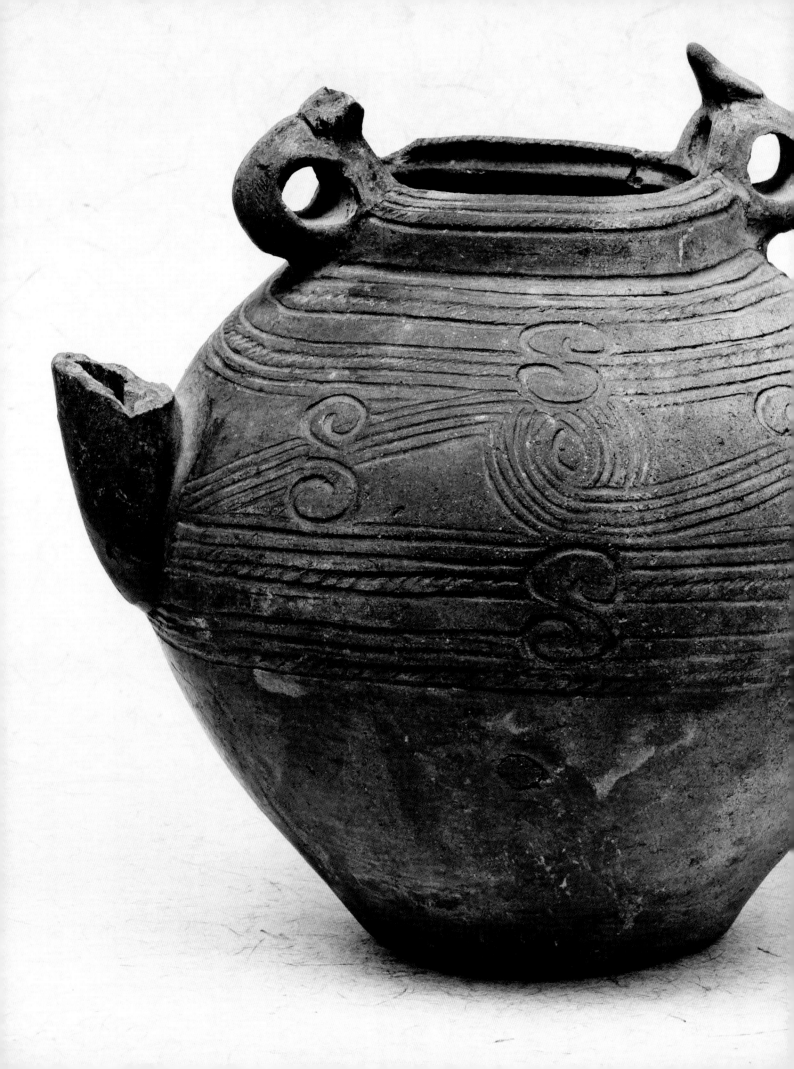

SAN
THREE

FOUR HISTORIC ELEMENTS

In this chapter Hiroko Roberts-Taira identifies four historical elements of kintsugi: ceramics, lacquer, gold and Japanese tea ceremony. Together she and I look for the story of its origin and development.

Hiroko and I are in the Folk Museum of Higashimurayama outside Tokyo. It's strange to find ourselves in such a modern building when we've come to see the oldest known pottery in the world. We are meeting with the specialist Chiba Toshirō, who has brought out a stunning spouted vessel for us to see. Its shape is round, with a distinct, high rim on which there are two strong finger-sized handles. A chunky spout comes off the centre of its belly. Its surface is covered in intricate flowing incisions and impressions. Pit-fired to a low temperature between three and four thousand years ago, its fragility is evident. It has been in pieces at one time, and is now held together with filament. We sit in front of it, rather speechless with its beauty and age. After we have peered closely at it for a while, Mr Chiba points to the reason he has brought it out: a small round plug on one side. It is a repair. It appears to be of rough clay, but when we ask about it, he tells us it is urushi, or lacquer, an example of how far back in history lacquer repairs to ceramics go.

Figure 50: *Jōmon vessel with urushi repairs, c. 2000–1000 BCE. Important cultural property. Courtesy of Folk Museum of Higashimurayama.*

Figure 51: *Detail of Jōmon vessel with a small hole filled with urushi. Important cultural property. Photo by Nonaka Akio. Courtesy of Folk Museum of Higashimurayama.*

THE EARLIEST POTTERY AND *URUSHI*

The Jōmon, the earliest people known to have inhabited the Japanese islands, open this story. Pottery or ceramics is the first component of kintsugi, and Jōmon pottery is the earliest to be found in the world thus far, with early pieces excavated at the Odai Yamamoto site in northern Honshu radiocarbon dated to 14,500 BCE.[36] It is thought that like many early civilizations the Jōmon people would have made new vessels as and when they were needed.[37] The skill involved in making these pots must have been extensive, and would have involved finding, gathering and refining the clay, then coiling, smoothing and decorating the pots, then drying and firing them in an open bonfire, with the inevitable breakage and loss that such firings bring. Each fragile vessel must have represented hours of work, and just as it is today, it would have taken years for a person to fully develop his or her skills, each pot representing the embodiment of that individual's and that society's aesthetic. With this kind of investment, it is easy to imagine why the Jōmon searched for a way to repair their broken pots.

The Jōmon people were semi-sedentary hunter-gatherers who lived in family groups, and although they did not have highly developed agricultural skills, it is evident from the *urushi* (lacquer) tree logs found at the Shimoyakebe site in Tokyo (*c*. 1800 BCE), that they managed plantations of *urushi* trees to produce the second component of kintsugi: *urushi*. They prepared the sap in a variety of ways for different purposes.[38] Artefacts excavated from this site suggest that it was used in four distinct ways: to strengthen a surface, as decoration, as an adhesive and as a filler.

Urushi is the refined sap of the *Toxicodendron vernicifluum* tree. The oldest excavated *urushi* tree was found in the Torihama Kaizuka midden in central Honshu, and carbon dating has been established as 10,615±30 BCE.[39] Although, as always, there is some dispute, the oldest *urushi* artefact yet found appears to be a woven cloth that is painted with red *urushi*, dated to 7040 BCE and excavated from the Jōmon Kakinoshima B site in Hokkaido in 2001.

Black *urushi* was used as a paint. It was processed by filtering the sap through cloth to remove debris, then thickening it through evaporation, while stirring it to make it homogeneous. Red iron oxide was mixed with the black preparation to make red *urushi*. *Urushi* to be used as adhesive and filler was mixed with fibre or soil to give it viscidity and body. In talking with contemporary kintsugi artists, we find that these ancient techniques are very similar to ones used today.

Careful consideration went into these Jōmon *urushi* repairs. Mr Chiba brings out a sherd from the Shimoyakebe site. It is an intact spout, attached with *urushi* to the remaining piece of the pot's body. Strikingly, after making the repair, the join has been covered with coarse sand or grit, clearly for decorative effect. So even as early as this, we see the drive towards the combination of repair and decoration that is kintsugi.

There was a long transition from the Jōmon era to the Yayoi era, which some historians now believe can be traced back to as early as 1000 BCE.[40] The new era is marked by the arrival from the Korean peninsula of the Yayoi people, who established more permanent agrarian settlements based on rice cultivation. The earliest Yayoi settlements were mostly in the south and west of Japan, the areas closest to the Korean peninsula, and far from northern and eastern parts of Japan, where *urushi* trees were more abundant. Mr Chiba speculates that this may have been a

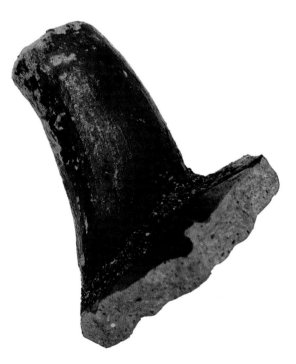

Figure 52: *Red urushi decoration on pottery sherds, 2000–1000 BCE, from the Shimoyakebe excavation site, Higashimurayama City. Important cultural property. Courtesy of Folk Museum of Higashimurayama.*

Figure 53: *Repaired spout with decorated urushi seam from a Jōmon pot, 2000–1000 BCE, Shimoyakebe site, Higashimurayama City. Important cultural property. Courtesy of Folk Museum of Higashimurayama.*

Figure 54: *Detail of material used as decoration on urushi repair of Jōmon pot, 2000–1000 BCE, Shimoyakebe site, Higashimurayama City. Important cultural property. Courtesy of Folk Museum of Higashimurayama.*

52
53 54

Figure 55: Great Buddha Daibutsu at Todaiji, Nara, Japan. The creation of Daibutsu follows the discovery of gold in Japan in 749 CE. The 15-metre sculpture is a National Treasure. The Historic Monuments of Ancient Nara are registered as a UNESCO World Cultural Heritage site. Photo by John S. Lander/LightRocket/Getty Images.

contributing factor in why there is so little *urushi* found in Yayoi pottery.[41] Although there is evidence that the Jōmon and Yayoi cultures influenced each other to some extent,[42] *urushi* artefacts from the Yayoi era do not include the red *urushi* used so extensively by the Jōmon people; the rare examples of *urushi* used to paint Yayoi artefacts are black, some containing a black pigment not used in the Jōmon era.[43] In addition, very little Yayoi pottery with *urushi* repairs has been excavated.

Yayoi pots are smoother, thinner, largely untextured, often covered in slip (liquid clay), and fired to higher temperatures. They demonstrate a more sophisticated level of clay skill, in both making and firing techniques. In effect, they have a more 'perfect' appearance, and hence a very different appeal, one that may not have lent itself to easily accepting breakages and repairs. The contrasting lifestyles of the Jōmon and Yayoi people also may have contributed to the differences. Perhaps the non-farming Jōmon had more time to spend decorating their wares,[44] or perhaps the Yayoi developed a professional potter class, who needed to produce pots more quickly and efficiently. Whether the decline in the use of *urushi* is due to a loss of knowledge, a lack of materials or a change in aesthetic remains unknown, but it would be centuries before there is a widespread use of *urushi* to repair ceramics again.

THE USE OF GOLD

The Jōmon people introduced two of the components needed for the emergence of kintsugi: ceramics and *urushi*. By the mid-seventh century the value of *urushi* was well established, evidenced by the fact that it became a currency for paying taxes.[45] A Department of *Urushi* (*Muribe-no-tsukasa*) was established under the Ministry of Finance by Taihō-ritsuryō in 701.[46]

During the Kofun era (mid-third to seventh century), a group of people with specialized skills arrived from China and Korea.[47] The *tehito* ('handcraft people') produced armour, swords, leathered shields and lacquered table linens. In third-century BCE China, and by the end of the fourth century CE, these linens were being used to create Buddhist statuary. The technique came to Japan with Buddhism, and was originally used to make coffins for the nobility. It was then applied to

Buddhist statuary and this became widespread in Japan by the late seventh and into the eighth century.

The construction of the gold-covered *Daibutsu* (Great Buddha) at Tōdaiji in Nara by Emperor Shōmu (701–756) follows the discovery of the first gold field in the eastern Tōhoku region of Japan in 749.

Reference to this is found in a poem recorded in the *Man'yoshu*, the oldest collection of poems in Japan, by Ōtomo no Yakamochi:

> すめろぎの
> 御世栄えんと
> 東なる
> みちのく山に
> 黄金花咲く

> Long live the Emperor
> Gold blossoms bloom in the east
> In Michinoku Mountain
> Wishing lasting prosperity
> Of his majesty's reign[48]

The treasures of *Shōsō-in*, Tōdaiji's repository, include many of Emperor Shōmu's belongings, including lacquered objects with *kingin-e* (gold and silver picture) decoration, which was popular in the Nara era before *maki-e* techniques were developed. *Kingin-e* was a style of painting onto lacquer using a solution of gold and silver powders mixed with a glue-like substance.

CHANOYU, JAPANESE TEA CEREMONY

So we see that in the Heian era the material components for kintsugi (ceramics, *urushi* and gold) were there, yet kintsugi was still many centuries away. Like *urushi* techniques and the use of gold, the fourth

element of kintsugi, the antecedents of *chanoyu* (Japanese tea ceremony), were also brought to Japan with Buddhism. *Chanoyu* influenced many aspects of Japanese culture, and its aesthetic values are deeply embedded within the aesthetics of kintsugi. In addition, the utensils, *dōgu*, used for *chanoyu* garnered high economic, cultural and political value, and kintsugi became an important way of repairing and maintaining them.

The culture of drinking tea was brought to Japan from China by Buddhist monks. It is said that twice a year Emperor Shōmu (701–756) invited one hundred monks to the Imperial Palace to pray for peace and the prosperity of the state. The event lasted three to four days and the monks were served tea.[49] Although limited to monks and aristocrats, tea was drunk in Japan, and also grown there, throughout the Heian period.

In *Azuma Kagami*, or *Mirror of the East* (c. 1266), an historical chronicle edited by the Kamakura *bakufu* (military government), it was recorded that the Zen Buddhist monk Eisai (also known as Yosai) (1141–1215) offered *matcha*, powdered green tea, to Shogun Minamoto no Sanetomo (1192–1219). The inclusion of this story shows how important tea drinking had become in Japan. Eisai's practice of tea and his book, *Kissa Yōjōki*, or *Drinking Tea for Health*, were substantial factors in the development of what would become *chanoyu*, or tea ceremony.

At the end of the Heian period the samurai class grew in strength, resulting in the beginning of the shogunate in the Kamakura era (1185–1333) and the diminishing of the power of the emperor. The samurai, who were guards to the aristocracy, adopted the practice of *chanoyu*. According to *Kuntaikan Sosachoki* (Register of the Shogunal Family, Left and Right Volumes), written

early in the Muromachi period (1333–1573), tea was prepared using Chinese utensils, known as *karamono*, and the room was decorated with *karamono* paintings and ceramics. During this time the functional and aesthetic concepts that underlie the utensils used in the art of Tea began to be defined. For example, unlike steeped tea, *matcha* is not made in a teapot then decanted. The tea is made from dried, powdered leaves, which are whisked with hot water. It is prepared in and drunk from the same vessel: the teabowl.

As *chanoyu* developed, it spread to the rich merchant class, becoming a defining aspect of the culture of Japan. As the drive to possess more and more valuable Chinese utensils increased, including teabowls, so did the monetary value of such wares. These expensive *karamono* were equated with high prestige and ostentatious wealth. It was into this exclusive style of Tea that challenges to the aesthetic began to appear.

Nōami (1397–1471) was a painter and poet. He turned away from the flamboyance of *chanoyu* as it was being practised and developed a style that drew upon its early link to spirituality. The Buddhist monk Ikkyū Sōjun (1394–1481), by all accounts a non-conformist, began to use everyday objects in his practice, rather than expensive *karamono*. Murata Jukō (also known as Shukō) (1423–1502) also embraced an approach that sought the unpretentious. The *wabi* aesthetic, often associated with Zen Buddhism, embraces imperfection or irregularity, rusticity, authenticity and humility, naturalness, and a lack of pretention or grandeur, all qualities often found in kintsugi. Jukō is known for the beginnings of *wabi-cha* (*wabi* tea). He developed *sōan-cha*, or thatched hut tea, which embraces the four-and-a-half-mat tearoom (approximately three by three metres). This reduction in scale may have been one small factor leading to the development

Figure 56: Bakōhan *(Locust bowl), Longquan (celadon) ware, Southern Song period (13th century) with later rivet repair. Important Cultural Property, Japan. This bowl was sent to China for replacement, but returned with repairs done with rivets. The rivets look like locusts. 9.6 x 15.4 cm rim; 4.5 cm base diameter. Tokyo National Museum: Gift of Mr Mitsui Takahiro. Photo credit: TNM Image Archives.*

of kintsugi, as a kintsugi-repaired pot can create a kind of intimacy that could be lost in a larger and grander space.

Takeno Jō-ō (1502–1555) further cultivated the tea ceremony aesthetic along the lines that Jukō had begun, and he is often credited with solidifying the concepts of *wabi* in tea ceremony. Jō-ō was known for using inexpensive Korean rice or food bowls,

known as *Ido* bowls. Many such bowls with kintsugi repairs are found today in museums, although we have no way of knowing when the repairs to these bowls were undertaken.

In establishing an approximate date for the earliest kintsugi wares, we need to look at the famous story of Ashikaga Yoshimasa (1436–1490), the eighth shogun of the Muromachi era, who was the owner of a beautiful

and elegant Chinese celadon bowl. Writing about the bowl around two hundred years later, Ito Togai (1670–1736) wrote that the bowl developed a crack at the bottom, so Yoshimasa sent it to China, asking for an identical replacement. However, instead of a new bowl, the original teabowl was returned to him repaired with metal rivets, with the explanation that it was no longer possible to find a celadon teabowl of the same quality. On its return, it was named *Bakōhan*, or large locust clamps, as the rivets resemble locusts. The teabowl has since become one of the most famous and iconic teabowls in history. [Figure 56]

The use of rivets in this story suggests that kintsugi did not exist in China at that time, and probably not in Japan, giving us a date prior to which we can assume kintsugi had not yet developed. An apocryphal legend has arisen, probably outside Japan, that Yoshimasa instructed his courtiers to find a better way to repair ceramics and that kintsugi was the result. This, however, seems unlikely since *Bakohan* was clearly treasured in its repaired state after its return.

Sen no Rikyū (1522–1591), Jō-ō's student, is the tea master credited with bringing *wabi-cha* to fruition. Rikyū created an even smaller teahouse, made up of just two tatami mats (approximately two by two metres). Into this intimate space Rikyū introduced the famous Raku teabowls, created in collaboration with the potter Chōjirō, the primogenitor of the long line of Raku potters, which continues to this day.

During his lifetime Rikyū became the undisputed arbiter of Tea taste. There is a story in *Chawa Shigetsu-shu*, written by Fujimura Yoken (1613–1699) and published by Kusumi Soan in 1701, about a famous *chaire* (ceramic tea caddy) called *Unzan*. In the tale the owner of *Unzan* invited Rikyū to a *chakai* (tea gathering) and proudly

used it when serving tea. Rikyū didn't appear taken with the *chaire*. The owner was greatly disappointed, and in a fit of pique, he threw the *chaire* down and it broke. His friend, who was watching, picked up the pieces, then glued them back together. Inviting Rikyū to a *chakai* of his own, the friend again used *Unzan*. This time Rikyū found the *chaire* 'admirable' – high praise indeed. The friend returned the *chaire* to the original owner. It later came to be owned by the feudal lord Kyōgoku, who asked the noted tea master Kobori Enshū (1579–1647) if it should be re-joined where the repair was not perfectly done. Enshū replied, 'It should be left as it is, as Rikyū appreciated the imperfection of its join.'[50]

As well as showing the reverence in which Rikyū was and is held, this episode reveals two interesting points. The first is that there is no reference to the use of gold, which suggests that the repair was made with *urushi* or some other adhesive alone. Unfortunately, we will never know, as the *chaire* is said to have been lost more than a century later in a fire caused by lightning. The second inference is about the quality of *wabi-cha*. We can assume that Rikyū embraced the *chaire*'s mended imperfection as an example of *wabi*. In fact, the appreciation of brokenness and/or repair is substantiated by several historical quotations. In Tea it is said that Rikyū allowed utensils in his small tearoom to be 'lacking' or imperfect, and this included ceramics that had been repaired.[51] Furuta Oribe (1543–1615), Rikyū's disciple and successor, said: 'Perfect teabowls are dull ones.'[52] And another quote states: 'Seeking for perfection is pursued by the immature. Imperfection should be appreciated.'[53] An important source supporting this view can be seen in *Nampō Roku* (*Recording on the Drinking of Tea which comes from the South*), traditionally credited to the Zen monk Nanbō Sōkei (dates uncertain), who was said to be a

student of Rikyū. It was published in 1690 in a book of writings by Tachibana Jitsuzan (1655–1708). 'Utensils used in the small tea room need not be entirely perfect. There are people who dislike even slightly damaged objects. This, however, is merely indicative of thinking that has not attained true understanding.'[54] These quotations are all embraced within the statement by Haga Kōshirō: 'Thus we arrive at one of the major characteristics of the *wabi* aesthetic: It finds a deeper beauty in the blemished than in the unblemished.'[55]

INNOVATION

Perhaps it is the concept of *mottainai* (See Chapter two), which admonishes us not to be wasteful, that also plays a part in the early use of kintsugi. *Kohiki Chawan Ō-Gorai* was owned by Hosokawa Sansai (Tadaoki) (1563–1646), who was a samurai and another of Rikyū's students. *Ō-Gorai* was a spouted Korean bowl. It was repaired and made into a teabowl after the spout was broken off. *Ō-Gorai* was cherished by its owner, Sansai, and has been passed down in the Hosokawa Family to this day. [Figure 58]

We see a further spark of creativeness with the development of *yobitsugi*, or patchwork joins, where fragments from a second pot are used in a repair. This is reflected in the teabowl that is simply called *Yobitsugi Chawan* (Patchwork Teabowl), which is said to have been possessed by Oda Urakusai (1548–1621), a younger brother of the powerful *daimyō* Nobunaga, and a student of Rikyū. Urakusai's *Yobitsugi Chawan* is thought by some to be the oldest existing example of *yobitsugi*.[56] The original pot is from Seto (one of the famous Japanese kilns), but the fragment added in the repair is *Nanking Sometsuke* (Chinese cobalt blue on white porcelain). They are joined with *urushi* without using gold. [Figure 59]

In using creative approaches, Oribe is known as the most *avant garde*, or even iconoclastic *chanoyu* master. The most famous of the teabowls he owned is named *Shumi* (also known as *Jūmonji*), the repair of which is in the shape of the Japanese number ten (十, pronounced 'jū'). It is said that Oribe thought the bowl was too large, so he cut it into four pieces, shaved them down, and re-joined them to make it small enough to be a teabowl. To do this he used red *urushi* alone. [Figure 60]

Oribe was known for using intentional destruction to make things more interesting. Kumakura Isao recounts from *Rōdan Ichigon Ki* that Ōkōchi Kimbei predicted a violent death for Oribe because he 'damaged the treasures of the realm', including scrolls, teabowls and tea caddies, and that such a person was sure to meet a sad end.[57] Oribe's intentional damage of ware challenges two concepts that underlie traditional kintsugi today: that it would be disrespectful to deliberately break an object in order to have it repaired, and that only precious objects are repaired. Furthermore, it presents kintsugi-repaired wares as possible objects of commodification, as it is said that this was done to sell the wares on at higher prices.

Within the story of *chanoyu*, kintsugi's emergence can be linked to the spread of Tea to the wealthy burgeoning merchant class, which resulted in a marked rise in both the aesthetic and the monetary values of *chadōgu*. *Chanoyu* is much more than just an art form or a social event. During this time it was becoming fully embedded in the politics of the era. The most eminent tea masters were part of a warlord's or the shogun's court. One of their responsibilities was to grant validation to various *chadōgu*. This was often done by bestowing a name on the utensil or writing on the box in which it was stored. In this way, the Tea aesthetic

was continuously defined and refined. Some utensils became priceless, and served as markers of wealth, often given as guerdons or rewards from a superior. Thus loyalties and allegiances were reinforced. Morgan Pitelka has reflected that precious items of long shogunal pedigree also endowed their new owners with some of the authority of their past owners.[58] So we can see that these objects were imbued with an importance that went far beyond economic or aesthetic values.

Although there were social occasions in which utensils were displayed, within *chanoyu*, utensils are functional, not just decorative. Therefore, if a prized utensil was to be seen and appreciated fully for both its beauty and for the statements it made about the owner's allegiance and favoured status, we can surmise that it was essential that the object was usable. Someone possessing such an object could not leave it broken and languishing in its box. Repairs became a crucial part of maintaining the *chadōgu* collections.

MOMOYAMA ERA (C. 1573–1600)

The application of *maki-e* techniques to repair ceramics and other materials, which we now know of as kintsugi, might well have arisen from the lavishness of the Momoyama era,[59] when political strife resolved into the extended peace of the Tokugawa or Edo period. It was a time of great ostentation, and the use of gold was used extensively in architecture and paintings, on furniture, and even in dress. An extreme example of this was the portable golden tearoom commissioned by Toyotomi Hideyoshi (1536–1598). In this grand space everything was either made of gold or covered in gold leaf, except the bamboo whisk, the cloths used in preparing tea and the tatami mats, which were covered in red and edged with gold brocade.[60] With gold and

all it represented so prominent within these eras, if a priceless ceramic item, which also served as a political link to power, was broken, how more appropriate could it be than to repair it with gold?

SEPPŌ

There is one particular teabowl in which all four of the elements we have identified as the components of kintsugi – ceramics, *urushi*, gold and tea ceremony – can be seen to have come together, one that well-represents the birth of kintsugi. The red raku teabowl called *Seppō*, or 'Snowy Peak', was made by Hon'ami Kōetsu (1558–1637). It is now classified as an Important Cultural Property and is part of the Hatakeyama Memorial Museum of Fine Art collection. [Figure 61] Kōetsu was a talented and highly respected man whose life is marked by exceptional accomplishment. Born into a family of noted sword appraisers and polishers, an esteemed profession, he was a much-consulted connoisseur of art objects, but his skills also included the practical. He was a famous painter, a founder of the Rinpa school. He also learned ceramics at the Raku studio, working with Jōkei II and Dōnyū III (Nonkō). He was a noted *chanoyu* student of Oribe. His calligraphy was widely admired, and he was known for *maki-e* (lacquer art), where his influence is marked. There are beautiful extant pieces attributed to him, including *Kikori Maki-e Suzuri-bako*, which is an Important Cultural Property. It is thought that the *urushi* and gold in *Seppō* might have been applied by Kōetsu himself. Raku Kichizaemon XV speculates this.[61] Kōetsu also named the bowl, and the name alludes to the kintsugi repair, indicating that the gold repair was not done at a later date. Although we cannot say for sure, we must ask if it was the combination of Kōetsu's talents in the four elements of kintsugi that came together to create this unique technique.

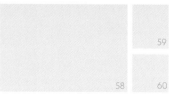

Figure 58: Ō-Gōrai, kohiki chawan (teabowl), Korea, 15th–16th century. Owned by Hosokawa Sansai (Tadaoki) (1563–1646). 9.5 x 17.8 cm. This photo shows the area where the spout was before it was smoothed over using urushi. Eisei Bunko Museum, Tokyo. Photo by Maruyama Mitsuru/SOBISHA.

Figure 59: Yobitsugi chawan (teabowl), Azuchi Momoyama-Edo period. Owned by Oda Urakusai (1548–1621). This is an early example of a repair using a fragment from another pot (called yobitsugi). 10.8 x 9.8 cm. Eisei Bunko Museum, Tokyo. Photo by Maruyama Mitsuru/SOBISHA.

Figure 60: Shumi, *also known as* Jūmonji, *Ō-Ido* chawan, *Korea, 16th century. Said to have been cut into pieces, shaved down and reassembled using red urushi to make it smaller by tea master Furuta Oribe (1543–1615). Photo courtesy of Mitsui Memorial Museum, Tokyo.*

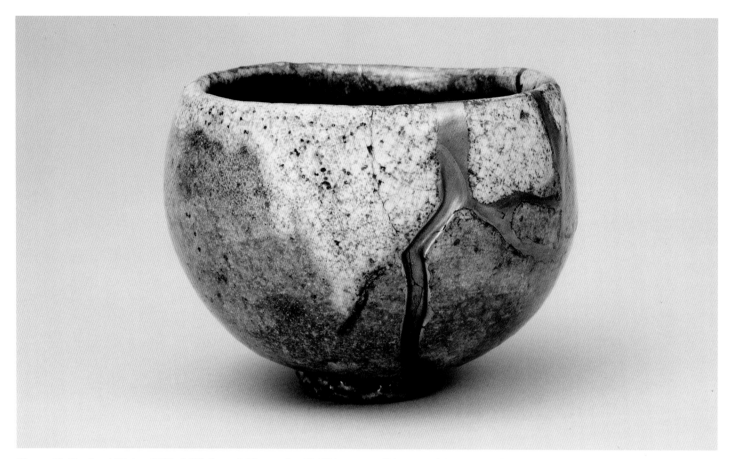

Figure 61: Hon'ami Kōetsu (1558–1637), Seppō ('Snowy Peak'), 17th century, Edo period. Important Cultural Property. Aka (red) Raku ware. One of the earliest repairs using gold that we know of. 11.6 cm diameter. Photo courtesy of Hatakeyama Memorial Museum of Fine Art.

A journal entry written at the Hatakeyama Memorial Museum of Fine Art in March 2019.

In the quiet elegance of this setting, it is not surprising that I should find there is a hush among the visitors. In this space, dedicated to the display of the Hatakeyama collection of tea ceremony utensils and other art objects, the lights are dim, echoing the *chashitsu*, or tearoom, the carpet muffles our steps, and the objects in front of us glow with beauty and refinement. None more so than the teabowl *Seppō*. It stands alone at eye level, its rounded shape, warm colours and subtle texture makes me want to hold it in my hands. Its rich red clay body shows through the glaze, with a hint of an enticing snow-on-the-mountain white that gives the bowl its name. There is a deceptive stillness in this bowl.

The teabowl looks worn, never tired, but well-used. This beautiful patina avows the respect and reverence in which it has been held through the centuries. There is drama in its kintsugi repair. It speaks of reawakening, of something broken made whole, of the damaged made beautiful. A wide and deep gouge runs from rim to foot-ring with smaller cracks running off it. The commanding channel is deep with steep straight sides, which my potter eyes tell me are *kamakizu*, cracks formed when the bowl was cooling in the kiln. The sharpness of this sunken crack and its keen edges reinforce its story. Like in a deep ravine in the earth, the gold 'flows' down as if it were snow melting in spring. I want to gently and carefully run my finger down the deep rift that scars its surface. It would be like kissing a young child's scraped elbow to make it better. The kintsugi of this caressable bowl speaks of human intervention and compassion.

Seppō, with its distinctive large crack, could have been considered a failure. Instead, Kōetsu chose to use lacquer and gold to accentuate the flaw, perhaps even further manipulating it.[62] This deep crevice, thought to have occurred unintentionally in the firing, is considered to be 'overwhelmingly beautiful' by Raku Kichizaemon XV,[63] who is the fifteenth-generation Raku master from Chōjirō. Hiroko speculates that perhaps *Seppō* serves as a metaphor for the death by *seppuku* (ritual suicide by sword) of Oribe, who was Kōetsu's teacher. Like Rikyū, when the order came, Oribe made no appeal to be spared. Kōetsu may have chosen to mark the dramatic crack in *Seppō* with gold as a way to commemorate the lives and deaths of his two teachers, both of whom did not compromise their integrity. If this is the case, it confirms that, from the very beginning, kintsugi was recognized as carrying an important metaphoric weight.

EDO OR TOKUGAWA ERA (1603–1868)

Maki-e, 'sprinkled picture', is a lacquer technique where different grades and shapes of gold powders are sprinkled on *urushi* (lacquer) to create elaborate, sometimes ornate paintings. It is used on many different objects, functional and decorative. It was *makie-shi*, or *maki-e* artisans, who undertook kintsugi repairs. It is *maki-e* skills that make kintsugi.

During the feudal and warring eras, *makie-shi* were employed by local lords, and most likely worked solely for that household creating and maintaining military gear, such as armour and sword scabbards. At the time, there were sumptuary laws that made *urushi* and gold regulated commodities, often used as tribute, so training in *maki-e* would have been highly restricted, as an individual craftsman would not have had access to these precious materials. When

Figure 62, above: *Inrō (small ornamental stacked boxes) with* maki-e *decoration, late 18th–early 19th century, Edo period (1615–1868), Japan. Five cases: lacquered wood with gold and silver* hiramaki-e, togidashimaki-e, *cut-out gold foil application on black and* nashiji *lacquer ground, 9.3 x 5.3 x 2.8 cm. Photo by Sepia Times/Universal Images Group/Getty Images.*

Tokugawa Ieyasu moved the capital from Kyoto to Edo (Tokyo), he extended the policy of *sankin-kōtai*, which required the *daimyō* to spend alternate years in Edo and to leave their families behind when returning to their domains. With the *daimyō* having to establish homes in Edo, many *makie-shi* moved there, and we see the beginning of a golden age of *maki-e* under the patronage of the ruling families in this urban setting.

In the early part of this era, we see the rise of the aesthetic of *kireisabi*. If Rikyū is known for an austere and simple *wabi* aesthetic, and his student Oribe is known for a rougher, more exaggerated irregularity, then within Tea aesthetics we look to Kobori Enshū for the addition of *kireisabi*, which is often described as 'subdued beauty', 'elegant simplicity' or 'elegant loneliness'.

In the late Edo period, with vast changes in the political landscape of Japan, which included the abolition of the samurai's exclusive right to carry weapons, the control of *maki-e* production began to ease as the lords lost power. As the call for armour and swords lessened, *makie-shi* began to take commissions from elsewhere, increasingly from the rising merchant class, and these were often for luxury household items, such as writing boxes, *inrō* (small cases worn with kimono) and combs. [Figure 62] Kintsugi would have been a professional sideline that meant extra income. It's doubtful the *makie-shi* who took on kintsugi projects would have advertised the fact, although some would have become known for it because of their skill or perhaps because of a famous patron. As Shimode Muneaki, who represents the youngest generation of a *makie-shi* family in Kyoto, says, 'Traditionally, there are no professional kintsugi craftsmen, but there are specialists.' Fine *maki-e* is attributable, but kintsugi repairs almost never were. As evidence of this, we found no records for most of the kintsugi repairs we came across in museum collections in Japan and elsewhere, even though many were done to old and venerated ceramic pieces.

There is another factor arising in the Edo period that may also have contributed to the spread of kintsugi, that was a growing interest in collecting, which included, among other things, Jōmon pottery. We have not been able to discern if the people of this era realized that *urushi* had been used for repairs in the Jōmon period, but in this time we do see *urushi* being applied again to Jōmon pots. One example was used by Neil MacGregor, then Director of the British Museum, in his noted BBC Radio 4 programme *A History of the World in 100 Objects*. It is a characteristically rough Jōmon pot that has been covered on the inside with lacquer and gold. It was used as a *mizusashi* (water container) for tea ceremony. The contrast of age and newness, as well as the exterior ruggedness and the interior's refinement, must have appealed greatly to the Tea practitioners of the day.

In recent years, kintsugi, although still often undertaken by *makie-shi*, has also become an independent profession, now sometimes referred to as *kintsugi-shi*, with training in kintsugi techniques alone being offered both inside and outside Japan. As we have seen, there are now kintsugi repair services around the world, mostly in major cities. Others trained in kintsugi are using it not as a repair technique, but as an artistic medium or simply as a tool to achieve a specific aesthetic end. Especially outside Japan, this has found favour, most likely because of the strong metaphor that kintsugi offers and its appeal as a model for sustainability. With the advent of new materials, many practitioners now offer the more affordable *kan'i-kintsugi*, or 'easy' kintsugi, which does not use the highly allergenic *urushi*, but various resins and epoxies instead. In addition, a new *urushi* is now available, which is said to produce a less allergic reaction and is therefore safer to use. This development has encouraged many people who are interested in kintsugi to 'give it a go'. Who knows where the techniques of kintsugi will go next?

Figure 63: Early Jōmon pot, c. 5000 BCE. Coiled and hand-moulded low-fired red pottery; decorated on the exterior with cord-markings and 'nail marks' in bands near the mouth; interior lacquered in gold in the 19th century (lacquered wooden lid not shown). 15 x 17 cm. Photo © The Trustees of the British Museum.

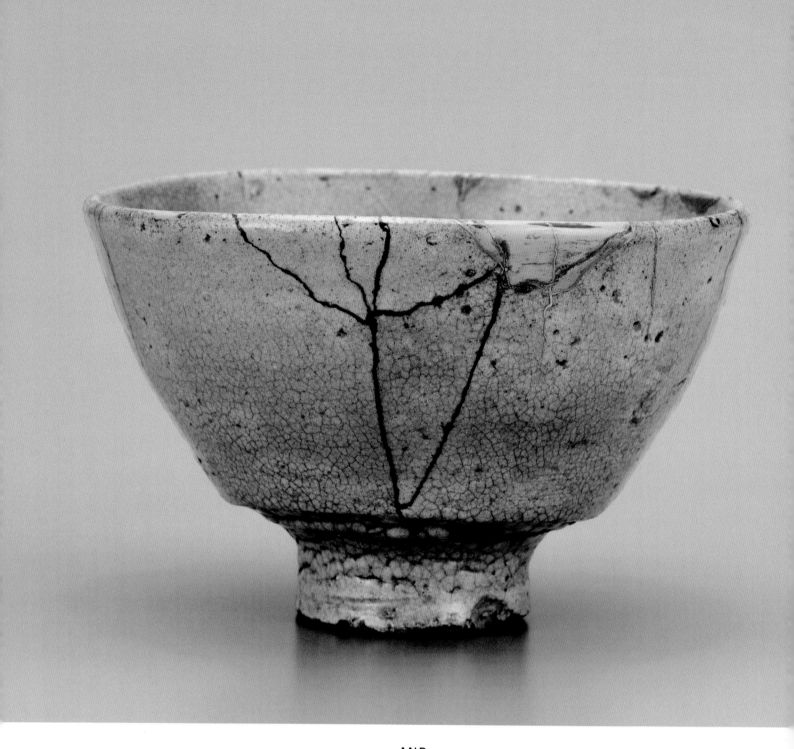

...AND
A FAMOUS TEMPER

Many kintsugi-repaired teabowls carry legends of how they were broken. Here, Hiroko Roberts-Taira tells the story of a famous teabowl called Tsutsuizutsu, a fit of fury, and a young life spared through humour and diplomacy.

It is February 1588. Toyotomi Hideyoshi is the most powerful samurai in Japan. In addition to being a great military leader and strategist, in an effort to overcome his humble beginnings, he has made vigorous efforts to learn classical literature, Zen philosophy, Nōgaku theatre, tea ceremony and to write poems. On this day Hideyoshi has invited five high-ranking samurai to a tea ceremony, and he is planning to use a famous Ido teabowl called *Tsutsuizutsu*, which is in the shape of a deep well. Hideyoshi had coveted this teabowl a long time. He had only – finally – obtained it. Its owner, Tsutsui Junkei, had presented it to him to plead for his and his clan's life after an attempted coup by one of his relatives. In this special Tea gathering Hideyoshi is showing off more than just his new bowl.

It is Hideyoshi's page who disrupts the planned exhibition of Hideyoshi's power and might. In front of Hideyoshi and his guests, the young man *drops* the teabowl. It breaks into five pieces. Hideyoshi is livid! 'What have you done?! You can't drop that teabowl, even if your life depends on it! And now it does!' Hideyoshi's hands go to his sword.

At that moment, one of the guests, Hosokawa Yusai, steps forward. Quietly he says, 'My lord, may I present a poem to you?' Using layers of puns he improvises:

Tsutsui's bowl
Broke into five pieces.
The blame lies
With none but me[64]

The poem alludes to a classic story of a young couple from *Ise monogatari* (*Tales of Ise*). It refers to the wooden structure near the cylindrical well. The original is a poem sent from a young man to the woman he loves.

My height that we measured
at the well curb
has, it seems, passed
the old mark
since last I saw you[65]

Hideyoshi, a great tactician, understands Yusai's intention to not only diffuse Hideyoshi's temper, but also to give him the opportunity to display his education in front of the noble samurai. Hideyoshi releases his hand from his sword. 'I like it, Yusai! I like it!'

The page's life is spared.

...and the broken teabowl is also saved. The precious fragments are put back together and *Tsutsuizutsu* exists today, having survived the vicissitudes of time and Hideyoshi's temper.

Figure 64, left: Tsutsuizutsu, Ō-Ido teabowl, Korea c. 1400–1600. 15.5 cm diameter. Important Cultural Property. Owned by Sen no Rikyū and Toyotomi Hideyoshi. Photo courtesy of Ishikawa Prefecture Educational Committee.

Figure 65, right: Sumiyoshi Jokei 住吉如慶 (1599–1670), Tsutsuizutsu 筒井筒 (By the Well Wall), a famous story from the Heian poem collection Ise-monogatari 伊勢物語 (Tales of Ise), c. 1662–1670. Painted silk. This shows a boy and girl standing by a well near a front gate. 19.6 x 17.3 cm. Photo © The Trustees of the British Museum.

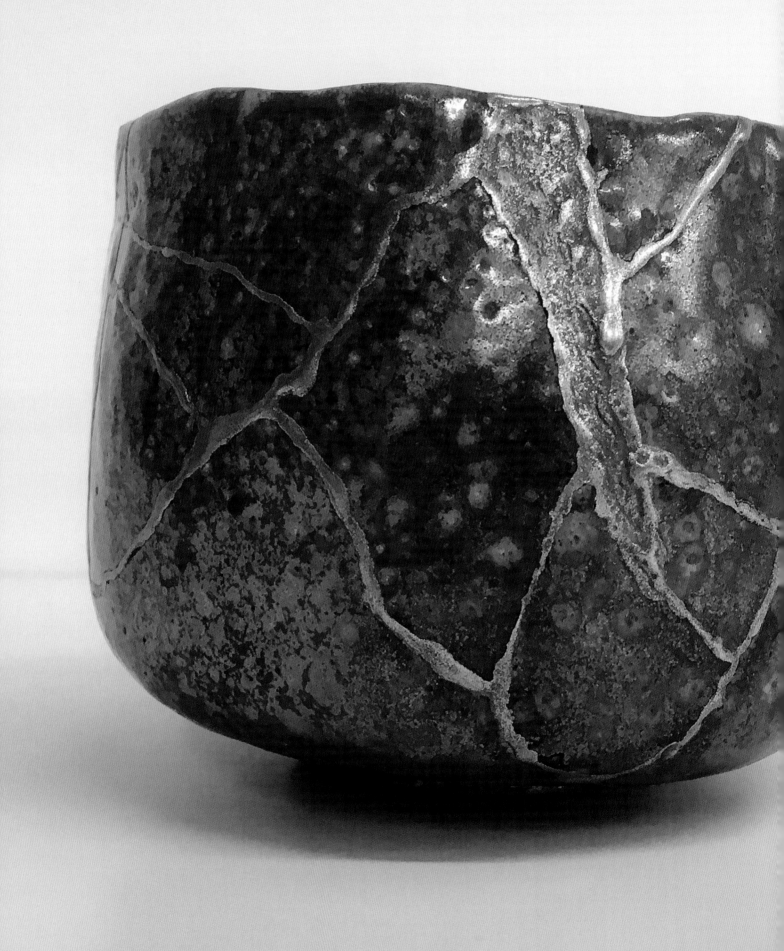

YON
FOUR

MATERIALS AND TECHNIQUES

A broken bowl. A dab of lacquer. A sprinkling of gold dust.

It seems so easy. Yet, kintsugi is a fine craft, and like any other, it requires years to gain both the explicit and tacit knowledge needed to become a master. Kintsugi is not a ceramic, but a lacquer technique. It encompasses skills that come from the art of maki-e, or 'sprinkled picture' lacquer work. Without maki-e, there would be no kintsugi, whether it is used to repair ceramics, lacquerware, glass or other materials.

We've all seen lacquerware: beautiful boxes with Japanese designs, or trays and plates with their deep, lustrous surfaces. For me, it will always be the black lacquer jewellery box my mother was given when we lived in Okinawa, where I was born. A picture of green bamboo adorned the top and ran down the front, contrasting the smooth, glossy black of the lacquer. It had a divided drawer at the bottom, in which my mother kept her earrings and rings. The lid lifted off the top, revealing a large space where she kept her necklaces and bracelets. For a young girl, it was the ultimate magical treasure box. It wasn't until I was an adult that I learned what made that glowing black surface what it is.

Figure 66: Mark Tyson, Teabowl, 2015. Hand-pinched from hand-dug stoneware clay, gas-fired to 1300°C in a salt kiln. A shelf support collapsed during the firing, so when the door was opened, the bowl fell out of the kiln onto the concrete and broke into many pieces. Urushi and 24-carat gold repairs with silver powder by Catherine Nicolas 2016–2017. 8 x 10.5 cm. Photo by Catherine Nicolas. Collection of Mark Tyson.

ABOUT *URUSHI*

Since its base material comes from a living tree, *urushi* (Japanese lacquer) is a rather magical material. Speaking to those who work with it, I've been struck with how the material is treated almost as if it is alive, as if it has a mind of its own. It will do this or that in autumn but not in spring... it will dry in this room but not in that. Although it is usually referred to as 'drying', it is more accurate to refer to the change in *urushi* as 'curing'. In fact, *urushi* needs moisture to become the high polymer that makes it so distinctive, and that curing must be

controlled. Curing a finished piece quickly, for instance, produces a darker colour. When fully cured, *urushi* is resistant to acid, alkali and alcohol, but it can continue to change. When exposed to ultraviolet light, such as sunlight, lacquer will 'burn', causing it to lighten as its polymers are destroyed.

The active ingredient in *urushi* is the oil urushiol, a gluey substance that is tapped from the tree *Toxicodendron vernicifluum*. The trees, which grow to be about twenty metres tall, are usually about fifteen years old before the sap is drawn. The tapping, or *urushi-kaki*, is done by professionals (*urushi-kaki-san*) who make horizontal cuts in the tree trunk, then collect the white sap as it seeps out. Not surprisingly, there is skill involved in even this step. The Echizen Lacquerware Cooperative lists the taps for *futabara-kaki* (cutting two sides of the tree) as *medate* (a preparatory cut); *hen-kaki* (one side cutting and collecting), which consists of *hatsu-urushi* (cut in June), *sakari-urushi* (cut in August) and *oso-urushi* (cut in September); and *urame-kaki* (back-side cutting and collecting in October); and *tome-kaki* (cut in November).[66] According to this professional body, the August cut is considered to produce the best *urushi* quality. The *maki-e* artist Mitamura Arisumi classifies variations in *urushi* caused by the time of harvest as: 1) adolescent: from mid-June to early July, which is 'filled with moisture and firm'; 2) mature: from mid-July to early September, which 'contains much urushiol' and is of 'particularly high quality'; and 3) aged: late September, which he lists as having a 'fine quality'.[67]

The *urushi* tree, or trees from the same family, grow in East Asia, but the qualities and types of *urushi* differ from country to country, and as it is an organic material, the specific geographical settings of the trees impact the final product. For example, *urushi* from Vietnam has a different active ingredient. Lighter in colour than

Japanese *urushi*, which is reddish, it is often used for making coloured *urushi*. It is also thinner, so it's good for stiffening the papers used for making kimono patterns and stencils. The percentage of moisture in a particular batch of *urushi* can affect its colour too. Thirty per cent moisture makes it more opaque. With less water it becomes darker. Good *urushi* has no smell; low-quality *urushi* has an odour even when it is dry. *Urushi* can be kept for years as long as it isn't in contact with air. High-quality *urushi* is the best for long-term storage.

A VISIT TO SATO KIYOMATSU SHOTEN COMPANY

After collection, the *urushi* sap is refined through filtering, heating and homogenization. Hiroko and I visited Sato Kiyomatsu Shoten Company in Kyoto to see the process. Sato Takahiko is a quiet man, brimming with knowledge. With a background in science he is now running the family *urushi* business. He has spent the past fifteen to twenty years making improvements to *urushi* through research, leading to an expansion of its applicability. The company buys raw *urushi* and processes it, then supplies it to different industries, large and small. They provide the *urushi* used in making the gorgeous ornate Kyoto kimono called *nishijin*, as well as the gold and silver threads used in decorating the famous shrines that are carried through the streets during festivals. They continue to supply *urushi* for these crafts, but Sato has gone on to produce specific *urushi* for more contemporary uses, such as for the fashion and construction industries, as well as various modern *urushi* that use industrially produced chemicals as the active ingredients. They also supply the new less-allergenic version of the traditional material.

Because of the use of new pigments, some of which, like *urushi*, are suitable for food use, over one hundred colours of *urushi* are now available. Sato showed us

Figure 67, left: Trunk of Toxicodendron vernicifluum *(Japanese lacquer tree), showing the scoring where cuts were made to draw the sap, which is made into* urushi *(lacquer). Photo by the author.*

Figure 68, above: Toxicodendron vernicifluum, *Japanese lacquer tree, the sap of which is used to produce* urushi. *Photo by Masayuki/Shutterstock.com.*

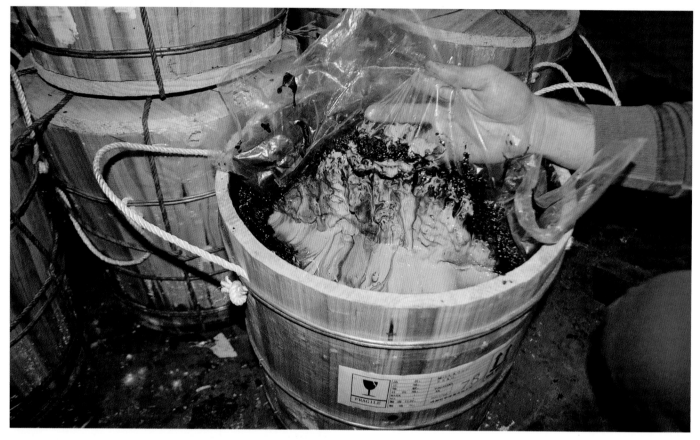

Figure 69, above: Urushi at Sato Kiyomatsu Shoten Company in Kyoto. *Photo by the author.*

Figure 70, right: Sato Takahiko demonstrating the viscosity of urushi. *Photo by the author.*

examples of how their *urushi* has been used in various products. Traditional chopsticks (*hashi*) and finely crafted hair ornaments were not a surprise, but the high heels of shoes designed for the catwalk? Or a beautifully crafted set of wrenches with elaborate *maki-e* ornamentation?

Sato takes us down to the womb of the building, where the *urushi* is processed. When the doors open on the small elevator, you immediately know you are in a different space. The basement is dark and cool, marked by a distinct shift in the feel of the air. There are layers of unusual smells here; some must be the *urushi* itself,

but there are overlays of the odours of aged wood and long history. Huge vats and old machinery sit darkly in the space, with stacks of wooden tubs filled with saps at different stages and of different origins in between the hulking presences.

Sato first shows us tubs filled with *urushi* covered by sheets of clear plastic. He lifts the film on one. What appears to be a dark resin-like liquid turns out to be only a skin, with the *urushi* underneath milky in appearance and consistency. He stirs the liquid, then lifts his spatula, and the creamy *urushi* drips off the tool in a smooth, viscid stream. He then shows us a huge

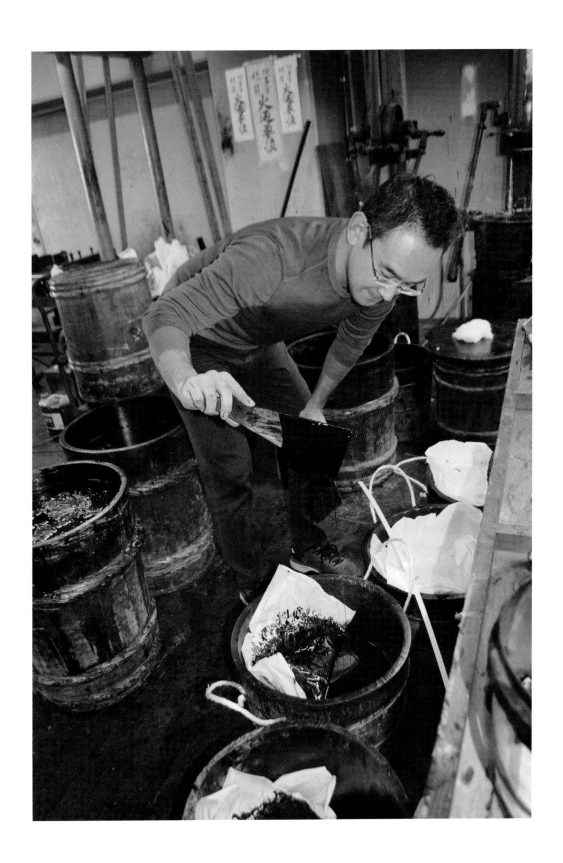

vat, explaining how *urushi* in its rawest state (*arami-urushi*) is heated in a double-boiler system to 70°C to make it runny. Then cotton wadding is added bit by bit until it forms a large lump, rather like dough. The ball is then put into a centrifugal separator, which produces the *ki-urushi*. This is then heated and stirred with an adjustable paddle, making the water particles smaller and reducing the water content. The finer the particles, the shinier the *urushi* will be. A higher paddle leaves the particles larger, creating matte *urushi*. You can make matte *urushi* glossy by polishing, but you cannot make glossy *urushi* matte. The *urushi* liquid is heated for evaporation, making it a clearer, amber colour. Black *urushi* is made by adding iron ions, which cause the *urushi* to react and become black. For other colours, pigments are added.

USING *URUSHI*

For use in the *urushi* arts, the processed *urushi* is applied by brush to a base object, most often wood, but of course *urushi* is also used in kintsugi. Most kintsugi does not need the broad spectrum of *urushi* types that are used in *maki-e*. Nonetheless, kintsugi *urushi* too has specific variations. There are four basic functions of *urushi* in kintsugi: 1) to glue the broken pieces together; 2) as a filler in cracks and in missing areas; 3) a layer to which the gold is applied; and 4) a layer on top of the gold. This can involve either three or four different *urushi* preparations.

To cure, *urushi* must be kept in 75–85 per cent humidity (some say higher) with a constant temperature of 25–30°C, sometimes for a long time, and usually for each layer applied, which is one reason kintsugi repairs often take months. *Urushi* needs moisture for the urushiol to become a high polymer. The moisture leaves the material once it is cured.

A few days after our visit to Mr Sato, I am sitting in the showroom of a traditional *makie-shi*. A young man with plenty of positive and sparkling ambition, Shimode Muneaki no longer does much *maki-e* himself, but he is still very much a part of his *urushi* heritage. As we talk, Shimode's father works in the studio area behind us. Shimode expresses both a realism about the fading fortunes of *makie-shi* and pride in its traditions, for which he repeatedly expresses a deep respect. He is one of those who speak of *urushi* as a living material. He explains that Japan has a culture of seasonality, so it is not surprising that not only is there seasonality in harvesting *urushi*, the time of year also affects its use and curing. Lacquer follows its own calendar. For example, Shimode says that May, known as *kinomedoki*, or season of baby leaves, is not a good month for creating *maki-e*. In his words, '*Urushi* simply will not dry in May.'[68]

THE PROCESS

A kintsugi repair is a complicated process requiring much skill for each of its many steps. Each repair is individual, based on the pot, the break and the repairer. Time is needed between the steps for the *urushi* to cure. Although it is impossible to show all of the procedure here, below is a simplified explanation of the basic stages of one repair, as explained and photographed by Sato Takahiko. It aims to serve not as instruction, but as illustration.

First, however, we must consider the health issues of using *urushi*. The name of the *urushi* tree, *Toxicodendron vernicifluum*, derives from the Latin and Greek for 'poison tree', and as it suggests, the sap can be a problem, as urushiol is the same substance found in poison ivy, oak and sumac. Although a few people I spoke to have no allergy to *urushi*, the majority of people can develop

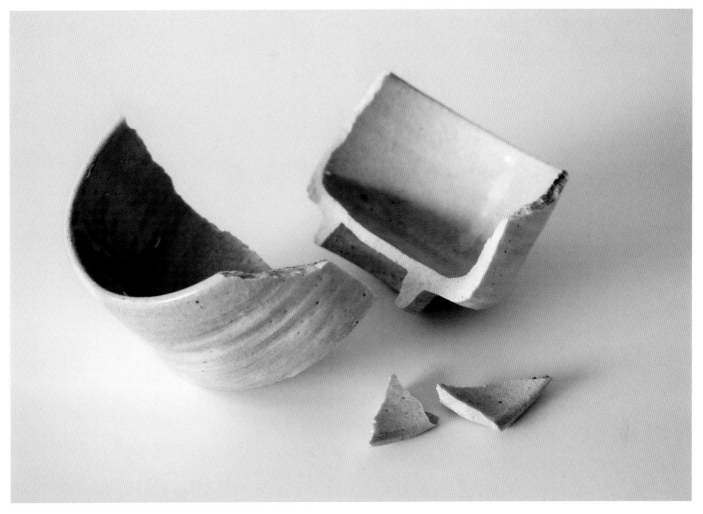

Figure 71: *A broken pot ready for a kintsugi repair.*

allergic reactions, sometimes severe with seriously unpleasant itchy weeping rashes and swellings, even if they are careful about skin protection. Some say it takes ten years for your body to stop reacting, although that figure sounds rather arbitrary. One kintsugi artist in Britain ends a slideshow of his experience of learning kintsugi in Kyoto with a photo of his face during his training. A fit and lean man, in the photo his face is hugely bloated, his eyes barely able to open. Someone else I met was hospitalised twice in the first year of setting up her kintsugi practice. Others I know have been put on steroids to calm the rash. This health risk has been one factor in the popularity of a new formula of *urushi*, which is less allergenic, and also in the use of other materials, such as epoxies and resins. Once cured, *urushi* ceases

to be a problem, and becomes non-toxic and safe to use. It should be cleaned by dusting first, then when necessary, wiped with a soft barely damp cloth, then dried. Do not immerse *urushi* wares.

If you decide to work with *urushi*, please take care. Make sure you wear gloves and long sleeves. Many people also wear face masks. The person in these photos is one of those individuals who does not develop a rash, which is why he is working with exposed skin.

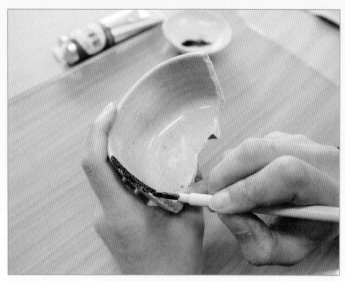

1-*Paint urushi on the edges of the cracks.*

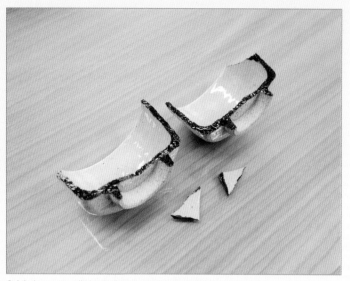

2-*Make sure all the edges are covered.*

3-*Mix urushi glue using starch glue and ki-urushi to make either nori-urushi, used for lighter applications, or mugi-urushi for ceramics and other things that require more strength.*

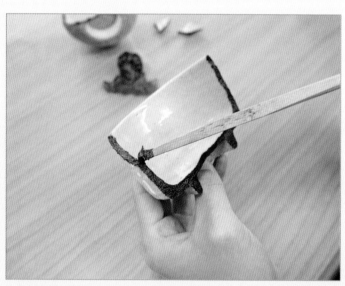

4-*Add more flour to the mixture to make it stickier. Put mugi-urushi on the edge of the cracks using a bamboo spatula (as shown).*

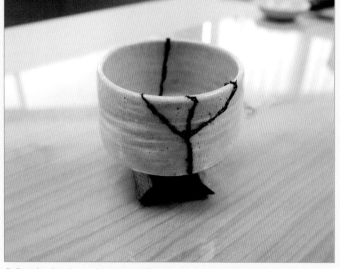

5-*Put the broken pieces together.*

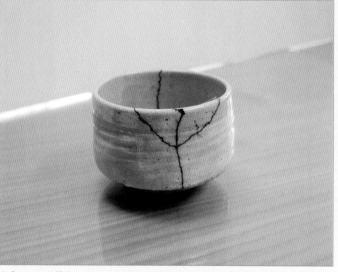

6-*Scrape off the excess mugi-urushi and fix with adhesive tape or rubber bands to keep the pieces together and flush.*

Figure 72: *Sequence showing the steps of a kintsugi repair.*

7-Make filler from starch glue, ki-urushi and fine sawdust.

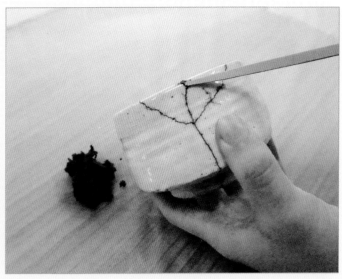

8-Apply filler to the gaps using a bamboo spatula.

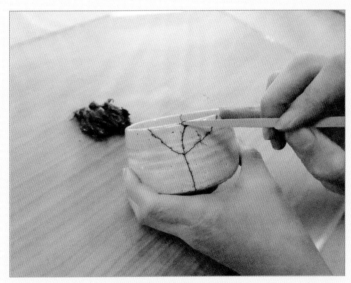

9-Make sabi (fine filler) from ki-urushi, tonoko (clay dust) and water. The largest part of the gaps are now filled. Apply sabi to fill and smooth any remaining gaps (as shown).

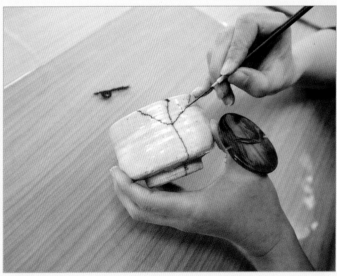

10-Allow the sabi to dry. Apply red urushi on top of the sabi to coat the joined areas and fill any indentations. After red urushi has dried, apply another coat if there are any irregularities (as shown).

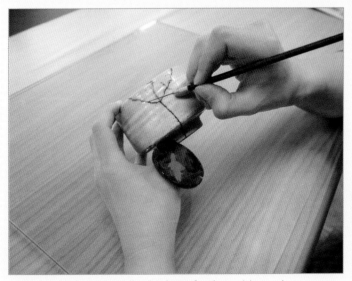

11-Apply urushi as an adhesive layer for the gold powder.

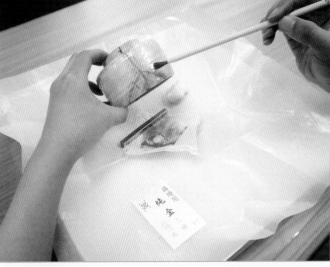

12-Sprinkle gold powder using a kebo brush onto the wet urushi.

13-Wipe off excess gold powder with silk wadding. Leave it so the urushi can dry.

14-Use isehaya-urushi (sealing urushi) thinned with turpentine over the gold.

15-Absorb the excess isehaya-urushi with washi paper. Leave it to dry for a week or more.

16-Polish the gold after it is completely dry, using abura-tonoko (a mixture of clay dust and rapeseed oil) on cotton wool.

17-Polish the gold areas again, using stone dust on your finger.

18-Give a final polish using a taiki, which is a tool made from a sea bream tooth.

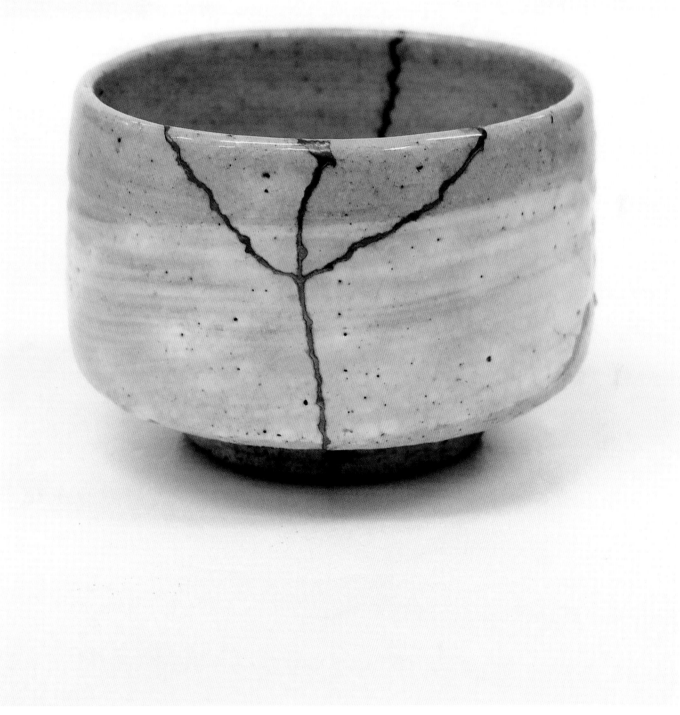

Figure 73: The same pot repaired with urushi and gold.

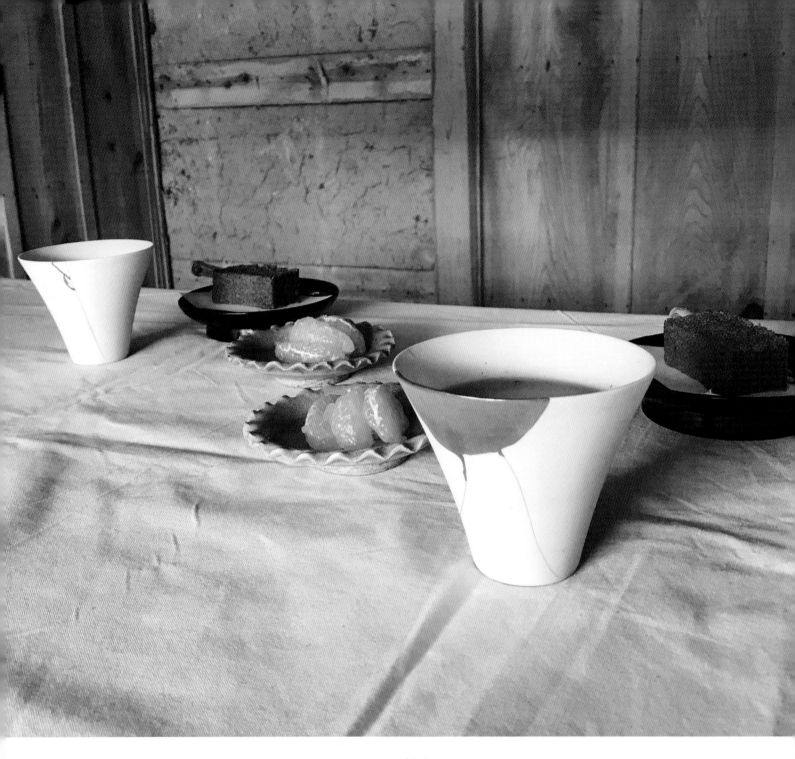

...AND
A COLLABORATION

Kuroda Yukiko is a kintsugi-shi _(kintsugi practitioner) and the author of a book on kintsugi in Japanese. Hamana Kazunori is a potter with an international reputation, who is known for his large 'natural' vessels._

It is February, and there is a hush of fir-green surrounding us as the car hugs the contours of the Japanese hills around Kuroda-san's house. The roads grow smaller and more serpentine as we near, until we are on a single lane. The taxi driver asks for the address again. He cannot find the house. We stop and peer, stop and peer, and finally, he stops and gets out of the car, meaning to look around, only to discover that the house sits just above us on the hillside.

With our focus on our careful footwork, we make the climb, barely noticing that the air is cool. But it is still winter, after all. Kuroda greets us in a small, bare clearing in front of the house. I get an immediate sense that she is someone I'd like to know. She is quiet but exudes a sense of knowing herself well, perhaps having achieved that by negotiating her way through life with care and contemplation.

Kuroda asks us to wait while she takes a moment to bring out some examples of her kintsugi. She shows us to a wooden garden room that is open to the valley below, and presently, she brings us tea and treats. There is *mikan*, a kind of satsuma, from a nearby tree, skinned and cut and set out on scallop-edged dishes, and moist cake on black lacquer plates. The tea is served in delicate, and delicately kintsugi-repaired, porcelain beakers that flare from a narrow base to a welcoming rim. This moment, sitting in the quiet, gives Hiroko and me a chance to leave Tokyo behind and slow down to Kuroda's time.

After a few minutes, Kuroda takes us back to the house, where she has set out a variety of repaired ceramics. A white oval porcelain plate is marked with strong black lacquer lines. Irregularly shaped small dishes are recreated from old Karatsu sherds, the joins in an emboldened gold. A series of three plates are patched mixing black and white and what looks like wood. [Figure 76] A platter catches my eye. The kintsugi repair seems to be finished in pewter, and on one side, Kuroda has carefully replaced some of the tiny broken pieces in two miniature loops of glaze pieces. [Figure 77]

Kuroda didn't start out as a kintsugi artist. She was first a graphic designer, and you can sense this in her strongly visual work. She came to kintsugi as a life event, following a decline in her health, which she attributes to an inner conflict between her worldview and her lifestyle. Looking to make herself better she decided that she needed to address one of the basics of living – what she was eating – and that led to a deep-seated interest in the plant life surrounding her. So food and

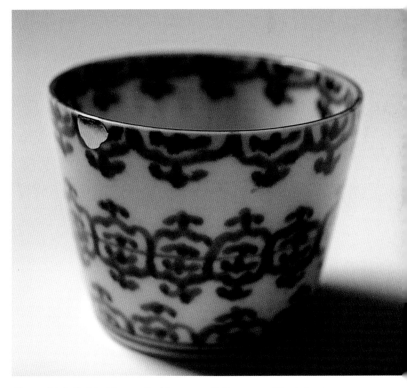

Figure 74, left: A light repast while we wait. Tea served in delicate porcelain cups repaired by Kuroda Yukiko. Photo by the author.
Figure 75, above: Kuroda Yukiko, Soba-choko (cup for dipping soba noodles), Japan, late Edo period. Ko-Imari porcelain with Sometsuke Yorakumon (design from India). Kintsugi repair by Kuroda Yukiko. 6 x 7 cm. Photo by the artist.

Figure 76: *Three oval plates repaired by Kuroda Yukiko. Photo by the author.*

Figure 77: *Detail of the intricate repair of a white plate. Photo by the author.*

careful, considered eating took on a principal role in her recovery. When her favourite bowl broke, she didn't hesitate to have it kintsugi repaired, the most natural and traditional repair available.

As usual, it took a long time for the repair to be completed, and this piqued her interest. What was going on in this technique that would require this length of time? The more she thought about kintsugi, the more engaged she became with the concept behind it, until she decided to study it and apprenticed herself to a *maki-e* master. There she learned the traditional techniques of using red, black and white *urushi* with gold, silver and pewter.

'Learning to put a pot back together helped me to put myself back together.'

It could be said that since becoming a kintsugi practitioner, Kuroda has lived the principles of kintsugi. Most importantly, she abhors waste, and lives a life of reusing, recycling and upcycling. Like putting together the pieces of a broken pot, she seems to quietly consider life step by step, but not in an overly calculated or self-indulged way. She seems to comfortably fit into 'slow living'. Her house is clean and neat, but naturally and charmingly a little shabby. The tatami is worn. The painted screens have tiny tears here and there. And the cold from outside feels just the

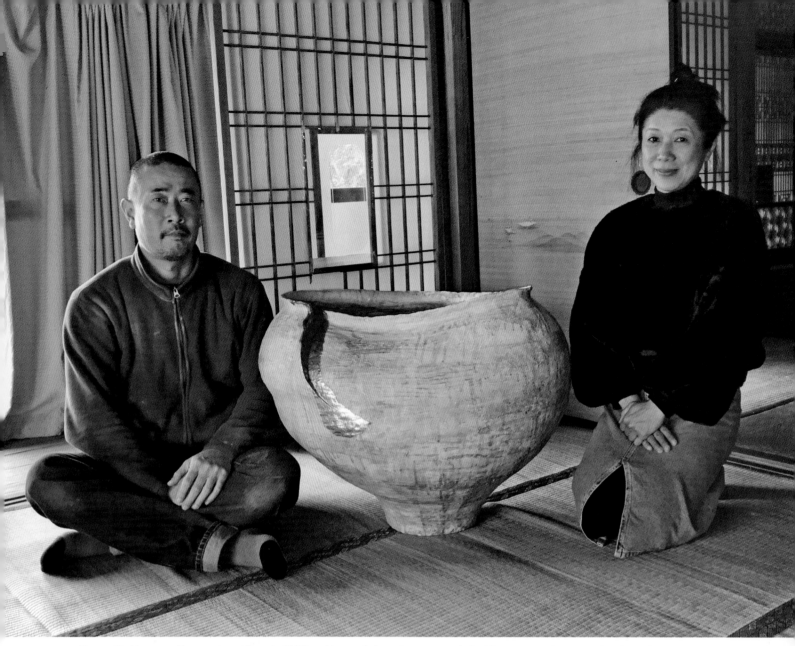

Figure 78: *Hamana Kazunori and Kuroda Yukiko with a collaborative pot made by Hamana and 'repaired' by Kuroda. Photo by Hiroko Roberts-Taira.*

same inside. But the wood draws your attention, with its warm, natural colours, with imperfect grain and knots. Then it's the light; it works its way through the *shoji* and into the rooms. I've come to associate this soft diffused light with Japan. My eyes grow used to the lower light levels as we sit and talk.

Although she is trained in kintsugi, Kuroda will use whatever she feels will best suit a pot, accepting that in some cases a repair may not be the answer.

'Each piece is individual. For a doctor, if there are one hundred patients, there are one hundred ways of treating them. It is the same with kintsugi.' This suits Hamana Kazunori, who has come to her with a series of *tsubo*, or large jars, that have broken in the kiln. Hamana is known for how he uses the natural world in his work. First, his clays and other materials are locally sourced, and with some pots, once they are finished, he leaves them outside to 'age' before exhibiting them.

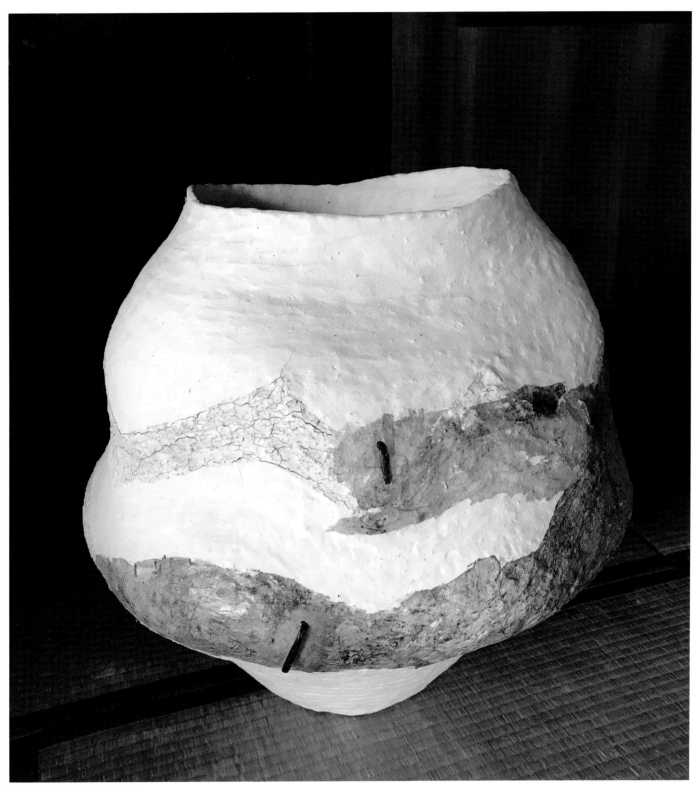

Figure 79: *Hamana Kazunori, tsubo (large jar), 2019. Repairs using metal rivets and washi (Japanese paper) with urushi by Kuroda Yukiko. Photo by the author.*

Figure 80: *Kuroda Yukiko, Bonnie Kemske and Hamana Kazunori pose for the requisite photo of the visit.*

Seeing these particular Hamana pieces in her home you sense that Kuroda has carefully contemplated each one before deciding how to approach the repairs. For some, she simply accentuates the breaks and cracks with *urushi* and silver. [Figure 78] For others, she uses the ancient Chinese technique of riveting, creating huge metal staples to hold the cracks together. On one, she has cut off the rivets' pointed ends, which protrude into the pot, but on another the spikes remain, creating a threatening interior to what is a softly-sculpted pot on the outside.

Hamana-san drops by for a visit while we are there. He is confident, busy, a contrast to Kuroda's soft and slow approach. Unlike many potters I have met who want tight control of how the kintsugi repairs are done, Hamana seems appreciative and accepting of Kuroda's creative conceptual approach. As artists working together, they seem to complement each other, sharing an underlying philosophy but with differing attitudes to work.

My favourite of this series is an oddly-shaped *tsubo* with two bulges, the hip a bit wider than the shoulder. [Figure 79] I sit on the tatami next to it so I can see the detail. Reaching forward I run my hands across the surface. Despite its scale this large pot appears delicate and fragile. Kuroda's repair emphasizes this. The *tsubo* is white, with a slightly rough, finger-textured surface. Around it run undulating bands of dark under white slip, which has cracked and fissured. Kuroda has chosen to repair the large cracks with bold rivets, but she has also added a second layer to the decorative banding using *washi*, traditional Japanese paper, and *urushi*. The ecru to brown paper and *urushi* band accentuates the pot's shape, and having it run around the hip visually lifts the pot even higher on its narrow base.

If I were pressed to find two terms to describe the well-spring of Kuroda Yukiko's kintsugi work, I think they would be beauty and emotion. Each repair she has undertaken exudes the beauty that comes from working within a consciousness of one's own feelings and life.

Figure 81: *Saying goodbye. Kuroda Yukiko and Hamana Kazunori outside Kuroda-san's house. Photo by the author.*

CRACKS, BREAKS AND RECONSTRUCTIONS: KINTSUGI IN CONTEMPORARY USE

As soon as the practice of kintsugi began to take hold outside Japan, artists started to experiment with the technique, the materials and the concept. This chapter touches on those explorations. Breakage and restoration have been incorporated into performative events. New adhesives and components have been used to create works that speak to the contemporary world. And by building on the expansive metaphor of kintsugi, artists are creating works that evoke strong visceral reactions.

Figure 82: *Doris Salcedo, Shibboleth, 2007. In The Tate Modern, London, Salcedo created a crack in the concrete of the Turbine Hall, which ran the 167-metre length of the hall. Photo by Peter Macdiarmid/Getty Images.*

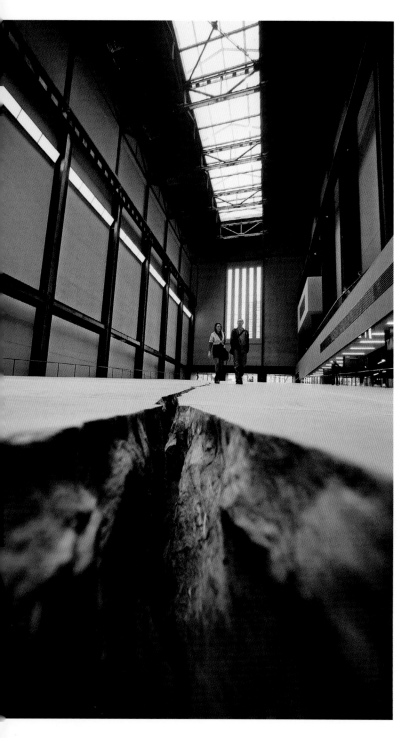

Figure 83: Doris Salcedo, Shibboleth *(detail). See Figure 82. Photo by Peter Macdiarmid/Getty Images.*

A BREAK IN TRADITION

Before there is kintsugi, there is breakage. The very frangibility of ceramics means that over the years many artists have chosen breakage as an act of artistic performativity, from Yoko Ono's various events, including breaking a large vase in *Promise Piece* (1966) and distributing the pieces to the audience with the promise that they would meet in ten years to reassemble the pot, to Ai Weiwei's *Dropping a Han Dynasty Urn* (1995), to David Cushway's performance piece *Plate Spinner* (2011), in which he spun plates on poles in the style of a circus performer until they all fell and broke. Both Ono's and Ai's pieces challenged cultural value systems by destroying 'precious' historical ceramics. Cushway destroyed specially commissioned plates that were decorated with transfers left in the abandoned Spode china factory buildings in Stoke-on-Trent, referencing the history and decline of the ceramics industry in the UK.

Looking away from ceramics we see that the themes of kintsugi, breakage and reassembly often appear in other areas of art. The British environmental artist Andy Goldsworthy, for instance, has repeatedly used cracks and fissures, breaks and disassembly. Goldsworthy has given us many excellent examples of the creation of beauty through destruction, forging order out of damage, often resulting in formal archetypal shapes and images. They appeal to our sense of rightness, the break made whole, and offer balance both figuratively and metaphorically.

Although the Colombian-born site-specific artist Doris Salcedo is not known for the repeated use of the break, her Tate Modern installation *Shibboleth* (2007) is a dramatic utilization of the crack. [Figures 82 & 83] A shibboleth is an object, characteristic, belief or

even a word belonging to an individual that identifies him or her as part of a specific group. Salcedo's use of the term invoked the immigrant crisis of our era. In this monumental installation, cracks ran the entire length of the Turbine Hall at the Tate Modern, London, representing catastrophe and serving as a constant but subtle reminder that there is a political issue in our lives for which we should be finding a solution. 'I wanted a piece that intrudes in the space, that it is unwelcome like an immigrant that just intrudes without permission, just gets in slowly and all of a sudden it's there and it's a fairly big presence.'[69] The artist goes on to state that it was important to her that even after this installation had its day, 'it will be sealed so a permanent scar will always be [in] the Turbine Hall as a memory...'.[70]

FIXED AND FUSED

A more recent performance piece of Yoko Ono's that touched on repair rather than destruction was in response to the 9/11 attack on the World Trade Center in New York. In *Mend Piece to the World* (originally 1966; various re-enactments) Ono invited participants to put together broken ceramic pieces, which had been gathered from around the world. In one incarnation of this public art event she left the instructions, 'Mend with wisdom, mend with love. It will mend the earth at the same time.'[71] By invoking breakage and re-assemblage, Ono aims to encourage healing – of individuals, peoples and the world.

Like Ono, the Korean conceptual artist Yee Sookyung works across many media, including video, performance art and site-specific works. She also brings together the complementary concepts of breakage and assembly in her series *Translated Vases*. [Figure 85] The materials for these works are sherds from reproductions of Joseon Dynasty (1392–1910) ceramics. The fragments come from

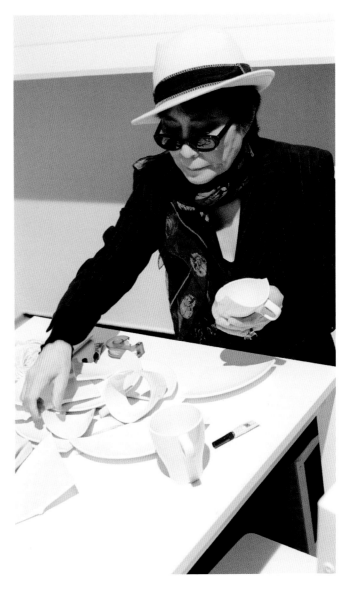

Figure 84: Yoko Ono attends the opening of her exhibition Fly at the Centre of Contemporary Art Warsaw, Poland, 2008, where attendees were asked to repair ceramics. Photo by WENN Rights Ltd/Alamy Stock Photo.

Figure 85: *Yee Sookyung, Translated Vase Nine Dragons in Wonderland, 57th Venice Biennale in the Korea pavilion, 2017. Ceramic sherds, epoxy, 24-carat gold leaf. Photo by bepsy/Shutterstock.com.*

vessels smashed and discarded by the potters because of imperfections. She assembles them into sculptures and sometimes larger installations using epoxy, which is then covered in gold leaf, playing on the similarity of the Korean word 'geum', which means both gold and crack. Unlike many others who use sherds to create new works, Yee's artwork does not reproduce or even echo the sherd's original forms, which is what takes it away from kintsugi. Yet, in an interview for Phaidon, Yee's comments echo the values of traditional kintsugi: 'I am attracted to failed, broken or ephemeral things. Things in a broken state provide me with a chance to intervene. It is not about fixing or mending, but about celebrating the vulnerability of the object and ultimately myself. This broken state allows me to explore new narratives which are not bound by hierarchy. The narrative gives rise to a real world, even more concrete than this existing world, built by art practice and filled with countless endeavors to reach sublime beauty.'[72] These magical works bubble and effervesce on a monumental scale. They seem to move and writhe with a concurrent sense of fragility and solidity, creating cohesion out of the chaos of destruction and abandonment. The gold serves as both decoration and a connecting mesh, marks them as precious treasures, and reminds us of the grand but troubled history of Korean ceramics.

The Dutch-born artist Bouke de Vries comes to his artwork through an unusual route. Following almost ten years of working in fashion, de Vries retrained in restoration. Using those skills he is now a well-established fine artist working in ceramics. In conjunction with his own work, he also continues to undertake kintsugi and other repairs for museums, dealers and leading ceramic artists. An example of this is Grayson Perry's *The Huhne Vase*. [Figure 86] In this piece Perry offers commentary on former politician Chris Huhne, who served time in prison for perverting the course of justice when he lied about asking his wife to say she had been driving his car when it was caught by a speed camera. This classically-shaped vase, which Perry smashed for de Vries to reconstruct, has repeating images of Huhne's face, along with his personalized car license plate, penises and other symbols.[73]

Many of de Vries' own pieces are one-off artworks created through reconstruction. Although the work can lure us in through its drama, it also can evoke a response on a very personal level. Sometimes it is contemplative and in the form of still-lifes, although 'still' is not necessarily a word one would associate with de Vries' work. *Deconstructed teapot with butterflies* (2017) is a frozen moment of an exploding Chinese porcelain teapot. [Figure 87] Of his *Memory Vessels*, de Vries says, '*Memory Vessels* are a series of works where I find broken containers (usually vases) and put them back together with tape to establish their original shape. I then have a scientific glass blower make an exact replica, after which I glue the fragments inside the glass replica. The glass replica becomes a "ghost" of the original piece and a kind of funerary urn of itself.'[74] Intriguing. [Figure 88] Using and referencing many different restoration techniques, de Vries pays homage to past cultural icons at the same time as undermining them. [Figure 89]

Bouke de Vries's work as a restorer, as opposed to his artistic interpretations of reconstruction, exemplifies the basis and traditional role of kintsugi. Raku Kichizaemon XV has periodically returned to the traditional use of kintsugi or gintsugi (silver repair), employing a *makie-shi* with whom he has worked for many years (see '... and *Nekowaride*'). However, he exploits the traditional techniques and materials in non-traditional ways. In February 2019 I was invited to Sagawa Art Museum for a personal tour of the *chashitsu*, or tearoom, which Raku designed. The Sagawa Art Museum is a contemporary

Figure 86: *Grayson Perry, The Huhne Vase, 2014. Glazed ceramic with kintsugi repair. 67 x 40 x 40 cm.* *The vase alludes to Chris Huhne being sent to gaol for perverting the course of justice.* *Photo by Stephen White. © Grayson Perry. Courtesy of the artist and Victoria Miro, London/Venice.*

Figure 87: *Bouke de Vries, Deconstructed teapot with butterflies, 2017. 18th-century Chinese porcelain* famille rose *teapot and mixed media. 30 x 30 x 38 cm. Photo by the artist.*

Figure 88: *Bouke de Vries, Marine memory vessels, 2016. 18th-century Chinese porcelain marine* *archaeology storage vessels. 19.5 x 27.2 cm. Photo by the artist.*

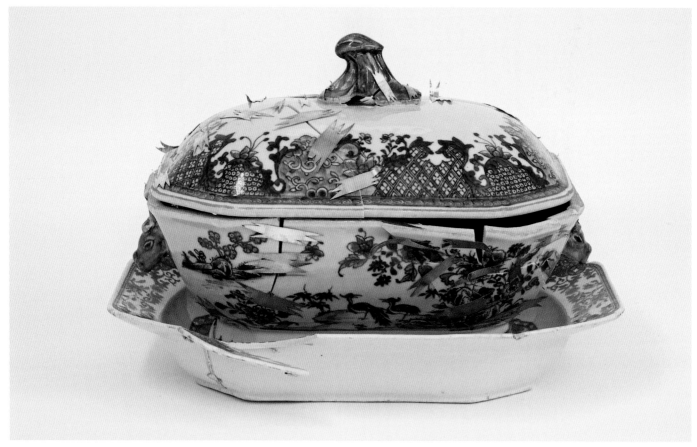

Figure 89: Bouke de Vries, The Repair 2, 2014. 18th-century Chinese porcelain tureen stand, tureen cover and mixed media. *This piece echoes the ancient Chinese technique of riveting. 36 x 27 x 25 cm. Photo by the artist.*

venue dedicated to just three artists who are felt to 'embody the spirit of Japanese art': the painter Hirayama Ikuo, the sculptor Sato Churyo and the ceramic artist Raku Kichizaemon XV.[75]

Looking out of the window of the train on my way here, I was dismayed to see that the drizzle had turned to rain, but as I walk towards the museum entrance now, past the wide expanses of water that are part of Sagawa Art Museum's contemporary architecture, I can't help but feel privileged to see the raindrops create a moving texture as they fall onto the water's flat surface. The sound is soft and even, the colours quiet, and the rain makes me feel more a part of the landscape – almost like it is holding me.

The exhibition *Kichizaemon X Wols* opens with a single teabowl by Raku. With theatrical lighting, it sits in a large glass case on its own. Raku is best known for his *yakinuki* teabowls, where he combines the dramatic use of dark and light, with powerful and sometimes

Figure 90: Raku Kichizaemon XV (Raku Jikinyū), untitled, 2018. *Yakinuki-type teabowl in white clay, 11 x 9-14.8 cm mouth diameter. Photo by Taguchi Yōko. Private Collection.*

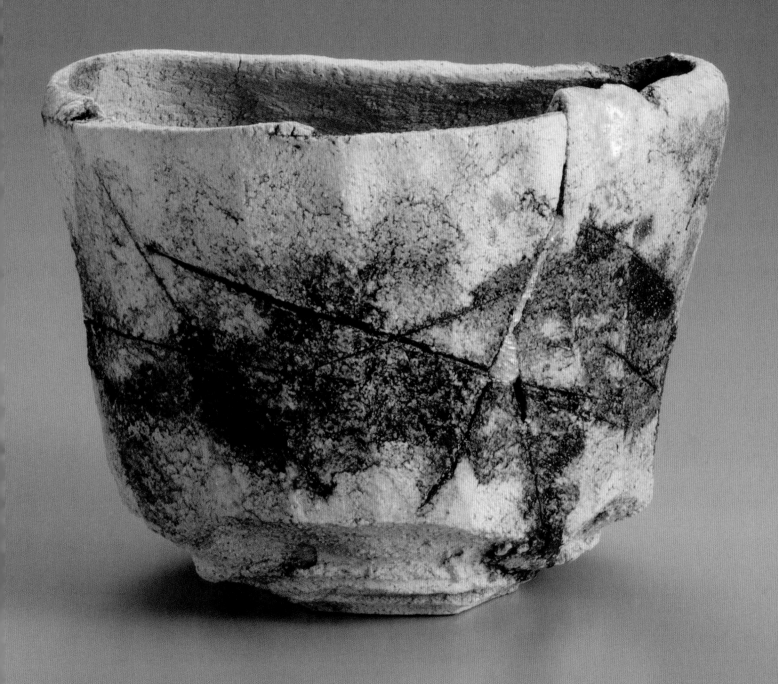

sombre and monumental results. In an overt response to the early twentieth-century Art Informel painter known as Wols, whose paintings and drawings served as the spark for this series of work by Raku, this first teabowl reflects Raku's spiritual connection to Wols. In white clay with vibrant blue glaze, lines of almost black, and a bold cut-away sculpted feel, this first bowl echoes Wols's drawings. Running down from a crack in the rim is a gold fill of kintsugi. Startling in its sparsity, it both accents the break and offers the solace of repair. [Figure 90]

Reiko Kaneko is a UK potter who has learned kintsugi skills. She offers a kintsugi service as part of her business

platform, but she also incorporates kintsugi into her own studio artwork. In *All That is Broken is not Lost* (2019) an overfired kiln produced two slumped plates in their setters (props used to keep the wares apart in a glaze firing). Instead of discarding them, Kaneko decided to leave them as they were and fill the cracks created by the firing with gold. This is a new take on the repair of *kamakizu*, or 'kiln wounds'. The two plates slide and drip with movement, creating visual confusion, animation and humour.

Like many potters, Suzuki Goro does *kan'i-kintsugi*, or 'easy' kintsugi, using glues and gold rather than *urushi*. He cuts and breaks and reassembles. Some of his pieces are large – of human proportions (see *...and a visit to Goro*). His most recent work appears at first

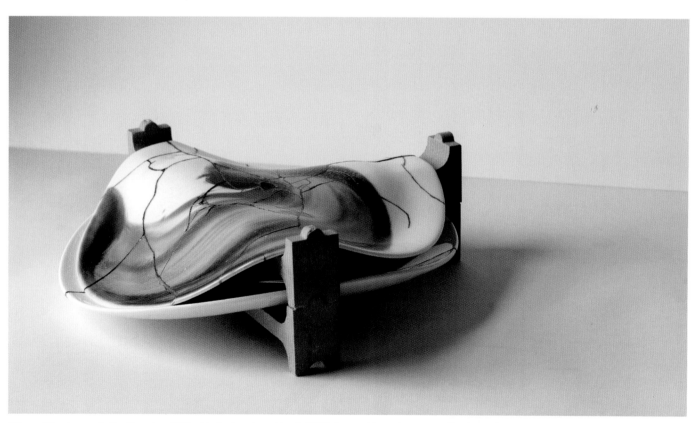

Figure 91, above: *Reiko Kaneko, All That is Broken is not Lost, 2019. Bone china plates overfired on plate setters, mended with gold powder and Kölner ceramic size. 10 x 30 cm. Photo by Chris Crawford.*

Figure 92, right: *Suzuki Goro, Chawan, Yobitsugi, 2009. 9.5 x 13.9 cm. A teabowl that nearly encountered an elbow. Photo by George Bouret. Courtesy of Lacoste/Keane Gallery.*

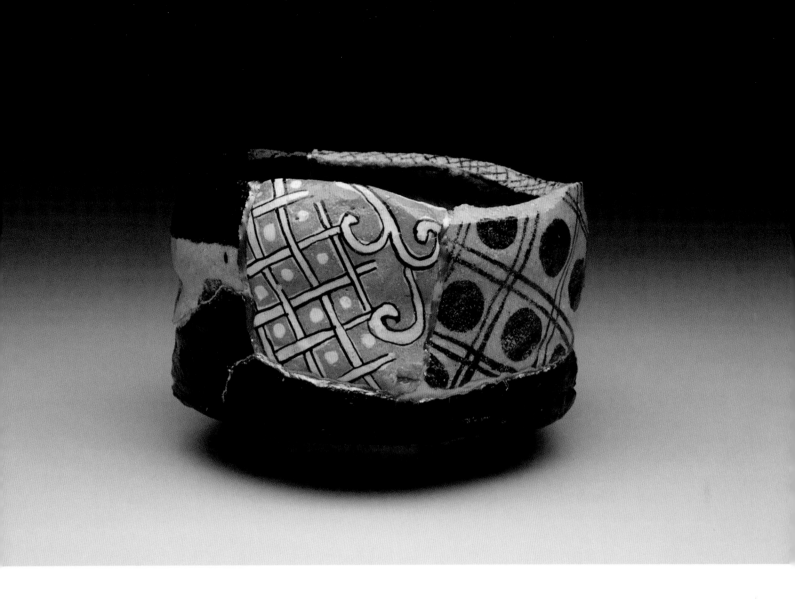

to be *yobitsugi*, but is instead carefully marked and decorated to appear so. This involves a new technique he has developed, which he calls *'goribe'*, which is Goro's cheerful nod to Oribe-style ceramics.

Having known about Suzuki Goro's work for many years, it was only in March 2018 that I actually saw it. I had agreed to give a talk at Lacoste Gallery in Concord, Massachusetts, following the publication of my book on teabowls. In the gallery, plinths with a wonderful collection of ceramic works stood around the space. My slides were projected onto a wall on one side of the gallery. Enough people had arrived to create an agreeably-sized audience, and they seemed engaged

– always a good sign. When I give a talk, I have a tendency to gesture. In honesty, I do more than that. I tend to walk around too. On this night the space was small, but I was still walking and gesturing. I was five minutes into the talk when I suddenly remembered what was behind me. I froze. 'Lucy [Lacoste], would you come move this teabowl for me please?' Behind me sat the most wonderful Suzuki Goro teabowl, an example of his *yobitsugi*-style. It sat on its own, with only its huge price tag for company. Goro pots justifiably fetch premium rates. Lucy quickly moved the beautiful bowl. I was sorry it was gone, but pleased it was now in her capable hands, rather than toppling to the floor at the

end of my elbow. That would have meant a very serious kintsugi repair to what is already a conceptual kintsugi piece.

As we've seen, one route into kintsugi is through ceramics. Like Suzuki, Tsurata Yoshihisa is a potter. It was on a cool and rainy day in February that I stopped at a tourist information centre in Arita, Kyushu, the historic town where porcelain was first discovered in Japan. When I said to the friendly woman at the desk that I was interested in kintsugi, she disappeared, then reappeared, saying she had arranged for me to visit Tsurata-san.

As often happens in Japan, even as an unexpected visitor, I was greeted with gracious warmth and generosity by Tsurata, his wife and their friend Tsuru Miyuri. Sitting in their front room with green tea and cakes, we talked about kintsugi and how popular it had become. Tsuruta is one of those now offering courses for visitors from abroad. He is a Karatsu potter with

Figure 93: *Tsuruta Yoshihisa, Shoki-imari shōchikubaimon chawan ('Three friends of winter: pine, plum and bamboo teabowl), 2018. Shoki-imari (Early Imari) sherds, joined with resin and decorated. 10.7 x 7 cm. Photo by the author.*

tremendous skills, but non-traditional materials are part of his portfolio as well. He uses resin-based kintsugi in a lot of his work. Tsuruta's technical acumen has given him great sensitivity and control of the material. He had a reconstructed teabowl in which he'd used resin. Holding it in my hands it was hard to tell that it wasn't all ceramic.

TELLING A STORY

Raewyn Harrison is a potter who delves deep into London's historical past – literally. She is a mudlarker, combing the shores of the River Thames at low tide to find treasures in the form of ceramic sherds from London's complex history. In 2019 she started incorporating eighteenth-century Delft sherds into new bowls, which is reminiscent of *yobitsugi*, or patched kintsugi. The bowls tell the story of the Delft workers who escaped Protestant persecution in Holland and made their name as potters on the Thames.

Paul Scott's ceramic work is also built on our ceramic past. For many years he has been working with blue and white transfer wares, overturning their original pastoral or bucolic themes through erasure, new prints and often the addition of *kan'i-kintsugi*. His themes focus our attention on war and conflict, the destruction of the countryside, environmental disaster and industrial decline. In *The Syria Series*, plates that we immediately recognize as everyday ceramic wares are disrupted by transfer print replacements of scenes of war-torn Syria and kintsugi repairs. In *Aleppo* (2016) the burnt-out shells of dwellings and a minaret stand amid a hill of rubble. In the background stand ghostly romantic classical remains. A fighter jet soars past. The scene is broken by a single gold line, a lightning strike that reminds us how quickly a city can be destroyed [Figure 96]. In *Palmyra* (2017) the gold kintsugi lines circle the

Figure 94: Raewyn Harrison, Mud Larking Tea Bowl, 2019. Thrown porcelain with Delft fragment insert found at the River Thames, and ceramic transfer print. 12 x 8 cm. Photo by the artist.

Figure 95: The shoreline of the River Thames at low tide, showing sherds from a dump of kiln waste from the Hermitage Pothouse (1663–1773). Photo by Michael Webber.

scene, drawing our attention to a 'technical', a converted pickup truck on the back of which is mounted a heavy machine gun. A man in a hood turns in the driver's seat to look at us. In the background again are ghostly images of classical architecture. In *Damascus* (2017), the scene is again framed with gold but a single additional line of gold bisects the picture, cutting through a pale building that is part of the background image, but leaving the devastation left by an attack in place. It is through the use of kintsugi, as well as re-imaging and repurposing these domestic plates and platters, which speak to the tropes of historical industrial ceramics, that Paul Scott has been able to create works that make such powerful statements.

Figure 96: Paul Scott, Scott's Cumbrian Blue(s), The Syria Series No:9, Aleppo, 2016. In-glaze decal collage and gold lustre on partially erased Aleppo pattern, Clementson, Young and Jameson plate, c. 1844. 23 cm diameter. Photo by Ollie Hammick.

Figure 97: Paul Scott, Scott's Cumbrian Blue(s), The Syria Series No:8, Damascus, 2017. In-glaze decal collage and gold lustre on partially erased, broken Edward and Enoch Wood, Damascus pattern plate, c. 1830, Kintsugi repair. 25 cm diameter. Photography by the artist.

Figure 98: Paul Scott, Scott's Cumbrian Blue(s), The Syria Series No:10, Palmyra, 2017. In-glaze decal collage and gold lustre on partially erased, cracked Palmyra bowl by Brownfield, c. 1870. 25 cm diameter. Photography by Ollie Hammick.

INTENTIONAL BREAKAGE

Although historically there have been those who deliberately broke ceramic pieces in order to repair them, such as the tea master Oribe (see Chapter three), many believe that this goes against the inherent ethos of kintsugi. As the ceramic gallerist and critic Robert Yellin said, 'Kintsugi is a process of love and caring for a broken piece, bringing it back to a useful life. Like each of us, a work has its own destiny and as such fate should unfold naturally, meaning don't break your arm on purpose or smash a work just to get the kintsugi effect.'[76]

This is certainly true in traditional kintsugi repairs. In the hundreds of kintsugi pots I have seen, those where the breaks have been undertaken intentionally often lack a sense of integrity.

Looking at its non-traditional use and placing it in a different context, kintsugi has been added to the artists' repertoire of techniques, and is being used on a conceptual as well as practical level. Paul Scott frequently fires the old plates he uses at the start of his interventions, and they sometimes crack or break at their stress points when heated. However, he will also at times employ the judicious whack of a hammer to break the piece. A ceramicist who deliberately breaks her works as part of the creative and conceptual process is Claudia Clare. Clare uses the violence of breakage to represent the violence that many women around the world endure. All of Clare's powerful artworks come out of her feminist stance and her driving need to tell these women's stories.

In 2004, at the age of sixteen, Atefeh Rajabi Sahaaleh was executed by hanging in Neka, Iran, after being found guilty of adultery and crimes against chastity. Atefeh had been repeatedly raped and abused for several years by a fifty-one-year-old married taxi driver, and it was those rapes that led to her arrest and conviction. In 2011 Clare set out to tell Atefeh's story through ceramics and ceremony. She built her piece *Remembering Atefeh* as a large, formal, gracefully shaped vessel. On the outside she painted images of lilies, roses and wildflowers with a blue clouded sky above. After it was fired the vessel was taken to a spot outside the Iranian Embassy in London. A group of Iranian refugees gathered at sunset to hear readings in English and Farsi, a minute's silence was held, then the vessel was smashed. Back at the studio Clare reconstructed the fragments, adding an image of

Figure 99, above: Claudia Clare, Remembering Atefeh (detail), 2011–2013. See Figure 100. Photo by Sylvian Deleu.

Figure 100, right: Claudia Clare, Remembering Atefeh, 2011–2013. Coiled then smashed; reassembled using cellulose nitrate glue and gold leaf. 75 x 35 cm. Photo by Sylvian Deleu.

Figure 101: *Miwa Ikemiya, Broken Stories: Plate, 2013. Ceramic, silicone, acrylic paint. Part of a project to elicit narratives from visitors. 20.3 x 3.8 cm. Photo by the artist.*

Atefeh and further decoration to the interior before its final firing, and leaving out some sherds so the internal imagery could be seen. Clare said, 'These girls do not set out to be political activists, they are not heroes of the revolution, nor are they saints or martyrs. They are ordinary, anonymous girls and women from villages, small towns and big cities alike, whose behaviour and whose very existence is criminalised.'[77] In talking about her choice of medium, Clare has said:

Why would anyone want to use clay pots to tell stories about surviving sexual violence? It's the 'surviving' bit that's important. Clay pots are long lasting. They invite contemplation. They are a primary source of evidence from archaeological sites. They can be shattered and pieced back together. These pots tell the forgotten stories, the ones left behind after the journalists and NGOs [Non-Governmental Organizations] have departed, the ones the editors ignored because they didn't fit the 'real rape' template. The perpetrators are known, they are not the strangers in the dark alley; the woman survives, lives on beyond the aftermath, into a slightly altered life. Or it might be dramatically altered. Or she may not have survived, or not into the long term.[78]

Clare continues to work with women's organizations, including exiting services for women wishing to leave prostitution, one of which offers a programme they call 'Kintsugi groups'.

NEW MATERIALS

It is natural that as new materials are developed and become available, those interested in kintsugi will explore how to use them. Miwa Ikemiya is a designer working out of San Francisco. In one project, *Broken Stories*, plain white plates and beakers were covered in silicon. Then visitors were invited to 'break' them, the silicon holding the pieces together as cracks formed, which were then filled with paint. Afterwards, they were asked to tell a story that the broken and repaired pieces evoked. This seemed to give them a focus for reflecting on events in their lives. In another short project in ceramics and new technology, done in conjunction with Tommy Dykes in Newcastle, UK, a finger running along a filled crack on a broken plate triggered photos on a small screen nearby, telling a story.

Guy Keulemans is a designer, artist and researcher. He has been using photoluminescent glues to reassemble broken pots. In *Archaeologic Vases, Series 3* (2015), during the day the brightly-coloured glues absorb energy, and in the dark they release it as glowing cracks, creating a dramatic and beguiling shift in our perception. [Figure 102 & 103] In *Archaeologic Vases, Series 5* (2019) brightly-coloured, formally-shaped pots show their repaired seams through traditional riveting in sterling silver, presenting us with a contemporary version of *yobitsugi*. [Figure 104]

The representational sculptor Paige Bradley has undertaken several projects that use light as fill for cracks, making the metaphor of kintsugi overt and unmistakable. *Expansion* (2005) is one such artwork. [Figure 105]

Rachel Sussman is a contemporary artist and photographer. Her artistic research interests are broad, and she is best known for her bestselling book *The Oldest Living Things in the World* (2014), which contains essays arising from her extensive travels and exploration of Earth's oldest mosses, trees and lichens, among

Figure 102: *Guy Keulemans, Archaeologic Vases (Series 3), (2015). Stoneware repaired with photoluminescent glue; wheel-thrown and fired to bisque by Kiyotaka Hashimoto. Shown in light. All 25 x 14 cm approx. Photo by Guy Keulemans.*

Figure 103: *Guy Keulemans, Archaeologic Vases (Series 3), 2015. Stoneware repaired with photoluminescent glue; wheel-thrown and fired to bisque by Kiyotaka Hashimoto. The same vessels shown in darkness. All 25 x 14 cm approx. Photo by Guy Keulemans.*

Figure 104: *Guy Keulemans, Archaeologic Vases (Series 5), 2019. Painted stoneware repaired with sterling silver rivets; wheel-thrown and fired to bisque by Kiyotaka Hashimoto. 26 x 19 cm approx. Photo by Kristoffer Paulsen.*

other things. 'I had spent 10 years looking at ancient organisms who have withstood the test of time. I was already connected to the aesthetic philosophy of *wabi-sabi* inherent in the work and the organisms themselves: quiet and imperfect, bearing the proud patinas and injuries of age, while flirting with the boundaries of permanence.'[79] It was this sensitivity that led her into a series of urban interventions called *Sidewalk Kintsukuroi* (2017). This was followed by filling in cracks in other human-produced architectural features, such as floors, paving and walls.

As a ceramicist I have always felt that there is a close connection between ceramics and textiles, perhaps because both require a certain sensual appreciation of materials. Zoë Hillyard creates works from broken pots using the principle of *yobitsugi*. She covers each ceramic sherd in fabric, then sews the pieces together to reconstruct the pot as something new. [Figure 108] She says, 'I am interested in the lifecycle of objects and in building value into the things we own. The ceramics I use have already lived a life... The silks are often ex-fashion.... The process of re-making brings a new chapter to the journeys of both elements and in a combined reincarnation they become one-off statements, possibly appreciated within gallery-style settings, but definitely starting out on a new chapter.'[80] [Figures 109 & 110]

There is no doubt that the 'style' and concept behind kintsugi is here to stay, and that its appeal means that we will continue to see the use of more kintsugi, or variations of it, in art and craft in the future.

Figure 105: *Paige Bradley,* Expansion, *2005. Bronze. Light serves as the kintsugi gold in this sculpture. 71.1 x 88.9 x 43.1 cm. Photo by Victor Lefar.*

Figure 106: *Rachel Sussman,* Study for Sidewalk Kintsukuroi #03 (MASS MoCA), *2015. Archival pigment print, enamel, metallic powder. Kintsugi moves beyond ceramics to the wider world. Photo courtesy of the artist.*

Figure 107: *Rachel Sussman,* Installation image for Sidewalk Kintsukuroi (Des Moines Art Center), *2017. Resin and 23-carat gold. Photograph by and courtesy of the artist.*

Figure 108: *Zoë Hillyard undertaking ceramic patchwork, 2016. Photo by Warren Malkin.*

Figure 109: *Zoë Hillyard,* Red Leaf Bloomfield Bowl *from the Kiln Cracked Series, 2017. This Linda Bloomfield piece was reworked with vintage rayon fabric and polyester thread. 18.5 x 11 cm. Photo by the artist.*

Figure 110: *Zoë Hillyard,* Katharina's Brown Bowl *from the Kiln Cracked Series, 2018. This pot by Katharina Klug was reworked in vintage silk and polyester thread, 13 x 27 cm. Photo by the artist.*

109

108

110

...AND
A VISIT TO GORO

In my search for kintsugi I have discovered many different approaches, understandings and meanings. Meeting the potter Suzuki Goro gave me the opportunity to see kintsugi as an outlet for a creative spirit.

I've driven in Japan before, on the roads and avenues that I knew while living in Kyoto, but this visit to see Suzuki Goro is the first time I've ventured on unknown highways. In the car beside me is a young Japanese woman named Sayaka, who has offered to come along to help with translation. We arrive in Nagoya from Kyoto by *shinkansen* (bullet train), using the journey to get to know each other a bit. I'm pleased to find she is excited by the day ahead, both at meeting Suzuki Goro and at the opportunity to learn about ceramics and kintsugi. I'm also glad to find that she is good with Google Maps!

'Turn... left... *hidari*... left... here!' Oops! Missed it. 'Next one... no. That one!' In our small rental car we finally find our way out of Nagoya and onto the back roads that surround it. An hour's drive and we are on a country lane, staring up a steep drive that might or might not be Suzuki's. Okay. Up we go!

Mayu-san, Suzuki's daughter, is the first to greet us. '*Hajimemashite. Yoroshiku onegaishimasu.*' I'm so pleased to use the one Japanese expression I've been told I pronounce well. The problem is that Mayu immediately thinks I understand more Japanese than I do. Sayaka sees us through the first confusion I've created.

Introductions completed, we are invited into the house. We step into a large room and feel like we're stepping into a ceramic wonderland. Sayaka and I walk, pause, walk, pause, eyes drawn first to full-sized colourful ceramic chairs, then to large brightly patterned vessels that stand next to them. Huge ceramic boxes, Suzuki's famous large *Stacks*, sit here and there. It takes a while to move forward but we ultimately end up at a large table. Suzuki and his wife Yoshiko stand to meet and greet us. And now I can see why people who know him call him by his given name, Goro; he is friendly and welcoming. Yoshiko goes out and returns with

Figure 111, left: *Suzuki Goro drinking coffee from one of his mugs. Photo by Suzuki Mayu.*

Figure 112: *Suzuki Goro, E Oribe Chair, c. 2000. Ceramic, E Oribe. Height 109 x 48 x 44 cm. Photo by Suzuki Mayu.*

coffee, and for the second time in just a few minutes I am thrilled by what I see. The mug the coffee is in is tall and thin, with an attached 'saucer' and a handle that connects them. It is all Goro, strangely shaped and decorated with Oribe green, iron brushwork and warm ochre. I must have a photo of this!

My lips fit well on the coffee mug, as does my hand in the handle. The base is almost roughly finished, making me feel it is substantial, yet not overly self-conscious. Mayu and Sayaka begin to talk, and I take the opportunity to look around. On the shelves behind Goro I see high-handled serving dishes, and smaller oddly shaped ones – plates and platters – mugs and jugs – and teabowls. Many teabowls. I have seen one

or two of Suzuki's teabowls before, but here I am immersed in an abundance of his work, in the number, the scale, the variety.

The conversation has edged a bit towards the absurd as it bounces and skids between Goro, me, Mayu and Sayaka, with everyone enjoying the misunderstandings that arise with my poor Japanese and Sayaka's lack of ceramic knowledge. Old catalogues appear, brought out to explain one technique or another that Goro has developed. Examples are taken down from shelves. He gives me a beautiful exhibition catalogue; I give him a copy of my book on teabowls. Then we exchange signatures. He signs his catalogue with inkstone and brush; I sign my book with a lowly felt-tipped pen.

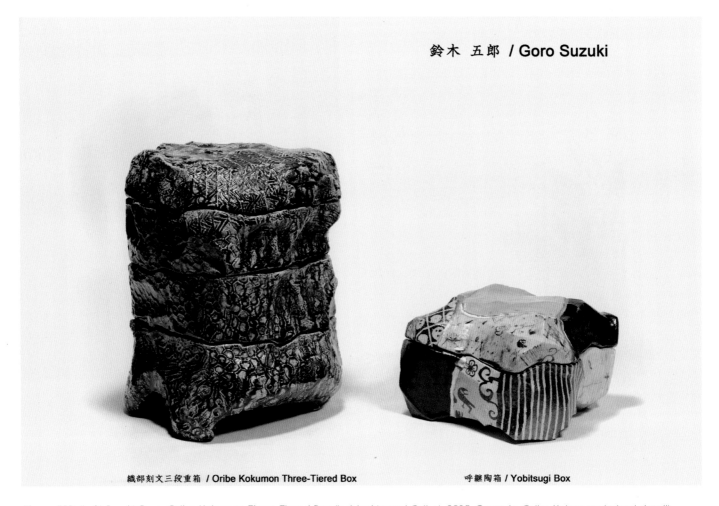

鈴木 五郎 / **Goro Suzuki**

織部刻文三段重箱 / **Oribe Kokumon Three-Tiered Box** 呼継陶箱 / **Yobitsugi Box**

Figure 113: (Left) Suzuki Goro, Oribe Kokumon Three-Tiered Box (inside: Narumi Oribe), 2015. Ceramic, Oribe Kokumon (raised detail). 41 x 32 cm / (Right) Yobitsugi Box, 2008. Ceramic, yobitsugi. 18.5 x 29 cm. Photo by Suzuki Mayu.

Goro asks Mayu to bring other teabowls to us. The first is a rounded bowl decorated with Goro's distinctive graphic designs and lined in bright yellow. 'Pick up. Pick up!' I do. It must be my expression that makes him smile. The teabowl looks thickly made and heavy, but in fact it is double-skinned and light as air. [Figure 116] Now Goro is lifting a teabowl that sits in front of him. It is carved from granite, and has a lightning slash of kintsugi running through a lightbulb image, one of his signature motifs. Goro loves to play.

'Why did you begin to use kintsugi?' I ask.

'I was making huge boxes for an exhibition. Many broke while they were drying. I didn't have enough time to make more, so I decided to use the pieces of the broken boxes, and I even cut up more. I thought of *yobitsugi* because the exhibition was at the Noh Theatre. Noh costumes are like *yobitsugi*. So I made ten pots in *yobitsugi* style. It was a success from a failure.

'After that, I started making things, then cutting them into pieces. Before I cut, I paint lines with *sumi* (black ink), making patterns of how to cut. From there it becomes a struggle. I think about the pattern and style to bring

to each piece – Oribe or Seto or Sometsuke perhaps. To think about the balance is difficult. I can only imagine it; I can't draw it. So when I have everything in my head, I start marking the pieces. When you cut the pieces, you can mark each piece with which way is up, to the right, etc with arrows and letters. Then I start decorating each piece. They are put together using modern kintsugi, a kind of glue. Then I put on *urushi* and gold powders. Sometimes I use black.

'The biggest *tsubo* is 1.8 or 1.9 metres (6 feet) tall. All of the big *tsubo* have paintings inside. I used a ladder to get in. Once, I was in there painting – and smoking,

Figure 114: Suzuki Goro signing a catalogue with brush and ink, 2019. Photo by Suzuki Mayu.

Figure 115: Bonnie Kemske displaying Suzuki Goro's signature, 2019.

the crate is one of his large *tsubo*. It stands taller than me! Behind it is another. Behind that, another.

The word 'creative' keeps coming into my mind. Goro is a Creative. That term is often used to label artists who have arrived at some wonderful destination and become masters of that specific style. But with Goro I instinctively feel there is something more. Inside this quiet and sometimes droll man I sense there is a driving and overwhelming need to create, to make things, combined with an unbridled imagination that leaps up and runs, long before it ever has time to register where it's going. And his use of kintsugi is an example of that.

smoking, smoking. But the smoke went up this way, then came down this way, and it got thicker and thicker. 'Okay,' I said, 'I can't smoke inside.' So I kept my cigarette outside, then I'd stand up and put my head out the top – puff, puff – then back down to work more, then stand up again – puff, puff, puff.

'I developed what I call *Goribe* after that work. It's a way of using both oxidised and reduced sections in the same piece. [Reduction is the restriction of oxygen in the firing; oxidation does not restrict oxygen in the firing. The different firings produce different results] I wanted to use certain colours together, some that only happen in reduction and some in oxidation. It should be impossible to fire them together, so I had to find a way. That's *Goribe*. The works look like *yobitsugi* but I build them in one.'

We are heading into the workrooms now, where there is work at different stages. Goro walks us through the studio spaces and into a darkish room beyond. I am standing with my toes almost touching an open boarded crate. It takes me a moment to realize that in

Figure 116, top left: Bonnie Kemske admiring a lightweight double-skinned teabowl with the artist, Suzuki Goro, 2019. Photo by Suzuki Mayu.
Figure 117, bottom right: A scene from the Noh play, Yashima, in which the ghost of Yoshitsune appears. Kyoto, Japan. The costuming shows a mix of colours and patterns, similar to yobitsugi. Photo by Yuki Sakai/Getty Images.
Figure 118, next page: Suzuki Goro, Yobitsugi Large Bowl, 2008. Ceramic, yobitsugi. 41 x 32 cm. Photo by Suzuki Mayu.

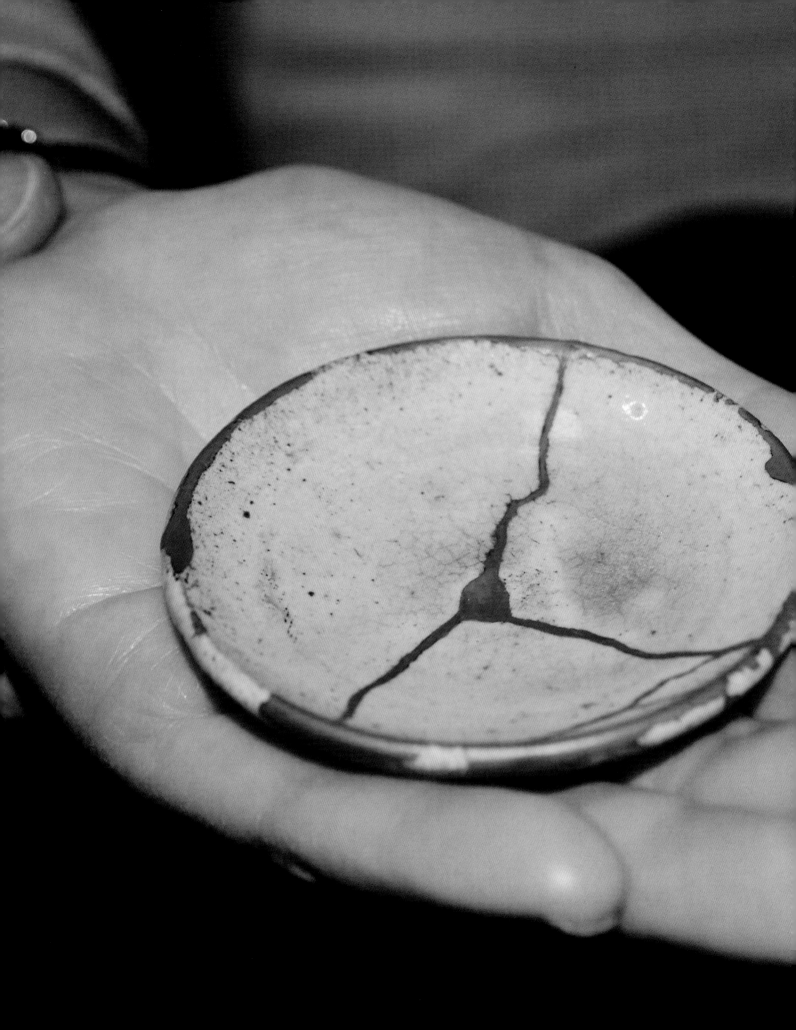

ROKU

SIX

A METAPHORIC WORLD

Loss and recovery, breakage and restoration, tragedy and the ability to overcome it. The amazing technique of kintsugi gives us an opportunity to incorporate this strong and historical metaphor into our lives. Although its use can result in strikingly beautiful ceramics, the real power of kintsugi lies in the metaphoric overlay that we, as the flawed humans we are, apply to it.

Kintsugi is a slow technique, taking many weeks to complete. This allows time for reflection, especially in an age when we have learned to appreciate the small instances in life that reinforce the positive.

A kintsugi repair speaks of individuality and uniqueness, fortitude and resilience, and renewal and re-invention in this difficult time of pandemic and the imperatives of global climate change.

Figure 119: Small late Edo period dish, Aburazara (oil tray). Kintsugi repair by Heki Mio using urushi, tonoko, kanbaiko and pure gold powder in 2018. This small dish shows kintsugi on an intimate scale. 6 x 1 cm. Photo by Nozawa Sayaka.

In a visit with Raku Kichizaemon XV and his wife Fujiko during a research trip to Japan, Hiroko Roberts-Taira and I asked if they felt the metaphor offered by kintsugi is important. In response they told us about their friend, a very successful businessman. Unfortunately, his business failed and he lost everything. When he visited, they served him tea in *Nekowaride*, the bowl I describe earlier in this book (see ...and *Nekowaride*). A year later the businessman wrote to thank them again, saying that he had been very unhappy when he had been with them, but as time went on he thought again and again about *Nekowaride*, the teabowl that had been broken and brought back to life, and it had inspired him to continue to work hard until he had overcome his setbacks.

A good metaphor shouldn't have to be explained, yet here I am, writing a chapter on it, if only to present how widely and deeply the metaphors that emanate from kintsugi extend. We will look at many metaphoric themes that play out in kintsugi, including: physical attributes; tragedy and pain; acceptance of imperfection; preciousness; healing, caring and rebirth; resilience and strength; hope; and connection. Kintsugi has been used extensively (some might even say promiscuously) in art, pop culture, literature, music, psychology and spiritual healing. It has also been used as a model for sustainability in our quest to heal our damaged planet.

A metaphor is a laying over of the qualities of one thing onto another. A visual metaphor can be direct and apparent. For instance, the kintsugi repair of a ceramic object may symbolize a landscape. Delicate channels of gold may suggest branches, a water cascade, a landscape scene or another aspect of nature. One of the best examples of this is the teabowl called *Seppō* (see Chapter three) by Hon'ami Kōetsu.

Metaphors can, however, be less direct. They can wrap us snugly within our own inner being, or they can expand to include universal values and concerns, representing the trials and successes that we all hold in common. A good metaphor is transformative; it makes a difference to how we think or feel. Milan Kundera wrote in *The Unbearable Lightness of Being*, 'Metaphors are dangerous. Metaphors are not to be trifled with.'[81] Metaphors are indeed powerful things. As James Geary says in *I is an Other*, 'Metaphor is a way of thought before it is a way with words.'[82] I would add that metaphors are about a way of feeling long before they are a way of thought or words. We can easily regulate what we say; it is harder to control what we feel. Metaphors create a direct inroad to these feelings.

THE LANGUAGE OF CRACKS AND BREAKS

Cracks and breaks of every sort are part of our everyday lives. They become part of our visual culture. Some carry metaphoric loading; others do not. Many are shared by a whole country, such as the traumatic cracks caused by earthquakes in Japan, or the oft-repeated filming of the destruction of the Twin Towers. Some express very specific meanings, such as the crack in the Liberty Bell, an iconic symbol of freedom used for both American independence from Britain in 1776 and the later abolitionist movements of the early nineteenth century.

Some metaphors about cracks and breakage inhabit a more personal space. In many cultures there is a superstition that a broken mirror brings bad luck. As a child in the USA stepping on the cracks of a sidewalk carried the threat of breaking my mother's back, although looking more deeply into this children's saying, it seems it might have an even more sinister origin. We live with broken hearts and broken dreams,

Figure 120: American Boy and Girl Scouts looking at the crack in the Liberty Bell, which represents American ideologies of freedom and independence. Photo by Lambert/Getty Images.

and often within broken families. We inevitably break a promise or two. Even after a personal sorrow, we try to pick up the pieces. And we repeatedly see people with difficult lives who fall between the cracks in our social care services. However, not all breaks are bad. We celebrate when someone breaks a world record. Breaking a glass ceiling is always a good thing. Taking a short break can help us at work or even in a relationship. And there's no more joyful feeling than when we crack up with laughter.

Sometimes a metaphor is general, such as how we view a damaged kettle within tea ceremony as signifying the transition from the verdancy of summer to the bleakness of winter, but sometimes the metaphor is more specific. Recently, because of many factors, including the rise of a Make Do And Mend culture, the appreciation of 'sloppy craft', a desire to support a sustainable environmental lifestyle, and a sensitivity to an aesthetic that privileges narrative, many people now cherish the old, the broken, the mended. The writer and ceramic artist Edmund de Waal was recently on *Only Artists* (BBC Radio 4), speaking with the writer Tracy Chevalier about a set of broken china he owns, some of which he has since had kintsugi-repaired.

> So these are broken Meissen pots from 1760. And they are extraordinary. This is a dinner service that was looted from the German Klemperer family... in 1939. The truck with this porcelain in it was going through Dresden in February 1945 when the bombing, the destruction of Dresden, happened. The whole of Dresden was destroyed, hundreds of thousands of people killed. And all of this porcelain was destroyed too. It was found in fragments. You can see the damage here, the fire damage. After the war it was found in the basement of the castle in Dresden. It was restituted to the Jewish family about ten years ago. It came up for auction and I bought all these broken plates. We use them at Christmas. We bring them out and use these broken plates with their extraordinary history.[83]

It is metaphor that gives this story its depth and meaning and power. Without metaphor, without narrative, these plates would just be broken plates.

NARRATIVE AND OVERCOMING THE VICISSITUDES OF LIFE

The breaking of an object as metaphor has always been a rich seam to mine. In many ancient cultures, including in Japan, India, Egypt and with the Mimbres of the American Southwest, broken pots were part of rituals surrounding death and burial. In Psalm 31.12, the writer chooses the shattered pot to describe his abject state before giving himself over to God: 'I am forgotten as a dead man out of mind: I am like a broken vessel.'[84]

A break, a crack – there is always a story. In *A Little Life* by Hanya Yanagihara, Harold writes to his adopted son, asking him not to apologize for breaking a precious mug that had belonged to his natural son, who had died: '[T]hings get broken, and sometimes they get repaired, and in most cases, you realize that no matter what gets damaged, life rearranges itself to compensate for your loss, sometimes wonderfully.'[85]

A scar is a kind of repair, and even a golden kintsugi repair is still a scar, one that is borne proudly. In Chris Cleave's *Little Bee* it is Little Bee herself who comments on scarring:

On the girl's brown legs there were many small white scars. I was thinking, do those scars cover the whole of you, like the stars and the moons on your dress? I thought that would be pretty too, and I ask you right here please to agree with me that a scar is never ugly. That is what the scar makers want us to think. But you and I, we must make an agreement to defy them. We must see all scars as beauty. Okay? This will be our secret. Because take it from me, a scar does not form on the dying. A scar means, I survived.[86]

'A scar does not form on the dying.' Kintsugi's metaphor includes healing, strengthening and rebirth. For almost five years Chanel Miller was known as Emily Doe, the claimant in a well-known sexual assault case on the campus of Stanford University, California. In 2019 she decided to reveal her identity through the publication of a memoir entitled *Know My Name*. The cover design chosen for her book represents three lines of kintsugi, serving as a statement of acceptance of what happened to her, and even as a challenge to those who might silence her.[87]

RELIGIOUS AND CULTURAL OVERLAYS

I can't help but think that kintsugi's popularity outside Japan is partly because one of its fundamental metaphors taps into a European Christian heritage, which lives on in our culture whether or not belief does. A metaphor, after all, is a kind of parable. Searching for kintsugi on our vast cultural database, the internet, I clicked on one link after another. I came across myriad examples that relate to kintsugi, ones that express what you might call fridge magnet philosophy. This one sums up the Christian perspective I most often encountered: 'Broken things can become blessed

things if you let God do the mending.' Many of these devotional references present kintsugi as celebrations of suffering, of glorified martyrdom. This does not sit easily with me. Even kintsugi's current Wikipedia page, many people's first port of call, edges towards this: '*Kintsugi* is the general concept of highlighting or emphasizing imperfections, visualizing mends and seams as an additive or an area to celebrate or focus on, rather than absence or missing pieces.'[88]

On a morning this past autumn I went for a walk to try to tease through these thoughts. Arriving in our village I passed the church's community base on the High Street, and spotted the vicar sitting and reading inside. Alice Goodman is not your typical English village priest. For one thing, she's female. For another, she's American by birth, as am I. Thirdly, she is a noted poet and librettist, being the librettist for the opera *Nixon in China*. We had met before, but only briefly, as I'm not Anglican, tending throughout my life towards Quaker worship when I'm so inclined. After a re-introduction, I simply explained kintsugi, then asked if she felt it related to Christian suffering. Alice was quick to respond. 'No, it doesn't feel like it taps into suffering or martyrdom to me. It's more about the wounds we receive and what we do with them. When Christ rises from the dead, it is in a new state that recognizes his wounds. Thomas puts his fingers in the wounds of Christ to verify their presence.'[89] [Figure 121] So for Alice, it's about wounds: making them part of ourselves and actively accepting them, rather than either being passively resigned to them or celebrating them. She suggests I look at Paul Bunyan: 'My Marks and Scars I carry with me, to be a witness for me that I have fought his Battles who now will be my Rewarder.'[90] I like the idea of kintsugi 'scars' as not celebration of, but witness to a story.

Figure 121: *Caravaggio (1571–1610), Incredulità di San Tommaso (The Incredulity of Saint Thomas), c. 1601–02. Thomas inspects the wounds of Christ. Is kintsugi popular in European-influenced cultures because it appeals to a Christian ideology? Sanssouci Picture Gallery, Potsdam, Germany. Photo by Fine Art Images/Heritage Images/Getty Images.*

In reading lifestyle guru Candice Kumai's book *Kintsugi Wellness: The Japanese Art of Nourishing Mind, Body, and Spirit*, I saw a different perspective of kintsugi. She relates it to what she calls the ten principles of kintsugi 'work' for self-improvement. They can also be read as ten Japanese metaphors of kintsugi.

Wabi-sabi—Admire imperfection
Gaman—Live with great resilience
Eiyoshoku—Nourish your body
Ki o tsukete—Learn to take care
Ganbatte—Always do your best
Kaizen—Continuously improve
Shikata ga nai—Accept what cannot be helped
Yuimaru—Care for your inner circle
Kansha—Cultivate sincere gratitude
Osettai—Be of service to others, welcoming gifts[91]

Kumai's Japanese heritage and American upbringing has allowed her to draw on concepts embedded in kintsugi that might otherwise remain unarticulated.

HEALING

The twentieth-century American psychiatrist Elisabeth Kübler-Ross, who is best known for promoting a psychological understanding of death and dying, said, 'The most beautiful people we have known are those who have known defeat, known suffering, known struggle, known loss, and have found their way out of the depths. These persons have an appreciation, a sensitivity, and an understanding of life that fills them with compassion, gentleness, and a deep loving concern. Beautiful people do not just happen.'[92]

Kübler-Ross's quote is one good way to explore the kintsugi of psychological healing. Recently there has been a burst of therapeutic literature that uses the metaphor of kintsugi more directly in its approach. Tomás Navarro's book *Kintsugi: Embrace Your Imperfections and Find Happiness – The Japanese Way* is one example. It is filled with good, sound advice (despite some historical inaccuracies about kintsugi), such as 'Don't try to live a pleasant life devoid of suffering, because if you do, you will be resigning yourself to surviving instead of living intensely. Instead, seek an active and full life, knowing that you are stronger than any of the adversities you could ever encounter, aware that you will always be able to heal.'[93] Much of this type of writing aggrandizes kintsugi. This does not, however, take away from kintsugi's metaphoric power. As we saw with the businessman encountering the Raku teabowl *Nekowaride*, metaphor can be transformative, and it is often used in counselling and therapy. '... [T]he use of metaphor permits the client to externalize whatever may be thought of as "the problem" and to construct a story about part or all of his or her life.'[94]

In January 2019, when beginning the nuts and bolts research for this book, I set up a Google alert for 'kintsugi' and 'gold mend'. Evidence of its popularity popped into my inbox every week. Here is one I followed up. It's from an online interview with personal development coach Céline Santini after publication of her book *Kintsugi, the Art of Resilience*. It is typical of the fervour of kintsugi converts: 'The first time I heard about the Kintsugi, I had an enlightenment. As if the soul of the Kintsugi Resonated in me and called me.' [Capitalization from original source][95] She admonishes, 'Give life a chance to transform you: Take the Kintsugi-do, the Way of Kintsugi...'[96] 'Dō' is the Japanese word for 'way', as we see in *kendō* (the way of the sword), *bushidō* (the way of the warrior) and *chadō* (the way of tea). In Japan, during our kintsugi travels, Hiroko and I did not find such hyperbole, even when people were

clearly 'transformed' through kintsugi's metaphor, such as Kuroda Yukiko (see '...and a collaboration'). This could be because of cultural differences. To shamelessly generalize, in the West we want to articulate everything. As an American I am probably as guilty as most. In Japan, there are many things that are seen as ineffable, and a desire for them to remain so. Articulation can sometimes limit a concept, and conversely, sometimes it expands it beyond its end point. This is not to say that the metaphor of kintsugi does not exist in Japan – it does – but perhaps it sits less ponderously, although just as solidly.

A romanticized notion of kintsugi can be a way of dealing with a crisis or a difficult situation. In *Far From the Tree: Parents, Children and the Search for Identity*, Andrew Solomon presents a thorough and thoughtful study of the relationships between parents and 'difficult' children. In talking about disability he refers to people '[a]ggrandising the nobility of woe'[97] as a coping strategy. Perhaps we should not be too judgemental about those who magnify the metaphors of kintsugi.

In a blog post for a London-based practice of relationship counsellors, Kathy Rees, cites kintsugi as a way to understand how a broken relationship might be repaired: 'A relationship that is safer, deeper, richer, and more resilient than the one that existed previously, can be created. The vicissitudes of a committed relationship are recognized and, crucially, hurt is not disowned, dismissed or repressed.'[98]

The snapshot shown in Figure 122 of a bulletin board with a poster advertising prayer gatherings and worship was taken by a friend in the US. It shows how far the metaphor of kintsugi has travelled into healing, psychology and spirituality. One can only wonder what 'Kintsugi Worship' is. If I were in Pittsburgh, where the Hot Metal Bridge Faith Community is, I'd give it a go. I have also come across kintsugi being evoked in relation to overcoming prostitution, low self-esteem, 'mindful living', recovery from surgery, and inclusive design.

TRAUMA, ILLNESS AND RECOVERY

Can we use kintsugi to describe our physical being as well as our emotion selves? Last year I contacted Per Hall, an eminent maxillofacial surgeon, who as a volunteer with Operation Smile UK goes out twice yearly to areas of the world where plastic surgery is not available. When I asked if he would like to talk about kintsugi, he was keen to enter the conversation.

Per is a tall man. I am feeling less anxious now that he is sitting at my kitchen table across from me and not negotiating our seventeenth-century cottage with its low wooden beams. I have made us coffee and am listening now as he jumps from one inspiring story to another. His surgical specialty is face and jaw reconstruction, most often for severe cleft palate, but it is clear that his skills are used in many different ways on his visits abroad. Per creates function where it doesn't exist, either because of congenital disorder or through war or other trauma. His stories made me realize that the metaphor of kintsugi is more than 'skin deep'. After all, as a plastic surgeon, he does not want to leave visible scars. We talked about how people's lives can be totally transformed and what that means. Per told me about a mother in India, who struggled when first seeing her young child after the repair of a significant cleft palate and lip. She had, of course, loved her baby as he had been. In this instance it was about accepting the change

Figure 122: Poster advertising 'Kintsugi Worship' spotted on a bulletin board. Photo courtesy of Garth Johnson.

Per Hall introduces Ikram

The little girl in the photo is called Ikram, and she first saw me in 2017, when she was four, because of an unrepaired cleft palate, which was a significant deficiency affecting the roof of her mouth. This was in a city called Jimma in Ethiopia, eight hours by road from the capital Addis Ababa.

I made a start on closing this wide palate and brought her back for review in 2018 with a speech pathologist. We decided that her palate was too short to work for clear speech so I did a second operation to make her palate longer by stealing a patch of her own tissue from the inside of her cheek hinging on its own blood supply (called a Flap) and inserting this into the roof of the mouth to enable the palate to be longer and more functional. Rather like I imagine fixing a pot with a new piece made to fit the defect, which has a different origin from the rest.

At the time of this picture, in March 2019, we had just seen her for review and we were delighted to find that she now has clear and understandable speech, so she can communicate with her peers and go to school. She was previously reluctant to attend school because of teasing and bullying for the way she spoke, but now she is a happy little girl and it was very lovely to see. She rushed up to me and jumped into my arms and then Clive took the picture!

Figure 123: Maxillofacial surgeon Per Hall and Ikram. Per is a British surgeon and Operation Smile UK volunteer. Ikram lives in Ethiopia. Per Hall repaired her serious cleft palate over the course of two years. In the photo Ikram is sporting cheerful stickers; the one on her forehead is a pink bear cuddling a teddy bear. The others are hearts. Photo by Clive Duke, Operation Smile UK.

that resulted in a 'new', 'transformed' child. Per's stories spoke to me about the amazing resilience and strength that lies within us.

DISABILITY

I met with Tom Shakespeare, the sociologist, broadcaster and disability spokesperson, at a busy outdoor café in a park in London. With a million things going on around us, we centred down to talk about the metaphor of kintsugi and disability. To start, he quoted Emmanuel Kant: 'Out of the crooked timber of humanity, no straight thing was ever made.'[99] He said he found this to be 'a liberating notion because everybody is flawed'. The acceptance of imperfection is fundamental to kintsugi thinking. It's about valuing the imperfect as well as the 'perfect', whether they are pots or people. Then the conversation veered towards renewal and how a kintsugi-repaired bowl becomes a new entity. He said that for people with a newly-acquired disability, who have 'gone through the breaking and the re-making...the metaphor of the new is a wonderful metaphor. A lot of people acquire a disability and they think their life is over – they feel stigmatized. Then they go through an identity re-formation. If they succeed, they end up with the feeling that they are valid as they are. They've reshaped their notion of normality. They learn that it's not what they thought it would be, but it's good in another way.' The inherent dual nature of kintsugi also came up. 'Most people acknowledge that having some kind of disability is bad, and we wouldn't want that, and yet the lives of individual disabled people are good. That seems contradictory.'[100]

Tom told me that kintsugi has been adopted as a metaphor by many disability organizations, including Down syndrome support groups, who have used it to

teach us all to accept imperfections in ourselves and our loved ones. Many of these groups use the kintsugi metaphor of bringing together different parts of a whole to advocate for social inclusion. 'Here at The Kintsugi Project, we believe that society is broken. We want to work together with our community to make it better and more beautiful.'[101]

If we recognize that we are all imperfect, then metaphors within kintsugi could include forgiveness, justice, family love, affection, validation, acceptance, or, citing my own artwork, simply a warm embrace. The same can be true for breakdowns in communities. Apology can be a particularly potent repair material. Elizabeth Spelman says, 'An apology is an invitation to share in a ritual of repair, in a dance that takes more than one dancer.'[102]

Kintsugi also offers us the metaphor of connection, of putting together separate pieces into a whole. This can be in the material world, or it can mean connections between individuals, or between the diverse cultures in the world. *Makie-shi* Shimode Muneaki says that the connection extends further: it brings together the past and the present, and reinforces the strength of our links to both past and future generations.[103]

WITHIN POPULAR CULTURE

Kintsugi appears in music and other forms of entertainment on a regular basis. The most commonly quoted lyrics relating to kintsugi must certainly be Leonard Cohen's lines:

> Ring the bells that still can ring
> Forget your perfect offering
> There is a crack, a crack in everything
> That's how the light gets in.[104]

These words echo a line from the Persian poet Rumi, which is often quoted as 'The wound is the place where the light enters you'.

Some musicians and singers have addressed the metaphor more directly. Gabrielle Aplin's use of metaphor in her song 'Kintsugi' (2019) is overt:

> I don't know how much more I can take
> Yeah, I'm broken into so many pieces
> Would be easy just to throw them away
> But I don't wanna give up on feeling
> 'Cause now that I'm shattered,
> I'm all kinds of me
> Was knocked off the shelf, but I'm also complete
> I'm under the weather with no place to be
> But maybe that's just what I need (kintsugi).
> [brackets original][105]

However, the link to kintsugi is more ambiguous in many releases. The US alternative rock band, Death Cab for Cutie, produced an album called *Kintsugi* in 2015, which was nominated for a Grammy Award for Best Rock Album. It rose to No. 5 in the US charts, and they toured the album through 2016. The track, 'Kintsugi' (2017), by Dutch electronic dance duo, DROELOE, has had almost four million hits. Other songs bearing the title 'Kintsugi' have also been released around the world. Even Beyoncé featured a kintsugi bowl in her video for 'Sandcastles', and uses the words, 'If we're gonna heal, let it be glorious.'

In 2019 Elhaq Latief debuted the ballet *Kintsugi* in Jakarta. Its theme centred on violence in relationships. The choreographer said, 'The philosophy behind it is that it treats breakage and repair as part of the history of an object, rather than something in disguise.'[106]

As we see, the use of kintsugi as a theme is widespread. In an exhibition entitled 'Pour Tout l'Or du Monde' (For All the Gold in the World) in Senegal, the concept of kintsugi was used as a way of helping attendees see the 'strength, resilience and incredible courage of all those who are broken and destroyed' by the dangerous practice of gold mining.[107] The link to the use of gold in kintsugi is a powerful one in this instance. Other exhibitions have drawn on the title 'Kintsugi' rather more tenuously. For example, Koo Stark mounted a 'kintsugi' exhibition of photographs in London in 2017. The Threshold Gallery in New Delhi drew together a mixed show in 2020 under the kintsugi title that was said to explore the social and political anxieties of present-day India.

Many products employ 'kintsugi decoration' besides ceramics and china, although most of these products seem to capitalize on kintsugi's style, leaving its metaphor behind. I have found clothing, jewellery, flooring and tiles. I have even found cakes iced in a kintsugi style and sneakers custom made to look like kintsugi. Gold line decoration also appears periodically as expressive facial and body make-up.

Perhaps a kintsugi reference seen by more people on Earth than any other appeared in December 2019 with the release of *Star Wars: The Rise of Skywalker*, the last in the third and final *Star Wars* three-trilogy film series. In it Kylo Ren, born into the Jedi tradition but seduced by the dark side of the Force, reappears having had his broken helmet re-forged, the seams highlighted in red. The director, J.J. Abrams, in an interview in *Empire Magazine*, acknowledges his debt to kintsugi in the design of the mask:

> Having [Kylo Ren] be masked, but also fractured, is a very intentional thing. Like that classic Japanese process of taking ceramics

and repairing them, and how the breaks in a way define the beauty of the piece as much as the original itself. As fractured as Ren is, the mask becomes a visual representation of that. There's something about this that tells his history. His mask doesn't ultimately hide him and his behavior is revealed.[108]

Of course, in the end Kylo Ren is redeemed, which if you recognized the kintsugi in the helmet when he first appears, you would know would be the outcome.

SUSTAINABILITY

In 2004 the Kenyan social, environmental and political activist Wangarī Muta Maathai was awarded the Nobel Peace Prize for her contribution to sustainable development, democracy and peace. Maathai took up the metaphor of *mottainai* (see Chapter two), which is closely linked to kintsugi, after learning about the concept on a visit to Japan. She subsequently set up the Mottainai Campaign, a worldwide movement that seeks environmental sustainability.

Sustainability in crafts, and in ceramics in general, manifests on two levels. First, there are issues to be addressed within the making of crafts in the use of fuels and resources as well as the pollutants that may be a consequence of the implementation of specific productions. Kintsugi, as a technique, uses lacquer made from Japanese lacquer trees, which come from managed sources. Using lacquer is a highly-specialized process requiring great skill and experience. Even harvesting the raw lacquer is a skilled profession. Kintsugi is slow and costly, and no one suggests that everything that is broken should be kintsugi repaired. However, because the second part of the sustainability discussion is about the reuse of objects, the idea of repairing rather

than replacing the objects in our lives puts kintsugi firmly within the sustainability canon. As environmental concerns become environmental imperatives, we look to challenge our profligate consumerism. The activist designer Bridget Harvey says, 'Where discarding and buying new is the instruction of capitalist culture, another route – that of the act of repair – is possible: a material action objecting to take, make, waste systems.'[109] Kintsugi, which, granted, has traditionally tended to be used for valuable and expensive items, nonetheless gives us a model for a new way of thinking and interacting with the things with which we surround ourselves. Employing concepts from Jonathan Chapman we can say that using kintsugi allows us to avoid the 'failed' user-product relationship that leads to our 'dumping' of old artefacts and replacing them with new[110] through a raised respect and appreciation of the repaired pot. As Nazli Terzioğlu has pointed out, by placing high value on the repaired object, kintsugi also shows us a way to overcome the stigma of repair.[111]

The use of *kan'i-kintsugi*, or easy kintsugi, which uses new non-allergenic materials, and can be done by the owners of the objects in their own homes, points us towards cherishing the objects in our lives, rather than replacing them quickly, feeding into the Make Do And Mend and sustainability movements. Although there is a world of difference between the home glue-based repair and the highly-skilled work of a trained *makie-shi*, *nuri-shi* or *kintsugi-shi*, there is nonetheless a place in our lives for such activities.

On an even wider scale, many people are now using these kintsugi metaphors to raise awareness of and explore ways of ameliorating the threat we pose to our world, helping us to develop a less destructive society and a healthier environmental conscience. Kintsugi stands boldly as a symbol of the possibility of a mended and more valued Earth.

Figure 124: Cracked earth. This photo shows a 'one-hundred-year bloom' at Death Valley National Park. Photo by Ted Soqui/ Corbis via Getty Images.

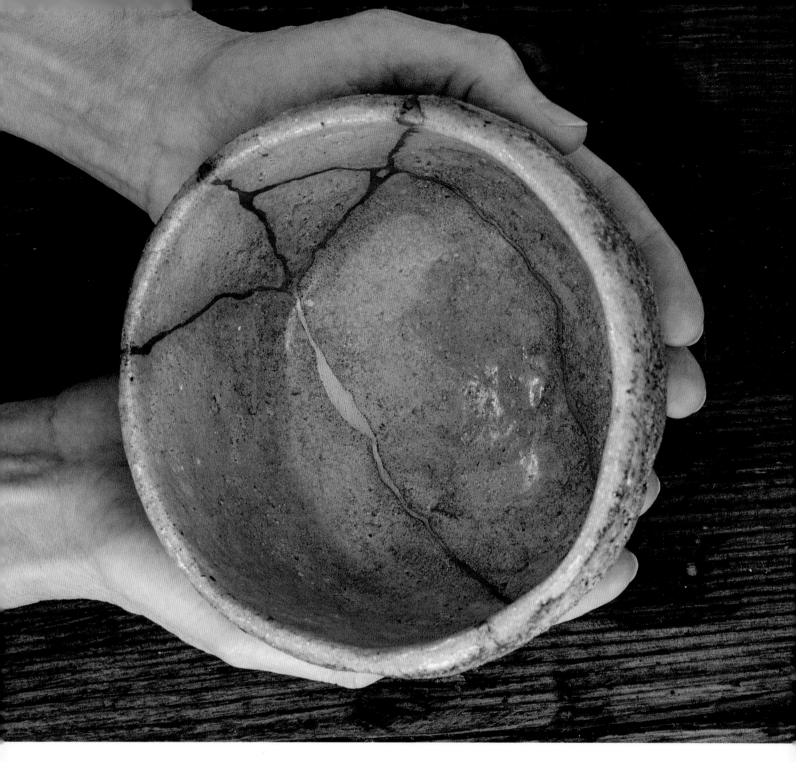

...AND
A KINTSUGI REPAIR

This is a story about the making, breaking and repair of a teabowl, created by me. Made almost thirty years ago, it was broken shortly after. It was entrusted to a kintsugi restorer at the beginning of the writing of this book, and the repair was finished the week the book was completed.

The quiet chill in the air is destroyed by the heat and the deafening, relentless sound of the burning gas as it shoots into the raku kiln. Even with the noise, ten of us – potters or tea ceremony students – gather around it in the hope of gaining its warmth. We say little. We have been firing pots since the morning, with only a break to sit around the picnic table for some of my husband Tony's thick warming soup. Firing Western-style, we've removed each bright hot pot from the kiln, putting it into a sawdust-filled bin for post-reduction. Each time we lift the bin lid, the smouldering sawdust turns to flame, hurling upwards, and singeing an eyebrow or two. We lower the ashy pots into water, creating the recognizable hiss of a raku firing.

My teabowl is next and I decide to fire it as it is done in Japan. The kiln is already hot but it seems a long time before I see the bowl begin to glow. I wait, watching for the telltale orange peel texture to develop on its surface. Then I pause for another few moments. My friend Alex, who also does both Tea and ceramics, is the second pair of hands for this firing. The air goes silent when I turn down the gas. Alex lifts the lid and I reach in with tongs to take the teabowl out. I set it onto a slab of concrete. It glows momentarily before the cool air sucks out its heat. When its colour has stilled, I hold my breath as I slowly lower it into the water for its final cooling. It is done. My first ever teabowl. I think this is to be one of many, but it isn't. Seduced away by the lure of sculptural ceramics at art school, in the next twenty years of studio work, there will be no more teabowls.

I gave that teabowl to Alex on the promise that it would be well used, which seemed certain as he was leaving shortly for three years of Tea training in Japan. But fate disagreed. Broken in transit, Alex carefully packed it away. It was when starting this book so many years later, that he reminded me of the teabowl. It took me but a moment to suggest I ask the kintsugi restorer Ronald Pile to repair it. Alex agreed.

So here I am, almost thirty years later. The teabowl has been repaired and sits in front of me on the smooth wood of Alex's table. I don't recognize it, but it is definitely my style, rounded with a heavily textured surface. At first I don't like the colour, but as I allow myself to look and accept, rather than criticize, it grows on me. I lift and hold it in my palms, and sense its form and external texture in its snugness.

Seams of gold accentuate, don't hide, its damage. I think about how the losses in my life have remade me since I was the young potter who created that teabowl. Then I think about the many individuals and groups I have met in writing this book who have used kintsugi as a way of getting through life's downturns. And in the Japanese tradition of naming teabowls, I call this pot 'Life's Renewal'.

KINTSUGI, THE POETIC MEND

A broken pot is made whole again, and with its golden repair we see a world of meaning.

First, we acknowledge the sadness of its breaking, and the pain of our own tragedies. We accept the pot's imperfection and the imperfections in ourselves. Then we may find joy in the beauty of its repair, as we might accept and bear our scars proudly. And we glory in how the pot has taken on a new life, just as we begin again after life's hard lessons.

In the new pot we see hope exemplified. And it is hope that shows us that we can put our pots, ourselves, and our Earth back together, as imperfect entities in an imperfect world.

Figure 125: Bonnie Kemske, Life's Renewal, made c. 1992, kintsugi repaired by Ronald Pile, 2020. Raku-fired pinched and stretched stoneware. Photo by Vilokini Gail Abbott. Courtesy of Alex Fraser.

LIST OF ILLUSTRATIONS

1. Stephanie Hammill, *Fruit Bowl*, thrown, glazed, and repaired by Stephanie Hammill, 2014. Stoneware with ash glaze; repaired with *urushi* and 24-carat gold powder.

2. Keiko Shimoda, 金継ぎ (kintsugi), 2020. *Sumi* ink on Japanese paper with brush.

3. *Ichō* (gingko) leaves create bright gold lines on a temple roof.

4. A stone wall in Kyushu, Japan.

5. A tree near Ginkakuji (Silver Pavilion), Kyoto, Japan.

6. A wall with a painterly quality and a crack running through it, Arita, Kyushu, Japan.

7. *Yaburebukuro* (Burst Pouch) *mizusashi* (fresh water jar), Japan. Momoyama period (early 17th century). Important Cultural Property, Japan.

8. A farmer studies the cracked earth in front of his house in Matsushiro, Japan, following an earthquake in 1966.

9. Tools used by Mitamura Arisumi for *maki-e* ('sprinkled picture').

10. Seeds from the *urushi* tree, from which lacquer is produced.

11. A teabowl broken in the 1923 Tokyo earthquake and repaired by Mitamura Jihō.

12. A bowl repaired by Mitamura Shūhō.

13. *The Broken Jug*, c. 1890. Sarreguemines porcelain plate with transfer-printed decoration and kintsugi repair.

14. Three partially-reconstructed Kangxi vases at the Fitzwilliam Museum, Cambridge, UK, which were broken in 2006.

15. Detail of a repair on one of the Kangxi vases at the Fitzwilliam Museum, Cambridge.

16. Thomas 'Sam' Haile, *Spinster's Rock*, c. 1948. Earthenware, slip-decorated, painted and glazed.

17. Guests participate in a kintsugi workshop, Washington, DC, 2018.

18. Identical dinner plates from the Seletti 'Kintsugi' range.

19. Laetitia Pineda, *Plate*, 2018. Gathered clays in south west of France, wood-fired, kintsugi-repaired.

20. Raku Kichizaemon XV (Raku Jikinyū), *Nekowaride (Broken by a Cat)*, 1985. Black Raku tea bowl, *yakinuki*-type.

21. Raku Fujiko points out the features of the teabowl *Nekowaride*.

22. *Noren*, traditional curtain hung in doors in Japan.

23. Drinking *matcha* from the teabowl *Nekowaride*.

24. Appreciating a teabowl in the Raku tearoom.

25. Raku Kichizaemon XV (Raku Jikinyū), *Nekowaride*, 1985. Black Raku tea bowl, *yakinuki*-type, in the tearoom.

26. Ōno Zuiho, teabowl with kintsugi repair, 20th century.

27. Nakano Kazuma, bowl with kintsugi repair, date unknown.

28. Teabowl by unknown potter, repaired by Natsuyo Watanabe.

29. Melon-shaped wine ewer with kintsugi repair, Korea, Goryeo period (1100s–1200s).

30. Alain Vernis, teabowl with decorated kintsugi repair, 2011.

31. Seto or Mino ware teabowl with decorated kintsugi repair, Muromachi period (1510–1530).

32. Karatsu teabowl, c. 1590–1630. Glazed stoneware with *yobitsugi* repair.

33. 18th-century Delft plate with a Cryptomeria (Japanese cedar) repair.

34. Kuroda Yukiko, a new bowl created by using discarded *ko-karatsu* (Old Karatsu) sherds.

35. Tsuruta Yoshihisa, *Ko-karatsu matsumon mukōzuke*, 2019. *Yobitsugi* (patchwork kintsugi) of *ko-karatsu* (Old Karatsu) sherds.

36. Vietnamese teabowl with blue decoration, 17th century.

37. *Shigaraki Jar*, Muromachi period (16th century) with black repair.

38. Kōetsu-style teabowl from an unknown Raku ware workshop, Edo period or Meiji era (19th century) with red lacquer repairs.

39. Otani Shiro, *Fired large dish* (detail), 1984. Anagama fired with black and gold repairs.

40. Teabowl with gintsugi (silver-joins) repairs, origin and date unknown.

41. Green plate of unknown original with kintsugi repair and *maki-e* decoration of frogs by Shimode Munaeki.

42. 13th-century Korean plate, gintsugi-finished by Iku Nishikawa.

43. Red raku-style teabowl by unknown potter, date unknown. Repaired by Natsuyo Watanabe.

44. Tearoom showing the utensils used in *chanoyu*.

45. John Domenico, *Kintsugi Jar V*, 2016. Wood-fired ceramic with kintsugi repair.

46. John Domenico and wife-to-be stoke the Denver anagama kiln, 2016.

47. 'More Halloween than Christmas'. John Domenico and the Denver anagama.

48. John Domenico, *Kintsugi Jar V* in foreground.

49. John Domenico, *Kintsugi Jar II*, 2016. Wood-fired ceramic with kintsugi repair.

50. Jōmon vessel with *urushi* repairs, *c.* 2000–1000 BCE.

51. Detail of Jōmon vessel with a small hole filled with *urushi*.

52. Red *urushi* decoration on pottery sherds, 2000–1000 BCE.

53. Repaired spout with decorated *urushi* seam from a Jōmon pot, 2000–1000 BCE.

54. Detail of material used as decoration on *urushi* repair of Jōmon pot, 2000–1000 BCE.

55. Great Buddha *Daibutsu* at Todaiji, Nara, Japan.

56. *Bakōhan* (Locust bowl), Longquan (celadon) ware, Southern Song period (13th century) with later rivet repair. Important Cultural Property, Japan.

57. Painting of the tea master Sen no Rikyū (1522–1591), after Tōhaku.

58. *Ō-Gōrai, kohiki chawan* (teabowl), Korea, 15th–16th century.

59. *Yobitsugi chawan* (teabowl), Azuchi Momoyama-Edo period.

60. *Shumi*, also known as *Jūmonji, Ō-Ido chawan*, Korea, 16th century.

61. Hon'ami Kōetsu, *Seppō* ('Snowy Peak'), Edo period (17th century). Important Cultural Property, Japan. *Aka* (red) Raku ware.

62. *Inrō* (small ornamental stacked boxes) with *maki-e* decoration, late 18th–early 19th century, Edo period (1615–1868), Japan.

63. Early Jōmon pot, *c.* 5000 BCE. Low-fired red pottery gold lacquer lining from the 19th century.

64. *Tsutsu-izutsu, Ō-Ido* teabowl, Korea, *c.* 1400–1600. Important Cultural Property, Japan.

65. Sumiyoshi Jokei, *Tsutsu-izutsu* (By the Well Wall), *c.* 1662–1670. Painted silk.

66. Mark Tyson, *Teabowl*, 2015. Gas-fired in salt kiln; kintsugi repairs.

67. Trunk of *Toxicodendron vernicifluum* (Japanese lacquer tree).

68. *Toxicodendron vernicifluum* (Japanese lacquer tree).

69. *Urushi* (lacquer) in storage at Sato Kiyomatsu Shoten Company, Kyoto.

70. Sato Takahiko demonstrating the viscosity of *urushi* (lacquer).

71. A broken pot ready for a kintsugi repair.

72. Sequence showing the steps of a kintsugi repair.

73. The same pot repaired with *urushi* and gold.

74. A table setting showing porcelain cups repaired by Kuroda Yukiko.

75. Kuroda Yukiko, *Soba-choko* (cup for dipping soba noodles), Japan, late Edo period. *Ko-Imari* porcelain with *Sometsuke Yorakumon* (design from India) and kintsugi repair.

76. Three oval plates repaired by Kuroda Yukiko.

77. Detail of the intricate repair of a white plate by Kuroda Yukiko.

78. Hamana Kazunori and Kuroda Yukiko with a large pot made by Hamana and repaired by Kuroda.

79. Hamana Kazunori, *tsubo* (large jar), 2019, with repairs by Kuroda Yukiko.

80. Kuroda Yukiko, Bonnie Kemske and Hamana Kazunori.

81. Kuroda Yukiko and Hamana Kazunori say goodbye.

82. Doris Salcedo, *Shibboleth*, 2007. Turbine Hall, Tate Modern, London.

83. Doris Salcedo, *Shibboleth* (detail).

84. Yoko Ono at her exhibition *Fly* at the Centre of Contemporary Art Warsaw, Poland, 2008.

85. Yee Sookyung, *Translated Vase Nine Dragons in Wonderland*, 57th Venice Biennale in the Korea pavilion, 2017. Ceramic sherds, epoxy, 24-carat gold leaf.

86. Grayson Perry, *The Huhne Vase*, 2014. Glazed ceramic with kintsugi repair.

87. Bouke de Vries, *Deconstructed teapot with butterflies*, 2017. 18th-century Chinese porcelain *famille rose* teapot and mixed media.

88. Bouke de Vries, *Marine memory vessels*, 2016. 18th-century Chinese porcelain marine archaeology storage vessels.

89. Bouke de Vries, *The Repair 2*, 2014. 18th-century Chinese porcelain tureen stand, tureen cover and mixed media.

90. Raku Kichizaemon XV (Raku Jikinyū), untitled, 2018. *Yakinuki*-type teabowl in white clay.

91. Reiko Kaneko, *All That is Broken is not Lost*, 2019. Bone china plates overfired on plate setters, mended with gold powder and Kölner ceramic size.

92. Suzuki Goro, *Chawan, Yobitsugi*, 2009.

93. Tsuruta Yoshihisa, *Shoki-imari shōchikubaimon chawan* ('three friends of winter' teabowl), 2018. Early Imari sherds joined with resin and decorated.

94. Raewyn Harrison, *Mud Larking Tea Bowl*, 2019. Thrown porcelain with Delft fragment insert.

95. The shoreline of the River Thames at low tide.

96. Paul Scott, *Scott's Cumbrian Blue(s), The Syria Series No:9, Aleppo*, 2016. In-glaze decal collage and gold lustre on partially erased *Aleppo* pattern, Clementson, Young and Jameson plate, c. 1844 with kintsugi repair.

97. Paul Scott, *Scott's Cumbrian Blue(s), The Syria Series No:8, Damascus*, 2017. In-glaze decal collage and gold lustre on partially erased, broken Edward and Enoch Wood, *Damascus* pattern plate, c. 1830 with kintsugi repair.

98. Paul Scott, *Scott's Cumbrian Blue(s), The Syria Series No:10, Palmyra*, 2017. In-glaze decal collage and gold lustre on partially erased, cracked Palmyra bowl by Brownfield, c. 1870 with kintsugi repair.

99. Claudia Clare, *Remembering Atefeh* (detail), 2011–2013.

100. Claudia Clare, *Remembering Atefeh*, 2011–2013. Coiled then smashed; reassembled using cellulose nitrate glue and gold leaf.

101. Miwa Ikemiya, *Broken Stories: Plate*, 2013. Ceramic, silicone, acrylic paint.

102. Guy Keulemans, *Archaeologic Vases (Series 3)*, 2015. Stoneware repaired with photoluminescent glue; wheel-thrown and fired to bisque. Shown in light.

103. Guy Keulemans, *Archaeologic Vases (Series 3)*, 2015. Stoneware repaired with photoluminescent glue; wheel-thrown and fired to bisque. Shown in darkness.

104. Guy Keulemans, *Archaeologic Vases (Series 5)*, 2019. Wheel-thrown painted stoneware, repaired with sterling silver rivets.

105. Paige Bradley, *Expansion*, 2005. Bronze and light.

106. Rachel Sussman, *Study for Sidewalk Kintsukuroi #03* (MASS MoCA), 2015. Archival pigment print, enamel, metallic powder.

107. Rachel Sussman, Installation image for *Sidewalk Kintsukuroi* (Des Moines Art Center), 2017. Resin and 23-carat gold.

108. Zoë Hillyard undertaking ceramic patchwork, 2016.

109. Zoë Hillyard, *Red Leaf Bloomfield Bowl*, 2017. Linda Bloomfield bowl reworked with vintage fabric.

110. Zoë Hillyard, *Katharina's Brown Bowl*, 2018. Katharina Klug bowl reworked with vintage fabric.

111. Suzuki Goro drinking coffee from one of his mugs.

112. Suzuki Goro, *E Oribe Chair*, c. 2000. Ceramic, E Oribe.

113. Suzuki Goro, *Oribe Kokumon Three-Tiered Box*, 2015. Oribe Kokumon (raised detail) and *Yobitsugi Box*, 2008.

114. Suzuki Goro signing a catalogue with brush and ink, 2019.

115. Displaying Suzuki Goro's signature, 2019.

116. Bonnie Kemske admiring a double-skinned teabowl with the artist, Suzuki Goro, 2019.

117. A scene from the Noh play, *Yashima*, Kyoto, Japan.

118. Suzuki Goro, *Yobitsugi Large Bowl*, 2008. Ceramic, *yobitsugi*.

119. Small late Edo period dish, *Aburazara* (oil tray) with kintsugi repair done in 2018 by Heki Mio.

120. American Boy and Girl Scouts look at the crack in the Liberty Bell.

121. Caravaggio, *Incredulità di San Tommaso (The Incredulity of Saint Thomas)*, c. 1601–02.

122. Poster advertising 'Kintsugi Worship'.

123. Maxillofacial surgeon, Per Hall, and his young patient, Ikram, in Ethiopia with Operation Smile UK.

124. Cracked earth at Death Valley National Park, US.

125. Bonnie Kemske, *Life's Renewal*, teabowl made c. 1992, kintsugi repaired, by Ronald Pile 2020. Pinched stoneware, raku-fired without post-reduction.

ENDNOTES

Preface

1. Ernest Hemingway, *A Farewell to Arms,* New York: Scribner, 1929/2014, 216.

Chapter One

2. Louise Allison Cort, personal correspondence.

3. Ueda Makoto, *Bashō and His Interpreters: Selected Hokku with Commentary,* Stanford: Stanford University Press, 1992, 127.

4. Suzuki Miho, ' "Heart mending" kintsugi – repairing keepsakes become popular after earthquakes', *Mainichi Shimbun,* Tokyo evening edition, 4 February 2019.

5. Ibid.

6. Pallavi Aiyar, 'A Japanese ceramic repair technique teaches us to embrace our scars', *Nikkei Asian Review,* https://asia.nikkei.com/NAR/Articles/A-Japanese-ceramic-repair-technique-teaches-us-to-embrace-our-scars, accessed 18 January 2020.

7. Elizabeth V. Spelman, *Repair: The Impulse to Restore in a Fragile World,* Boston: Beacon Press, 2002.

8. *Ibid.,* 11–13.

9. Richard Sennett, *The Craftsman,* London: Allen Lane (an imprint of Penguin Books), 2008, 200.

10. Angelika Kuettner, 'Simply Riveting: Broken and Mended Ceramics' in Ceramics in America 2016, Robert Hunter (ed.), found in *Chipstone,* www.chipstone.org/article.php/742/Ceramics-in-America-2016/Simply-Riveting:-Broken-and-Mended-Ceramics, accessed 18 January 2020.

11. Evan Nicole Brown, 'The Art of Repairing Broken Ceramics Creates a New Kind of Beauty,' *Atlas Obscura,* 15 February 2019, www.atlasobscura.com/articles/repairing-broken-ceramics, accessed 12 November 2019.

12. Mitani K., *Edo shobai zue,* Tokyo: Chuo Koron sha, 1995, 284.

13. Translation by Hiroko Roberts-Taira.

14. '1.07 Conservation Strategy [Website], *Understanding Conservation,* www.understandingconservation.org/content/107-conservation-strategy, accessed 18 January 2020.

15. Julie Dawson, in dialogue with the author, January 2020.

16. Chris Yeo on BBC 1 *Antiques Roadshow* [TV programme], 15 September 2019.

17. Spelman, *Repair,* 134.

Chapter Two

18. Reiko Kaneko, *Kintsugi: All that is Broken is not Lost* [Exhibition handout], Sway Gallery, 2019.

19. Christie Bartlett, 'A Tearoom View of Mended Ceramics', *Flickwerk: The Aesthetics of Mended Japanese Ceramics* [Exhibition catalogue], Herbert F. Johnson Museum of Art (Cornell University) and Museum für Lackkunst (Münster), 2008, 12. Available at http://annacolibri.com/wp-content/uploads/2013/02/Flickwerk_The_Aesthetics_of_Mended_Japanese_Ceramics.pdf, accessed 2 February 2020.

20. Guy Keulemans, 'The geo-cultural conditions of kintsugi', *The Journal of Modern Craft* 9, No. 1, 2016, 17.

21. Bartlett, 'A Tearoom View...', 11.

22. Charlie Iten, 'Ceramics Mended with Lacquer: Fundamental Aesthetic Principles, Techniques and Artistic Concepts', *Flickwerk: The Aesthetics of Mended Japanese Ceramics* [Exhibition catalogue], Herbert F. Johnson Museum of Art (Cornell University) and Museum für Lackkunst (Münster), 2008, 19. Available at http://annacolibri.com/wp-content/uploads/2013/02/Flickwerk_The_Aesthetics_of_Mended_Japanese_Ceramics.pdf, accessed 2 February 2020.

23. Alex Kerr, with Kathy Arlyn Sokol, *Another Kyoto,* UK publication: Penguin, 2018, 283–285.

24. Shimode Muneaki, in dialogue with the author, February 2019.

25. Institute of Making, *The Taste of Materials_spoons* [Research booklet], undated, 6. https://static1.squarespace.com/static/578f5f33f5e231d1bfff6cf4/t/59a6b4af3e00be1a65f40ff2/1504097460915/Spoons+Meal+Booklet.pdf, accessed 30 December 2019.

26. Raku Fujiko, in conversation with the author and Hiroko Roberts-Taira, February 2019.

27. Sasaki Mizue, 'Perspectives of language: Cultural differences and universality in Japanese', *Cultural Diversity and Transversal Values: East-West Dialogue on Spiritual and Secular Dynamics* [International symposium], UNESCO, 2006, 125. Available at www.rel-med.net/pdf/cultural_Diversity_transversal_values_unesco_ENG.pdf#page=120, accessed 19 January 2020.

28. Kumakura Isao, 'Sen no Rikyū: Inquiries into his Life and Tea', Paul Varley (trans.), in *Tea in Japan: Essays on the History of* Chanoyu, Paul Varley and Kumakura Isao (eds.), Honolulu: University of Hawai'i Press, 1989, 60.

29. *Ibid.*

30. Lorenzo Marinucci, '*Sabi* and irony. The cross-cultural aesthetics of Ōnishi Yoshinori', *Studi di estetica*, , anno XLVI, IV serie, 2018, 139. http://mimesisedizioni.it/journals/index.php/studi-di-estetica/article/view/594/1012, accessed 18 November 2019.

31. Morgan Pitelka points out that warriors influenced the development of tea ceremony very early by collecting Chinese art, including Tea wares. Morgan Pitelka, 'Warriors, Tea, and Art in Premodern Japan', *Samurai: Beyond the Sword*, Birgitta Augustin (ed.), *Bulletin of the Detroit Institute of Arts* 88, No. 1/4, 2014, 22.

32. Kumakura, 'Kan'ei Culture...', 146.

33. Kumakura, 'Kan'ei Culture...', 148.

34. Suzuki Daisetz T., *Zen and Japanese Culture*, (First published Bollingen Foundation Inc NY, 1959), Princeton & Oxford: Princeton University Press, 2019.

35. Michael Sōei Birch, *Workbook: An Anthology of the Seasonal Feeling in Chanoyu,* privately published, 1987, 52.

Chapter Three

36. Mitamura Arisumi, *Urushi to Japan,* Tokyo: Ribun Shuppan, 2005; and Odagawa Tetsuhiko, 'Incipient Jomon Period', *Bulletin of Aomori Prefectural Archaeological Artefacts Research Center* 6, 2000, 10–12.

37. Chiba Toshirō, in conversation with Hiroko Roberts-Taira and the author, February 2019.

38. Chiba Toshirō, 'Lacquerwork Techniques Found in the Shimo-yakebe Site', *Bulletin of the National Museum of Japanese History* 187, 2014, 227–228.

39. Suzuki Mitsuo *et al.*, 'Origin of Urushi *(Toxicodendron vernicifuluum)* in Neolithic Jomon Period of Japan', in *Bulletin of the National Museum of Japanese History* 187, 49-70, July 2014, 73. www.rekihaku.ac.jp/english/outline/publication/ronbun/ronbun8/pdf/187002.pdf, accessed 19 August 2019.

40. Fujio S. *et al.*, 'When did the wet-rice cultivation begin in Japanese archipelago?', *Sokendai review of cultural and social studies* 1, 69–96, 2005, 73.

41. Chiba, in conversation.

42. Mitamura Arisumi, *Geijyutsu ga izuru kuni Nihon,* Tokyo: Tokyo Geidai Press, 2017 .

43. Yotsuyanagi Kasho, *Urushi no Bunka-shi*, Tokyo: Iwanami Shoten, 2009.

44. Mitamura Arisumi, in conversation with the author and Hiroko Roberts-Taira, February 2019.

45. Yotsuyanagi, *Urushi*, 60.

46. Nagahara Keiji (ed.), *Iwanami Nihonshi Jiten*, Tokyo: Iwanami Shoten, 1999, 914.

47. Yotsuyanagi, *Urushi*, 54.

48. Translation by Hiroko Roberts-Taira.

49. Tanihata Akio. & Yamada T., 'Cha no rekishi', in *Chado Bunka Shinko Zaidan, Chado Bunka Kentei Koshiki Text 1-kyu • 2-kyu*, Kyoto: Tankosha, 2009, 11.

50. Tanihata Akio, *Gendai-go de sararito yomu cha no koten, Chawa Shigetsu-shu*, Kyoto: Tankosha, 2011, 56.

51. This is referred to in *Chawa Shigetsu-shu*, where Fujimura Yoken (1613–1699) quotes Yoshida Kenkō (1283?–1352?) in *Tsurezuregusa (Essays in Idleness).*

52. Tanihata, *Gendai-go,* 2011, 56.

53. Ibid.

54. Nambō Sōkei, *Nampōroku,* in Sen Sōshitsu, *Chadō Koten Zenshū*, Vol. 4, Kyoto: Tankōsha, 1956, 10.

55. Haga Kōshirō, 'The *Wabi* Aesthetic Through the Ages', Martin Collcutt (trans. and adapted by), in *Tea in Japan: Essays on the History of* Chanoyu, eds. Paul Varley and Kumakura Isao, Honolulu: University of Hawai'i Press, 1989, 198.

56. Ise Yuya, 'Yakugaku ga kureta watashi no michi', Interview with Nakanishi Yukito, *Farumashia (Pharmaceutical Society of Japan)*, 52, 10, 2016, 916. And Mori Kōichi, '*Hakaku no Tōgei'*, *Nikkei Shimbun.* 28 September 2015, 44.

57. Kumakura Isao, 'Kan'ei Culture and *Chanoyu*', Paul Varley (trans.), in *Tea in Japan: Essays on the History of Chanoyu,* Paul Varley and Kumakura Isao (eds.), Honolulu: University of Hawai'i Press, 1989, 141.

58. Morgan Pitelka, 'Warriors, Tea, and Art...', 27. See Note 31.

59. Cort, personal correspondence.

60. A.L. Sadler, *Cha-no-yu: The Japanese Tea Ceremony*, Rutland, Vermont: Charles E. Tuttle Co, Inc, 1962, 126.

61. Raku Kichizaemon XV, *Kōetsu-ko*, Kyoto: Tankosha, 2018, 278.

62. *Ibid.*

63. *Ibid.*

'...and a famous temper'

64. Shigenori Chikamatsu, *Stories from a Tearoom Window: Lore and Legends of the Japanese Tea Ceremony*, Kozaburo Mori (trans.), Toshiko Mori (ed.), Tokyo/Vermont: Tuttle Publishing, 1982, and E-book, location 1174.

65. Helen Craig McCullough (trans.), *Tales of Ise*, Stanford: Stanford University Press, 1968, 88.

Chapter Four

66. Echizen Lacquerware Cooperative [Website], 'What is urushi-kaki?', http://echizen.org/panel/p12/, accessed 19 January 2020.

67. Mitamura Arisumi, *Urushi Art: Glittering Moments in Time – A Tradition of Edo Gold-Sprinkled Lacquer*, Itani Yoshie (trans.), Tokyo: Ribun Shuppan, 2009, 97.

68. Shimode Muneaki, in dialogue.

Chapter Five

69. Tate [Website], 'Doris Salcedo: Shibboleth', *Tate Shots*, 1 October 2007, www.tate.org.uk/art/artists/doris-salcedo-2695/doris-salcedo-shibboleth, accessed 10 January 2019.

70. *Ibid.*

71. Alison Sinkewicz, 'Yoko Ono's "Mend Piece" at the Rennie Museum', *Montecristo Magazine,* 6 March 2018, https://montecristomagazine.com/arts/yoko-onos-mend-piece-at-the-rennie-museum, accessed 12 January 2020.

72. Phaidon [Website], 'Yeesookyung – Why I Create', undated, https://uk.phaidon.com/agenda/art/articles/2018/january/24/yeesookyung-why-i-create, accessed 12 January 2020.

73. In newspaper reports at the time, it was erroneously stated that this vase was 'repaired using an ancient Chinese technique'. Kintsugi is a Japanese technique. One example can be found at Mark Brown, 'Grayson Perry vase with Chris Huhne motifs depicts "audacious default man" ', *The Guardian,* 21 October 2014, www.theguardian.com/artanddesign/2014/oct/21/grayson-perry-chris-huhne-default-man-vase-national-portrait-gallery, accessed 9 February 2020.

74. Lisa Pollman, 'Splendid imperfection: Dutch artist Bouke de Vries and Chinese porcelain – in conversation', *Art Radar,* https://artradarjournal.com/2017/07/04/splendid-imperfection-dutch-artist-bouke-de-vries-and-chinese-porcelain-in-conversation, accessed 2 February 2020.

75. Sagawa Art Museum [Website], www.sagawa-artmuseum.or.jp/en, accessed 8 January 2020.

76. Robert Yellin, in personal communication with the author, February 2019.

77. Zuleika Gallery, https://zuleikagallery.com/artists/59-claudia-clare/works/2258-claudia-clare-remembering-atefeh-2011, accessed 12 January 2020.

78. Claudia Clare, *Shattered* [Exhibition catalogue], 2007, 1.

79. Allison Meier, 'An Artist Mends Cracks in the Sidewalk with Gold', *Hyperallergic,* 16 February 2017. https://hyperallergic.com/358112/sidewalk-kintsukuroi-rachel-sussman, accessed 12 January 2020.

80. Rachael Chambers, 'Zoë Hillyard: Piecing together the past', *craft&design,* July/August 2012: 70.

Chapter Six

81. Milan Kundera, *The Unbearable Lightness of Being*, Michael Henry Heim (trans.), New York: Harper & Row, 1984, 11.

82. James Geary, *I Is an Other: The Secret Life of Metaphor and How it Shapes the Way We See the World*, (First published by Harper, 2011), HarperCollins e-books, Kindle edition, Location 96.

83. BBC Radio 4, *Only Artists* [Radio programme], 9 October 2019, www.bbc.co.uk/programmes/m00094hg, accessed 15 October 2019.

84. King James Version

85. Hanya Yanagihara, *A Little Life,* London: Picador, 2016, 133–134.

86. Chris Cleave, *The Other Hand* (also known *Little Bee*), New York: Simon & Schuster Paperbacks, 2008, 9.

87. Chanel Miller, *Know My Name*, Viking/Penguin Publishing Group, 2019.

88. 'Kintsugi', *Wikipedia* page, https://en.wikipedia.org/wiki/Kintsugi, accessed 17 November 2019.

89. Rev Alice Goodman, in dialogue with the author, September 2019.

90. John Bunyan, *Pilgrim's Progress*, Mineola NY: Dover Publications Inc, 1678/2003, 320.

91. Candice Kumai, *Kintsugi Wellness: The Japanese Art of Nourishing Mind, Body, and Spirit*, Harper Wave/HarperCollinsPublishers, undated, 15.

92. Elisabeth Kübler-Ross, *Death: The Final Stage of Growth*, Englewood Cliffs, NJ: Prentice-Hall, 1975), 96. Quoted in Keith Barney, 'Resilience: How to Cope With Life's Pressures, Disappointments, or Losses', *Perspective 1:2*, 4. Available at http://scholar.googleusercontent.com/scholar?q=cache:sEOiR4zttAoJ:scholar.google.com/+death:+the+final+stage+keith+barney&hl=en&as_sdt=0,5, accessed 15 January 2020.

93. Tomás Navarro, *Kintsugi: Embrace Your Imperfections and Find Happiness – The Japanese Way*, Jennifer Adcock (trans.), London: Yellow Kite 2018.

94. Sana Loue, *The Transformative Power of Metaphor in Therapy*, New York: Springer Publishing Company, 2008, xiii.

95. 'Kintsugi Spirit' [Website], https://esprit-kintsugi.com/en/le-kintsugi-et-la-spiritualite, accessed 13 January 2020.

96. Céline Santini, *Kintsugi, the Art of Resilience*, Kansas City: Andrew McMeel Publishing, 2019.

97. Andrew Solomon, *Far From the Tree: Parents, Children and the Search for Identity*, London: Vintage, 2014, 369.

98. Kathy Rees, 'Rupture in a Relationship and the Idea of Kintsugi', Coupleworks [Blog], 10 February 2016, https://coupleworks.co.uk/2016/02/10/rupture-in-a-relationship-and-the-idea-of-kintsugi, accessed 17 January 2020.

99. Emmanuel Kant, *Idea for a General History with a Cosmopolitan Purpose* (1784), Proposition 6.

100. Tom Shakespeare, in dialogue with the author, May 2019.

101. The Kintsugi Project [Website], Plymouth UK, www.kintsugiproject.org/about-us, accessed 17 January 2020.

102. Spelman, *Repair*, 85.

103. Shimode Muneaki, in dialogue.

104. Leonard Cohen, 'Anthem' [Music album], *The Future*, Columbia Records, 1992.

105. Gabrielle Aplin [Music video], www.youtube.com/watch?v=EzASPS8LyYU, accessed 17 January 2020.

106. Elhaq Latief, 'Communicating A Social Issue of Abusive Relationship Through A Dance Show, KINTSUGI', 27 April 2019. www.scribd.com/document/419427144/Press-Release-Kintsugi-English, accessed 17 January 2020.

107. *Africa News*, 'Powerful new exhibition launches results of artisanal gold mining research in West Africa', www.africanews.com/2019/12/03/powerful-new-exhibition-launches-results-of-artisanal-gold-mining-research-in-west-africa, accessed 13 January 2020.

108. *starwarsnewsnet.com*, 'Complete breakdown of the entire Empire Magazine article about 'Star Wars: The Rise of Skywalker' ', 3 October 2019, www.starwarsnewsnet.com/2019/10/rise-skywalker-abrams-terrio-empire.html, accessed 14 October 2019.

109. Bridget Harvey, 'The Department of Repair: Repairing as Place Making', *From Space To Place/Making Futures Journal* 4, unpaged. https://drive.google.com/file/d/1nzvi-fwirby7z-FeQ1Za2j_5fSa6EJ3v/view, accessed 1 February 2019.

110. Jonathan Chapman, *Emotionally Durable Design: Objects, Experiences and Empathy*, Abingdon: Routledge, 2015, 65.

111. Nazli Terzioğlu, in correspondence with the author on issues in *Do-fix: creating deeper relationships between users and products through visible repair*, PhD thesis, Royal College of Art, London, 2017.

BIBLIOGRAPHY

'1.07 Conservation Strategy'. *Understanding Conservation*, www.understandingconservation.org/content/107-conservation-strategy, accessed 18 January 2020.

Adamson, Glenn, Martina Droth and Simon Olding. *Things of Beauty Growing: British Studio Pottery.* Yale Center for British Art (Yale University Press), 2017.

Africa News, 'Powerful new exhibition launches results of artisanal gold mining research in West Africa', www.africanews.com/2019/12/03/powerful-new-exhibition-launches-results-of-artisanal-gold-mining-research-in-west-africa, accessed 13 January 2020.

Aiyar, Pallavi. 'A Japanese ceramic repair technique teaches us to embrace our scars', *Nikkei Asian Review*, 1 December 2016. Available online: https://asia.nikkei.com/NAR/Articles/A-Japanese-ceramic-repair-technique-teaches-us-to-embrace-our-scars, accessed 18 January 2020.

Antiques Roadshow [TV programme]. BBC1, 15 September 2019.

Aplin, Gabrielle [Music video]. www.youtube.com/watch?v=EzASPS8LyYU, accessed 17 January 2020.

Arcadia University Art Gallery. *Ai Weiwei: Dropping the Urn: Ceramic Works, 5000 BCE–2010 CE.* Glenside PA: Arcadia University, 2010.

Barney, Keith. 'Resilience: How to Cope With Life's Pressures, Disappointments, or Losses', *Perspective 1:2*, http://scholar.googleusercontent.com/scholar?q=cache:sEOiR4zttAoJ:scholar.google.com/+death:+the+final+stage+keith+barney&hl=en&as_sdt=0,5, accessed 15 January 2020.

Bartlett, Christie. 'A Tearoom View of Mended Ceramics', *Flickwerk: The Aesthetics of Mended Japanese Ceramics* [Exhibition catalogue], Herbert F. Johnson Museum of Art (Cornell University) and Museum für Lackkunst (Münster), 2008. Available at http://annacolibri.com/wp-content/uploads/2013/02/Flickwerk_The_Aesthetics_of_Mended_Japanese_Ceramics.pdf, accessed 2 February 2020.

BBC Radio 4. 'Tracy Chevalier Meets Edmund de Waal', *Only Artists* [Radio programme], 9 October 2019, www.bbc.co.uk/programmes/m00094hg, accessed 15 October 2019.

BBC Radio 4. 'Mending Cracks with Gold', *Something Understood* [Radio programme], 1 September 2013.

Birch, Michael Sōei. *Workbook: An Anthology of the Seasonal Feeling in Chanoyu.* Published privately, 1987.

Bleed, Peter. 'Almost archaeology: Early archaeological interest in Japan', in *Windows on the Japanese Past: Studies in Archaeology and Prehistory,* Richard J. Pearson, Gina Lee Barnes and Karl L. Hutterer (eds.). Michigan: Center for Japanese Studies, 1986, 57–67.

Brown, Evan Nicole. 'The Art of Repairing Broken Ceramics Creates a New Kind of Beauty', *Atlas Obscura*, 15 February 2019, www.atlasobscura.com/articles/repairing-broken-ceramics, accessed 12 November 2019.

Brown, Mark. 'Grayson Perry vase with Chris Huhne motifs depicts "audacious default man"', *The Guardian*, 21 October 2014, www.theguardian.com/artanddesign/2014/oct/21/grayson-perry-chris-huhne-default-man-vase-national-portrait-gallery, accessed 9 February 2020.

Bunyan, John. *Pilgrim's Progress.* Mineola NY: Dover Publications Inc, 1678/2003.

Chambers, Rachael. 'Zoë Hillyard: Piecing together the past', *craft&design*, July/August 2012.

Chapman, Jonathan. *Emotionally Durable Design: Objects, Experiences and Empathy.* Abingdon: Routledge, 2015.

Chiba Toshirō. 'Lacquerwork Techniques Found in the Shimo-yakebe Site', *Bulletin of the National Museum of Japanese History*, 187, 2014, 217–233.

Chikamatsu, Shigenori. *Stories from a Tearoom Window: Lore and Legends of the Japanese Tea Ceremony,* Kozaburo Mori (trans.), Toshiko Mori (ed.). Tokyo/Vermont: Tuttle Publishing, 1982.

Claudia Clare. *Shattered* [Exhibition catalogue], 2007, 1.

Cleave, Chris. *Little Bee.* New York: Simon & Schuster Paperbacks, 2008.

Cohen, Leonard. 'Anthem' [Music album], *The Future*, Columbia Records, 1992.

Cort, Louise Allison. 'The Kizaemon Teabowl Reconsidered: The Making of a Masterpiece', *Chanoyu Quarterly: Tea and the Arts of Japan.* No. 71, Kyoto: Urasenke Foundation, 1992, 7–30.

Dahn, Jo. *New Directions in Ceramics: from spectacle to trace.* London/New York: Bloomsbury Academic, 2015.

Dunn, Michael (ed.). *Transmission of Beauty: Interviews with Hatakeyama Hisako,* Christopher Yohmei Blasdel (trans.). Tokyo: Hatakeyama Memorial Museum of Fine Art and Its Treasures, undated (Preface dated 2011).

Echizen Lacquerware Cooperative. 'What is urushi-kaki?', http://echizen.org/panel/p12, accessed 19 January 2020.

Flickwerk: The Aesthetics of Mended Japanese Ceramics [Exhibition catalogue], Herbert F. Johnson Museum of Art (Cornell University) and Museum für Lackkunst (Münster), 2008. Available at http://annacolibri.com/wp-content/ uploads/2013/02/Flickwerk_The_Aesthetics_of_Mended_ Japanese_Ceramics.pdf, accessed 2 February 2020.

Fujio, S. et al. 'When did the wet-rice cultivation begin in Japanese archipelago?', *Sokendai review of cultural and social studies,* 1, 2005, 69-96.

Garnsey, Monica. 'Death of a Teenager', *The Guardian,* 27 July 2006, https://www.theguardian.com/media/2006/ jul/27/iran.broadcasting, accessed 12 January 2020.

Geary, James. *I Is an Other: The Secret Life of Metaphor and How It Shapes the Way We See the World.* HarperCollins e-books, 2011.

Gray, Laura. ' "No Construction Without Destruction": Ceramics, Sculpture and Iconoclasm', in *Art and Destruction,* Jennifer Walden (ed.). Newcastle upon Tyne: Cambridge Scholars Publishing, 2013, 9–34.

Haga Kōshirō. 'The *Wabi* Aesthetic Through the Ages', Martin Collcutt (trans. and adapted by), in *Tea in Japan: Essays on the History of* Chanoyu, Paul Varley and Kumakura Isao (eds.). Honolulu: University of Hawai'i Press, 1989, 195–230.

Haino, A. 'Honpo-ji "Housouka raden Hokekyo kyobako" ', *Gakusou,* 11, 1989, 115–122.

Hammill, Stephanie. 'Kintsugi', *The Journal of Australian Ceramics,* Vol. 55, No. 3, November 2016, 70–73.

Harvey, Bridget. 'From Space to Place: The Department of Repair: Repairing as Place Making', *Making Futures Journal,* Vol. 4, 2015, unpaged. https://drive.google.com/ file/d/1nzvi-fwirby7z-FeQ1Za2j_5fSa6EJ3v/view, accessed 1 February 2020.

Hatakeyama Memorial Museum of Fine Art. *Yoshu Aigan Rimpa.* Tokyo: Hatakeyama Memorial Museum of Fine Art, 2007.

Hemingway, Ernest. *A Farewell to Arms.* New York: Scribner, 1929/2014.

Higashimurayama History Museum. *Shimoyakebe Iseki ten Jomon no urushi.* Tokyo: Higashimurayama History Museum, 2014.

Ikemiya, Miwa. 'about me' [Website], https:// cargocollective.com/miwadawn/about-me, accessed 1 December 2019.

Institute of Making. *The Taste of Materials_spoons,* (Spoons booklet), https://static1.squarespace.com/ static/578f5f33f5e231d1bfff6cf4/t/59a6b4af3e00be1a65f4 0ff2/1504097460915/Spoons+Meal+Booklet.pdf, accessed 30 December 2019.

Ise Yuya. 'Yakugaku ga kureta watashi no michi', Interview with Nakanishi Yukito, *Farumashia (Pharmaceutical Society of Japan)*, 52, 10, 2016, 913-916.

Iten, Charlie. 'Ceramics Mended with Lacquer— Fundamental Aesthetic Principles, Techniques and Artistic Concepts', *Flickwerk: The Aesthetics of Mended Japanese Ceramics* [Exhibition catalogue], Herbert F. Johnson Museum of Art (Cornell University) and Museum für Lackkunst (Münster), 2008. Available at http://annacolibri. com/wp-content/uploads/2013/02/Flickwerk_The_ Aesthetics_of_Mended_Japanese_Ceramics.pdf, accessed 2 February 2020.

Kaneko, Reiko. *Kintsugi: All that is Broken is not Lost* [Exhibition handout]. Sway Gallery, 2019.

Kaner, Simon. 'Jōmon and Yayoi: premodern to hypermodern', in *Routledge handbook of premodern Japanese history,* Karl F. Friday (ed.). Abingdon: Routledge, 2017, 55–67.

Emmanuel Kant, *Idea for a General History with a Cosmopolitan Purpose* (1784), Proposition 6.

Kemske, Bonnie. *The Teabowl: East and West.* London: Bloomsbury Publishing, 2017.

Kerr, Alex, with Kathy Arlyn Sokol. *Another Kyoto.* First published in Japan by Sekaibunka Publishing Inc. 2016, UK publication: Penguin 2018.

Keulemans, Guy. 'The geo-cultural conditions of kintsugi', *The Journal of Modern Craft,* Vol. 9, No. 1, 2016, 15–34.

Keulemans, Guy. 'Kintsugi and the art of ceramic maintenance', *The Conversation,* 11 October 2016, https://theconversation.com/kintsugi-and-the-art-of-ceramic-maintenance-64223, accessed 18 January 2020.

'Kintsugi', *Wikipedia,* https://en.wikipedia.org/wiki/Kintsugi, accessed 17 November 2019.

Kintsugi Project, The [Website]. Plymouth UK, www.kintsugiproject.org/about-us, accessed 17 January 2020.

Kleinman, Jake. ' "Star Wars: Rise of Skywalker": Kylo Ren's helmet has a Japanese influence', *Inverse,* www.inverse.com/article/54877-star-wars-rise-of-skywalker-kylo-ren-helmet-in-episode-9-reference-japanese-art, accessed 14 April 2019.

Kopplin, M. (ed.). *Lacquerware in Asia, Today and Yesterday.* United Nations Educational, UNESCO, 2002, 19–58, www.manupropria-pens.ch/angularmomentum-manupropria/uploadfiles/static/8ab89dd/22386f09-a23f-4a08-b5e4-cf399cf5065f.pdf/Lacquerware%20in%20Asia_%20today%20and%20yesterday.pdf, accessed 6 November 2019.

Kozu A. *Gendai-go de sararito yomu cha no koten, Choando-ki.* Kyoto: Tankosha, 2011.

Kübler-Ross, Elisabeth. *On Death and Dying.* London: Tavistock Publications, 1969/1975.

Kuettner, Angelika. 'Simply Riveting: Broken and Mended Ceramics' in *Ceramics in America* 2016, Robert Hunter (ed.), found in *Chipstone,* http://www.chipstone.org/article.php/742/Ceramics-in-America-2016/Simply-Riveting:-Broken-and-Mended-Ceramics, accessed 18 January 2020.

Kumai, Candice. *Kintsugi Wellness: The Japanese Art of Nourishing Mind, Body, and Spirit.* Harper Wave (HarperCollinsPublishers), undated.

Kumakura Isao. 'Kan'ei culture and *chanoyu*', Paul Varley (trans.), in *Tea in Japan: Essays on the History of Chanoyu,* Paul Varley and Kumakura Isao (eds.). Honolulu: University of Hawai'i Press, 1989, 135–160.

Kumakura Isao. 'Sen no Rikyū: Inquiries into his Life and Tea', Paul Varley (trans.), in *Tea in Japan: Essays on the History of* Chanoyu, Paul Varley and Kumakura Isao (eds.). Honolulu: University of Hawai'i Press, 1989, 33–69.

Kundera, Milan. *The Unbearable Lightness of Being,* Michael Henry Heim (trans.). New York: Harper & Row, 1984.

Kuroda Yukiko. *Kintsugi o tanoshimu.* Tokyo: Heibonsha, 2013.

Kwan, Pui Ying. 'Exploring Japanese Art and Aesthetic as inspiration for emotionally durable design', *DesignEd Asia Conference 2012*, Hong Kong. www.designedasia.com/2012/Full_Papers/Exploring%20Japanese%20Art%20and%20Aesthetic.pdf, accessed 2 April 2015.

Latief, Elhaq. 'Communicating A Social Issue of Abusive Relationship Through A Dance Show, KINTSUGI', 27 April 2019, www.scribd.com/document/419427144/Press-Release-Kintsugi-English, accessed 17 January 2020.

Laughlin, Zoe, Mark Miodownik (1st), Martin Conreen, Harry J. Witchel. 'The use of standard electrode potentials to predict the taste of solid metals', *Food Quality and Preference,* Vol. 22, Issue 7, October 2011, 628–637.

Loue, Sana. *The Transformative Power of Metaphor in Therapy.* New York: Springer Publishing Company, 2008.

MacGregor, Neil. 'Jōmon Pot: After the Ice Age: Food and Sex (9000-3500 BC)' on *A History of the World in 100 Objects* [Radio programme], BBC Radio 4, 29 January 2010, www.bbc.co.uk/programmes/b00q2p6g, accessed 20 January 2020.

Marinucci, Lorenzo. '*Sabi* and irony. The cross-cultural aesthetics of Ōnishi Yoshinori', *Studi di estetica,* anno XLVI, IV serie, 1, 2018.

Martin, Simon. 'Historic Narratives', *Ceramic Review* 257, September/October 2012, 36–39.

Matsuda Gonroku. *Urushi no Hanashi.* Tokyo: Iwanami Shoten, 2001.

Maytal, Anat. 'Yoko Ono Installs "Mend Piece"', *The Harvard Crimson,* October 22, 2001. www.thecrimson.com/article/2001/10/22/yoko-ono-installs-mend-piece-with, accessed 6 January 2020.

McCullough, Helen Craig (trans.). *Tales of Ise,* Stanford: Stanford University Press, 1968.

Meier, Allison. 'An Artist Mends Cracks in the Sidewalk with Gold', *Hyperallergic,* 16 February 2017. https://hyperallergic.com/358112/sidewalk-kintsukuroi-rachel-sussman, accessed 12 January 2020.

Metropolitan Museum of Art. *Momoyama: Japanese Art in the Age of Grandeur* [Exhibition catalogue], catalogue of

an exhibition at the Metropolitan Museum of Art organized in collaboration with the Agency for Cultural Affairs of the Japanese Government, New York: Metropolitan Museum of Art, 1975. Available at www.metmuseum.org/art/metpublications/Momoyama_Japanese_Art_in_the_Age_of_Grandeur?Tag=&title=&author=&pt=%7B25DDF CF6-356D-4DC6-AF04-799F191B9255%7D&tc=0&dept=0& fmt=0, accessed 2 February 2020.

Miller, Chanel. *Know My Name*. Viking/Penguin Publishing Group, 2019.

Mitamura Arisumi. *Urushi to Japan*. Tokyo: Ribun Shuppan, 2005.

Mitamura Arisumi. *Urushi Art: Glittering Moments in Time – A Tradition of Edo Gold-Sprinkled Lacquer*, Itani Yoshie (trans.). Tokyo: Ribun Shuppan, 2009.

Mitamura Arisumi. *Geijyutsu ga izuru kuni Nihon*. Tokyo: Tokyo Geidai Press, 2017.

Mitani K. *Edo shobai zue*, Tokyo: Chuo Koron sha. 1995.

Mori Kōichi. *'Hakaku no Tōgei', Nikkei Shimbun*. 28 September 2015.

Nagahara Keiji (ed). *Iwanami Nihonshi Jiten*. Tokyo: Iwanami Shoten, 1999.

Nambō Sōkei, *Nampōroku*, in *Chadō Koten Zenshū*, Sen Sōshitsu (ed.), Vol. 4. Kyoto: Tankōsha, 1956.

Navarro, Tomás. *Kintsugi: Embrace Your Imperfections and Find Happiness – The Japanese Way*, Jennifer Adcock (trans.), London: Yellow Kite 2018.

Odagawa Tetsuhiko. 'Incipient Jomon Period', *Bulletin of Aomori Prefectural Archaeological Artefacts Research Center*, 6, 10–12, 2000.

Ono, Yoko. *Grapefruit: A Book of Instructions and Drawings.* New York: Simon & Schuster, 1964 (1970, copyright renewed 1992, 1998).

Phaidon [Website]. 'Yeesookyung – Why I Create', undated, https://uk.phaidon.com/agenda/art/articles/2018/january/24/yeesookyung-why-i-create, accessed 12 January 2020.

Pitelka, Morgan. 'Warriors, Tea, and Art in Premodern Japan', *Samurai: Beyond the Sword*. Birgitta Augustin (ed.). Detroit Institute of Arts, 2014.

Pollman, Lisa. 'Splendid imperfection: Dutch artist Bouke

de Vries and Chinese porcelain – in conversation', *Art Radar,* https://artradarjournal.com/2017/07/04/splendid-imperfection-dutch-artist-bouke-de-vries-and-chinese-porcelain-in-conversation, accessed 2 February 2020.

Raku Kichizaemon XV. 'Hommage à Wols', *Kichizaemon X Wols* [Exhibition catalogue], Rupert Faulkner and Kyoko Ando (trans.), Sagawa Art Museum, 2018.

Raku Kichizaemon XV. *Koetsu-ko*. Kyoto: Tankosha, 2018.

Rees, Kathy. 'Rupture in a Relationship and the Idea of Kintsugi', Coupleworks [Blog], 10 February 2016, https://coupleworks.co.uk/2016/02/10/rupture-in-a-relationship-and-the-idea-of-kintsugi, accessed 17 January 2020.

Richie, Donald. *A Tractate on Japanese Aesthetics*. Berkeley CA: Stone Bridge Press, 2007.

Roma, Caterina. 'Kintsugi', *Ceramic Review* 260, March/April 2013, 62–65.

Rosner, Daniela K. 'A Beautiful Oops', *continent*, 6.1, 2017, 77–80, http://continentcontinent.cc/index.php/continent/article/view/285, accessed 22 October 2019.

Sadler, A.L. *Cha-no-yu: The Japanese Tea Ceremony*. Rutland, Vermont: Charles E. Tuttle Co., Inc., 1962.

Sagawa Art Museum [Website], www.sagawa-artmuseum.or.jp/en, accessed 8 January 2020.

Sakamoto M. 'Research on the Beginning Age of Yayoi Period – the Role of AMS Radiocarbon Dating', *Journal of the Vacuum Society of Japan*, 50, 7, 2007, 494–497.

Santini, Céline. 'Kintsugi Spirit' [Website]. https://esprit-kintsugi.com/en/le-kintsugi-et-la-spiritualite, accessed 13 January 2020.

Santini, Céline. *Kintsugi, the Art of Resilience.* Kansas City: Andrew McMeel Publishing, 2019.

Sasaki Mizue. 'Perspectives of language: Cultural differences and universality in Japanese', *Cultural Diversity and Transversal Values: East-West Dialogue on Spiritual and Secular Dynamics* [International symposium], UNESCO, 2006, 119–126. Available at www.rel-med.net/pdf/cultural_Diversity_transversal_values_unesco_ENG.pdf#page=120, accessed 19 January 2020.

Sasaki Sanmi. *Chado: The Way of Tea: A Japanese Tea Master's Almanac,* Shaun McCabe and Iwasaki Satoko (trans.). Boston: Tuttle Publishing, 2002.

Sennett, Richard. *The Craftsman,* Allen Lane (an imprint of Penguin Books), 2008.

Siniawer, Eiko Maruko. ' "Affluence of the Heart": Wastefulness and the Search for Meaning in Millennial Japan', *The Journal of Asian Studies,* 73, 01, February 2014, 165–186.

Sinkewicz, Alison. 'Yoko Ono's "Mend Piece" at the Rennie Museum', *Montecristo Magazine,* 6 March 2018, https://montecristomagazine.com/arts/yoko-onos-mend-piece-at-the-rennie-museum, accessed 12 January 2020.

Solomon, Andrew. *Far From the Tree: Parents, Children and the Search for Identity.* First published by Chatto & Windus 2012, London: Vintage, 2014.

Spelman, Elizabeth V. *Repair: The Impulse to Restore in a Fragile World.* Boston: Beacon Press, 2002.

starwarsnewsnet.com. '*Complete breakdown of the entire Empire Magazine article about 'Star Wars: The Rise of Skywalker', 3 October 2019,* www.starwarsnewsnet.com/2019/10/rise-skywalker-abrams-terrio-empire.html, accessed 14 October 2019.

Suzuki Daisetz T. *Zen and Japanese Culture.* First published Bollingen Foundation Inc NY 1959, Princeton & Oxford: Princeton University Press: 2019.

Suzuki Miho. ' "Heart mending" kintsugi – repairing keepsakes become popular after earthquakes', *Mainichi Shimbun,* 4 February 2019. Tokyo evening edition.

Suzuki Mitsuo, Noshiro Shuichi, Tanaka Takahisa, Kobayashi Kazutaka, Wang Yong, Liu Jianquan and Zheng Yunfei. 'Origin of Urushi *(Toxicodendron vernicifuluum)* in Neolithic Jomon Period of Japan', *Bulletin of the National Museum of Japanese History*, Vol. 187, July 2014, 49–70. www.rekihaku.ac.jp/english/outline/publication/ronbun/ronbun8/pdf/187002.pdf, accessed 19 August 2019.

Takahashi Tadahiko. *Gendai-go de sararito yomu chano koten, Kissa Yojo-ki.* Kyoto: Tankosha. 2013.

Takenishi Akari. 'Kintsugi', *Key Concepts in Intercultural Dialogue,* Center of Intercultural Dialogue, No. 92, 2018, https://centerforinterculturaldialogue.files.wordpress.com/2018/10/kc92-kintsugi.pdf, accessed 12 July 2019.

Takeuchi Jun'ichi. *Gendai-go de sararito yomu cha no koten, Yamanoue Soji-ki.* Kyoto: Tankosha, 2018.

Takeuchi Jun'ichi and Setsuo Watanabe. *Sen no Rikyu to yakimono kakumei.* Tokyo: Kawaide shobou shinsha, 1998.

Tales of Ise. McCullough, Helen Craig (trans.). Stanford: Stanford University Press, 1968.

Tanihata Akio. *Gendai-go de sararito yomu cha no koten, Chawa Shigetsu-shu.* Kyoto: Tankosha, 2011.

Tanihata Akio and T. Yamada (eds.). 'Cha no rekishi', in *Chado Bunka Shinko Zaidan, Chado Bunka Kentei Koshiki Text 1-kyu • 2-kyu,* Kyoto: Tankosha, 2009, 7–54.

Tate [Website], 'Doris Salcedo: Shibboleth', Tate Shots, 1 October 2007, www.tate.org.uk/art/artists/doris-salcedo-2695/doris-salcedo-shibboleth, accessed 10 January 2020.

Torniainen, Minna. *From Austere* wabi *to Golden* wabi: *Philosophical and Aesthetic Aspects of* wabi *in the Way of Tea. Studia Orientalia,* Vol. 90. Helsinki: Finnish Oriental Society, 2000.

Ueda, Makoto. *Bashō and His Interpreters: Selected Hokku with Commentary.* Stanford: Stanford University Press, 1992.

de Verneuil, Laurent (curator), 'My Blue China' [Exhibition catalogue], 11 June–21 November 2015, La Fondation d'enterprise Bernardaud.

Vitamin C: Clay + Ceramic. London/New York: Phaidon Press, 2017.

Wada Muneharu. *Hon'ami Gyojo-ki (1 • 2 • 3).* Tokyo: Haru Shobo, 2017.

Weaver, A.M. 'Yeesookyung at Locks', *Art in America,* June 2014.

Yanagihara, Hanya. *A Little Life.* First published New York, Doubleday 2015, London: Picador 2016.

Yellin, Robert. 'New and old blended in earthy harmony', *The Japan Times,* 24 July 1999, www.japantimes.co.jp/culture/1999/07/24/arts/new-and-old-blended-in-earthy-harmony/#.XiWGg1P7R3Q, accessed 27 October 2019.

Yotsuyanagi Kasho. *Urushi no Bunka-shi.* Tokyo: Iwanami Shoten, 2009.

Zuleika Gallery, https://zuleikagallery.com/artists/59-claudia-clare/works/2258-claudia-clare-remembering-atefeh-2011, accessed 12 January 2020.

GLOSSARY

*In searching out the terminology to include in this Glossary I discovered
that practitioners often use terms differently. Hopefully, what is included
here is standard to most people working in kintsugi. Any errors are my own
and are accompanied by an apology.*

arami-urushi	荒味漆	sap from the *urushi* tree before processing
bengara	弁柄	red pigment from iron oxide
bengara-urushi	弁柄漆	red *urushi*; last surface before gold
chawan	茶碗	teabowl; often used to denote teabowls used specifically for chanoyu
dōgu (chadōgu)	道具	*cha*=tea / *dōgu*=utensils
gin	銀	silver
gindei (gin-keshifun)	銀泥	finely ground silver leaf
ginfun	銀粉	silver powder
gintsugi	銀継	repair finished in silver; (*gin*=silver)
hibiware	ひび割れ	rather large crack
hiramakie	平蒔絵	*maki-e* technique used to finish kintsugi repair that results in a flat *(hira)* surface. In fact, it is very slightly raised when the gold is covered with a final layer of *urushi*
hotsure	ほつれ	very small chip
japanning		European technique imitating Japanese lacquerware that does not use *urushi*
jinoko	地の粉	clay-type powder mixed with water then added to *urushi* to be used as filler; although sometimes referred to as *tonoko,* it is finer.

kake	欠け	rather large chip
kakera	かけら	fragment or piece
kamakizu	窯疵	'kiln wounds'; cracks or damage occurring during the firing
kan'i-kintsugi	簡易金継ぎ	'easy' kintsugi using adhesives other than *urushi*
kashu	カシュー	synthetic lacquer made from cashew shells; often used in non-professional kintsugi repairs
kebō	毛棒	brush used in *maki-e*
keshifun/keshi/kindei	消粉	fine powder made from gold *(kin-keshifun)* or silver *(gin-keshifun)* etc
kin	金	gold
kinnaoshi	金直し	gold repair using lacquer
kintsugi	金継ぎ	'gold joining'; the terms *kintsugi* and *kintsukuroi* are often used interchangeably, with individuals in the field making subtle distinctions
kintsugi-shi	金継ぎ師	professional kintsugi repairers
kintsukuroi	金繕い	'gold repair'; the terms *kintsugi* and *kintsukuroi* are often used interchangeably, with individuals in the field making subtle distinctions
ki-urushi	生漆	base *urushi*
kokuso	刻苧	mixture of fibres with *nori-urushi* or *mugi-urushi* and used as base filler before using *sabi-urushi*; adds bulk but also aids curing
kuro urushi	黒漆	black lacquer; used under silver finish
makibanachi makihanashi/ makippanashi	蒔放し	sprinkling powder onto the lacquer without another layer of *urushi*

maki-e	蒔絵	'sprinkled picture'; decorative lacquer techniques where gold and other metals are sprinkled onto wet *urushi*
makienaoshi	蒔絵直し	*maki-e* repair; often refers to a decorative finish of the mend
makie-shi	蒔絵師	*maki-e* artist or artisan; someone who makes decorative lacquerware; traditionally, the artisans
makifude	蒔絵筆	brush used for sprinkling; also used to rub the gold into the lacquer
marufun	丸粉	'round powder'; gold used in *maki-e*, so also used in kintsugi, which is not gold-leaf powder but small balls of gold. It requires more gold and a higher level of skill to use, so is more costly
monozukuri	ものづくり 物作り	the skill and spirit of making things
mugi-urushi	麦漆	a strong flour and *urushi* mixture used to stick fragments together
muro (urushiburo)	室（漆風呂）	in lacquerware, it is the container or area in which the atmosphere is kept humid and warm so that the lacquer will 'dry' or cure
nori-urushi	糊漆	adhesive mixture of *urushi* and rice glue
nuri	塗り	lacquer objects or techniques
nurimono	塗物	lacquer things
nuri-shi	塗り師	lacquerware maker; sometimes these professionals undertake kintsugi
nyū/kannyū	にゅう（入） 貫入	hairline crack
sabi-urushi	錆漆	smooth mixture of *ki-urushi* and *tonoko* used mainly as a fine filler

shikki	漆器	lacquer vessel; lacquerware
sugurome urushi	素黒目漆	a stage in the processing of *urushi*
takamakie	高蒔絵	*maki-e* technique that results in a raised design; in kintsugi it can mean a raised seam (*taka*=high)
togidashi-makie	研出蒔絵	(*togi*=burnished); a *maki-e* technique requiring high skill that results in a flat surface
tomotsugi	共継ぎ	*urushi* repair rejoining the original pieces of a pot by using *urushi* that is coloured to match the original pot
tonoko	砥の粉	very fine stone powder added to *urushi*
toxicodendron vernicifluum		Japanese lacquer tree; formerly *rhus verniciflua*
tsugi	継ぎ	joining
tsunoko	角粉	powdered stag's antler
urushi	漆	Japanese lacquer
urushi-buro (muro)	漆風呂(室)	See *muro*
urushi kabure	漆かぶれ	allergic reaction to *urushi*
urushi-kaki	漆掻き	Tapping the *urushi* tree for sap; *urushi-kaki-san* = the people with the skills to tap the trees
urushiol		active ingredient in *urushi;* also the compound that causes allergic reaction
ware	割れ	break into more than two pieces
yakitsugi	焼き継ぎ	a repair technique from the Edo era that uses glass
yobitsugi	呼び継ぎ	when repaired, voids are filled with sherds from a different pot

ACKNOWLEDGEMENTS

This book has been both a joy and a challenge, and many people have been there to share the delights and to support me through the dips. As you read these acknowledgements, you will recognize many individuals who have featured in this story of kintsugi. Before I thank them, however, I must first express my gratitude to the Daiwa Anglo-Japanese Foundation and the Great Britain Sasakawa Foundation for financially supporting a trip to Japan in 2019. Without that sponsorship, the research for this book would have been impossible. In addition, I would like to thank Peter Roberts-Taira at the Kaetsu Educational and Cultural Centre, Cambridge, for additional funding that enabled us to include images of significant cultural objects from Japan.

My personal thanks must first go to Hiroko Roberts-Taira, who undertook research into the history of kintsugi. You will have seen her written contributions as well. She also organized our research trip to Japan, provided on the spot translation for our interviews, and helped me transcribe them on our return. She then continued to liaise with individuals in Japan about photos. She has been stalwart during this project from beginning to end. Hiroko is a fellow Japanese tea ceremony student, and I'd like to thank Peter Sōrin Cavaciuti, our Tea teacher in Cambridge, and Sōkei Kimura, Urasenke Tea master in London, along with Miho Kimura. All three have offered pertinent and poignant commentary on the many aspects of kintsugi. Thanks also go to the other Japanese tea ceremony students in the Cambridge branch of Urasenke for their continued interest and support. And my special thanks go to Alex Fraser, an old Tea friend, who gave his (always helpful) opinions freely and allowed me to have repaired the teabowl I gave him many years ago. It features at the end of the book. As I type this thanks I am filled with sadness because Alex died shortly after the repair was done. His loss is yet another kintsugi project to undertake. He would approve of that. Ronald Pile is the restorer who took on that repair, and I thank him for taking such care and for producing such a beautiful result, under what were sometimes adverse conditions. It has definitely made the one and only teabowl I have ever made into a better pot.

In the course of writing this book I contacted many people who have knowledge of, or an interest in, kintsugi. In Kyoto, meeting with the artist, Raku Kichizaemon XV and his wife, Raku Fujiko, who is also Vice-Chair and Deputy Director of the Raku Museum, was a pivotal point in the research. Matsuyama Sakiko, Curator at the Sagawa Art Museum, kindly showed us around Raku Kichizaemon's amazing *chashitsu* (tearoom) – a wonderful experience. Sato Takahiko, President of Sato Kiyomatsu-Shoten Company, gave a great deal of his time to this project, in showing us how *urushi* is produced and how it is used, then producing the sequence of images of the kintsugi repair. Shimode Muneaki shared his wide practical knowledge about *maki-e* and kintsugi repairs, as did Heki Mio, a *kintsugi-shi* practising in Kyoto. It was also wonderful to visit the gallery of Robert Yellin, who offered helpful insights into kintsugi.

In the Tokyo area, we were welcomed into the home of Professor Mitamura Arisumi and his wife Izumi, to learn about *maki-e*. A visit to Kuroda Yukiko, *kintsugi-shi*, was a highlight of our trip to Japan. There we also met Hamana Kazunori, whose large pots feature in the short story about our visit. Meeting with Chiba Toshirō, Curator at the Folk Museum of Higashimurayama, to see and discuss the role of *urushi* in Jōmon pottery was a revelation. Fukuda Yumi, Curator at Hatakeyama Museum, kindly met with us to discuss Hon'ami Kōetsu and the teabowl *Seppō*. Totoki Sakura and Sasaki Eriko, both Curators at Eisei Bunko, met with us to see and discuss works in the collection.

Outside Nagoya, meeting with Suzuki Goro, his wife Yoshiko, and daughter Mayu was just a delight, and I must also extend thanks to Nozawa Sayaka, who travelled with me as translator and companion of the day. In Arita, Kyushu, I couldn't have been made more welcome in my unexpected visit to the home of Tsuruta Yoshihisa and his wife, where I also met their friend Tsuru Miyuri. What a wonderful visit it turned out to be.

Hiroko Roberts-Taira would like to add her personal thanks to Nishinaka Yukito (glass artist) for sharing his thoughts on *Yobitsugi Chawan* and his passion in creating new arts to represent the energy of life; Isazawa Yuko, Chief Curator of the Gotoh Museum; and Koichi Mori, Chairman of the Japan Ceramic Society, for sharing their knowledge and thoughts on *Yobitsugi Chawan*; and Ishikawa Prefecture Department of Education and Saito Naoko, Curator of the Kanazawa Nakamura Memorial Museum, for sharing information on Tsutsuizutsu.

Back in the UK I must thank Rupert Faulkner, Senior Curator Japanese ceramics, prints and contemporary crafts at the Victoria and Albert Museum, London, for guiding me to the kintsugi objects in the collection. I would also like to extend my thanks to Louise Allison Cort, Curator Emerita for Ceramics at the Freer Gallery of Art and Arthur M. Sackler Gallery, Smithsonian Institution, Washington, DC, for help in understanding the beginnings of kintsugi; Meri Arichi, Senior Teaching Fellow at the School of Oriental & African Studies (SOAS), London, for helping me refine my thinking about the aesthetics of kintsugi; Julie Dawson, Head of Conservation, Fitzwilliam Museum, University of Cambridge, for a helpful discussion about contemporary museum restoration; and Bridget Harvey and Nazli Terzioğlu for sharing their work, their knowledge, and their thoughts about kintsugi as part of the repair and sustainability movement. I would also like to thank potters Laetitia Pineda and Emmanuel Alexia for welcoming me to their summer Tea gathering and allowing me to see and use their beautiful kintsugi-repaired ceramics.

In thinking about kintsugi as metaphor, I would like to thank Per Hall, Consultant Plastic Surgeon, for meeting to talk about kintsugi when we didn't even know if it actually had a metaphoric link to his work or not; Tom Shakespeare, sociologist, broadcaster and disability spokesperson, who shared his insights about how the

metaphor of kintsugi might be applied within disability; and Garth Johnson for a helpful discussion and his sending of the photo about 'kintsugi spirituality'.

Many individuals helped obtain photos and/or photo permissions for this book. In Japan Kohno Junki, CEO of Daimedia Company, Osaka/Tokyo, kindly arranged two photo shoots for us: Ōyama Seiko and Tsunei Iori took photos for us at the Raku Museum in Kyoto, and Maruyama Mitsuru took photos at the Eisei Bunko Museum in Tokyo. Inagaki Yumiko, Curator at the Raku Museum, gave freely of her time to help with photographs, for which I am very grateful.

Several galleries and individuals supplied photographs as well. Thanks go to Andrew Baseman for supplying the wonderful photograph of the plate depicting nineteenth-century ceramic repairs; Hannah van den Wijngaard at the Victoria Miro Gallery (London); Galen Lowe at Galen Lowe Art and Antiques (Seattle WA); Lucy Lacoste and LaiSun Keane at Lacoste Keane Gallery (Concord MA); Chris Yeo and Julia Donnelly from Ken Stradling Collection (UK); Thomas Bachmann from BachmannEckenstein (Basel); and the staff at the Festival Terrace Shop, Southbank Centre (London).

In addition, I have had photographs sent to me by many *kintsugi-shi* outside Japan, including Catherine Nicolas (France); Natsuyo Watanabe (Berlin); Iku Nishikawa (UK), who has also been an enthusiastic supporter of this project from the beginning, and along with Stephanie

Hammill (Australia), also helped me get what I hope is the right terminology and description of technique. Any mistakes will be my own. I only wish I could have included more images of the wonderful work being done in kintsugi.

Finally, my very personal thanks go to Jayne Parsons at Herbert Press, Bloomsbury, who followed up every query I had and took on every task I asked of her; Vana Mather, who is always supportive of my writing, regardless of what it might be; and Tony Holland, who learned more than he ever wanted to know about teabowls with my last book, and now knows more than he wants to know about kintsugi.

INDEX

Numbers in italic indicate illustrations